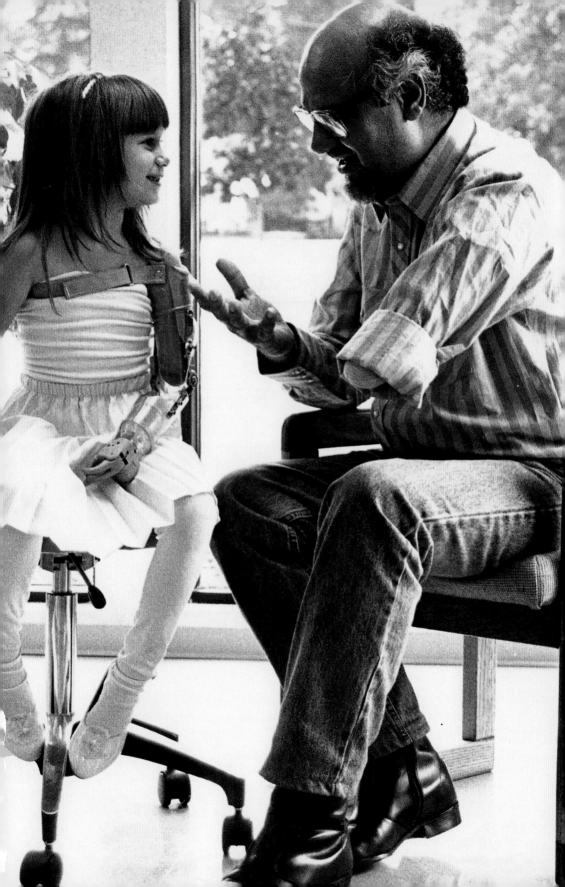

THE MAN WHO MOVED THE WORLD

THE LIFE & WORK OF
MOHAMED AMIN

BOB SMITH
WITH SALIM AMIN

FOREWORD BY MICHAEL BUERK

Camerapix Publishers International
NAIROBI

DEDICATION

THIS BOOK is dedicated to Mohamed Amin, an extraordinary man who led an extraordinary life. And to Brian Tetley without whom, quite literally, it could not have been written.

First published 1998 by Camerapix Publishers International,
3rd floor, ABC Place, Waiyaki Way, PO Box 45048, Nairobi, Kenya
Telephone: 254-2-448923/4/5
Telefax: 254-2-448926/7
E-mail: info@camerapix.com
Website: www.camerapix.com

British Library Cataloguing in Publication Data

Smith, Bob
 The Man Who Moved The World
 I. Biography
 I. Title II. Photography

ISBN 1 874041 99 7

Editor: Patrick Welland
Design: Calvin McKenzie
Colour separations: Universal Graphics, Singapore
Printed by UIC Printing, Singapore

*Above: Impish smile and a look of determination
already evident at the age of four.*
*Frontispiece: Any doubts Mo might have had about
coping with disability were banished when he met
five-year-old Stephanie Bogdan in the US.
Her unfailing courage in the face of adversity proved
an inspiration to the cameraman and the two became
firm friends.*

ACKNOWLEDGEMENTS

THE LONG list of Mohamed Amin's friends and colleagues would qualify for entry into the Guinness Book of Records. To all those who so generously offered their time, information and advice, I am extremely grateful. Special thanks are due to Mo's family and in particular his brother, Mohamed Iqbal, his widow Dolly and son Salim, who made available much of his father's extensive collection of files and personal correspondence, without which this book would have been the poorer. Thanks for reminiscences and guidance to Duncan Willetts, John McHaffie, Jan Hemsing, Sarah Elderkin, Azra Chaudhry, Rukhsana Haq, Mohamed Shaffi, Brendon Grimshaw, Debbie Gaiger, Michael Buerk, Mike Wooldridge, Colin Blane, Brian Barron, Eric Thirer, Mark Wood, Mike Payne, David Kogan, Tony Donovan, Sam Kiley, Mohinder Dhillon, Mary Anne Fitzgerald, Kate Macintyre, Eleanor Monbiot, Marcia Thomas, Ingrid Knapp, Roger Barnard, Brian Eastman, Graham Hancock, Rita Perry, Barbara Balletto, Robin Kewell, Steve Gill, Keith Hulse, Doctor Mohamed Rafique Chaudhri, Patrick Orr and John Billock. A special mention also goes to Frankie Tan and the staff at Universal Graphics, Singapore for their generosity and help in producing film and colour separations. Thanks also to Barbara, Rebecca and Rachel, a long-suffering and supportive family. And to Patrick Welland, a patient and encouraging editor.

Many others whose lives were touched by Mo freely offered personal tributes. I am indebted to President Moi of Kenya, the Right Honourable John Major, MP, former Irish President Mary Robinson, now a Commissioner to the UN, Michael Jack, MP, Sir Bob Geldof, Lionel Ritchie, Harry Belafonte, Kenny Rogers and Ken Kragan. I am grateful to the *Independent on Sunday* for permission to reproduce Mary Anne Fitzgerald's tribute to Mo, the headline from which has provided the title for this book, and to all the other publications quoted herein. My apologies to anyone who gave me help and whom I have failed to mention – a sin of omission and not of ingratitude.

Mo, as a skinny schoolboy, poses outside the Aga Khan Girls High School in Dar es Salaam.

Mo at 18. Many people have remarked on the alluring effect of his 'dark-circled' eyes.

AUTHOR'S NOTE

IN 1988, Brian Tetley wrote the story of Mo as a frontline cameraman. Painstakingly researched and compiled through interviews and tapes, it remains the most comprehensive record of the photographer's career. During research in Nairobi, I was given access to many of Mo's private papers and discovered tapes he made with Brian, which confirm the principal events and incidents of his remarkable life. Where appropriate, I have called upon Brian's notes, recordings and text, adding additional information from my own research. Brian was a gifted writer and my close friend. I respectfully acknowledge the debt this book owes to him.

I was also a friend and colleague of Mo's for more than 20 years, yet when Mo asked me to ghost his autobiography 18 months before he was killed, I was at first surprised. I did not know him intimately although we had worked jointly on many projects and had travelled together many times. We met in Nairobi, first becoming friends and then as occasional colleagues. The reason we were able to work together successfully was, I suspect, because I was never fully in his employ but we enjoyed mutual respect and trust. Out of this came the offer to work on his autobiography. It was the first time he had let anyone into the inner sanctum of his life. Initial discussion had all the elements of a boxing match, the two of us sparring around looking for openings, trying to gain the upper hand. As work progressed we learned that only complete candour could make the project succeed and, from such promising beginnings, a fruitful partnership developed. From the outset Mo was never less than frank. "I want this to be warts and all," he explained. "Some people will be shocked at what I have to say but I'm going to tell it all." In photographic parlance this would be a complete exposure.

Sadly, the warts and all factor was never achieved. We had recorded facts and anecdotes about public aspects of his life but further personal details were to come. It was virtually impossible to pin down such a globe-trotting free spirit, who was always on the move.

We planned a week away from everyone in Seychelles, a place sufficiently remote for even Mo to stop for seven days and complete the task, though he did have an office there. We were due to make that trip two weeks after Flight ET 961 crashed. As a result, what began as an autobiography has necessarily and sadly become a biography. But contained here are Mo's thoughts and comments up to the last few weeks of his life.

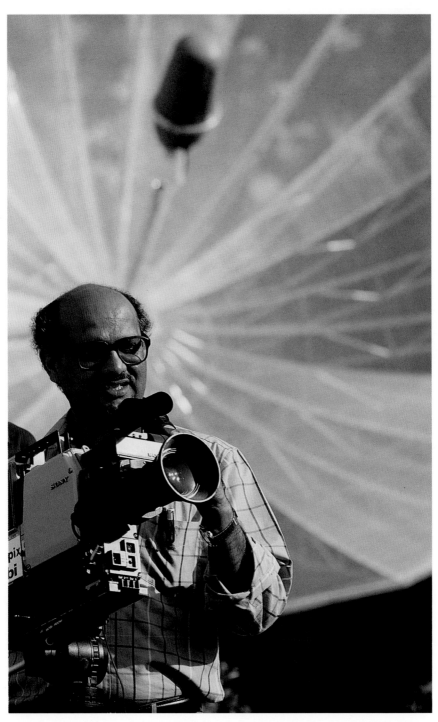

Symbol of the high-tech age of visual journalism, Mo poses with ubiquitous videocam against a satellite dish. With such equipment, he could relay his pictures across the world in seconds.

CONTENTS

FOREWORD BY MICHAEL BUERK *13*

1 THE FINAL FLIGHT *18*

2 THE EARLY YEARS *39*

3 TORTURE IN PARADISE *51*

4 NOBODY BEATS ME ON MY PATCH *93*

5 MURDER, MAYHEM AND MASSACRE *117*

6 DOWNFALL OF A DICTATOR *151*

7 THREE'S COMPANY *187*

8 CLOSEST THING TO HELL ON EARTH *211*

9 WITHIN A WHISKER OF DEATH *237*

10 THE OLD TESTAMENT WITH
ROCKET LAUNCHERS *255*

11 VARIATIONS ON AN ENIGMA *268*

THE LEGEND LIVES ON (Postscript) *284*

INDEX *296*

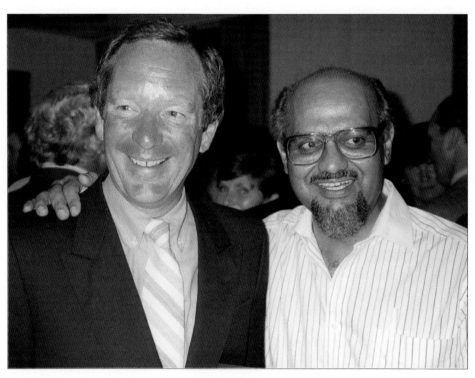

Happier times for Mo and Mike Buerk, at a function in London in 1992.

FOREWORD BY MICHAEL BUERK

MO WAS the great survivor, apparently indestructible, a character so much larger than life that, even though he plied his trade in the world's most dangerous killing grounds, even though he could be damaged, he would never be destroyed.

I remember so many occasions: driving along the sinister dirt roads of the Luwero triangle in Uganda's dark days, waiting for the MiGs to attack on the roof of the old Ghion Hotel in Makele, getting ready to go out again on to the ruined streets of Mogadishu with their packs of teenage murderers – on these and so many occasions, being desperately scared but drawing strength from Mo.

I always felt that if I could stay close enough to him I would be OK. Thinking about it now, that was probably the most dangerous place to be. He was no media cowboy, no thrill seeker; each risk was carefully calculated, but he was brave and committed. And his genius was being there when it happened.

I confidently expected to grow old with Mo, to catch up with him every couple of months, and watch him grow richer and crankier, even see him slow down a bit, but always with some new project, or some old feud to drive forward with that amazing energy of his.

It was not to be. His life ended dramatically as the focus of world attention. He was at the centre of a huge international news story – one, for a change, he had not sought out. He was wheeling and dealing with the hijackers of that plane right up to the last minute. It was all over in a split second. He is fixed now in my memory, in his prime, as one of the most extraordinary and vivid men I have ever met.

Maybe it is better than all that vigour, drive and force of life dribbling away in old age. But I miss him and he has left a big hole in all our lives.

Mo was probably the most famous cameraman in the world – an amazing achievement for somebody born into a poor Asian family in colonial Africa, who had to teach himself how to take pictures, and who operated throughout his life thousands of miles from his peers and from those who used his material.

Not many cameramen are well-known and very few become famous. Hardly any come from the great agencies like Reuters on whom everybody else depends, whose journalists are so admired within our industry, but who are normally unknown to the audiences they serve.

There was nothing anonymous about Mo. He became a legend and worked hard at it – not just because he was as much, if not more, of an egotist than the rest of us in this business, but because Mo, the ultimate

operator, knew how helpful it was to be famous. He had been unknown, an outsider, a supplicant for a long time. Maybe that was what drove him so hard.

He was a good cameraman, gifted, with a stills photographer's eye for the telling close-up. In the worst situations – when it was very dangerous, or when some huge tragedy threatened to drown emotion, feeling, judgment – he was a great cameraman, one of the very best.

In the highlands of Ethiopia in 1984, in the midst of the great famine, he worked with ruthless compassion, emotionally engaged, but professionally detached. We didn't speak much. I don't know what we could have said to each other that could have been adequate. We gathered pictures and information and each did his best to tell that story to hundreds of millions of people, rather than waste the intensity of our feelings on each other.

He was a strange man. He looked and sounded tough. A bit of a swagger, lots of bravura. Brisk, brusque, sometimes downright rude. But he had a wonderful sense of humour, a boyish sense of mischief – he was such fun to be with especially when the going got rough. And there was a deep vein of compassion in him, some of which I knew about, but a lot I didn't. When Mo got involved, he did not just lend his name, you got the full force of his personality. Things got fixed, things got done.

It wasn't just the big projects, though. Since he died, I have had dozens of letters from people who felt he was special, because they were somehow special to him. Ordinary people he took time and trouble to help, even though his life was so busy, so filled with projects, that his working day often had to start at four in the morning and end at 11 at night.

He was not a saint. It couldn't have been easy working for him, even if he drove others only half as hard as he drove himself. Having *him* work for *you* was probably even worse. Independent, intractable, a bureaucrat's nightmare, he was the antithesis of corporate man.

But he was a star. He achieved what no other cameraman has ever done; not just in the handful of video cassettes that once saved more than a million lives, but in what he was, his life, and what he made of it. Talent, determination, warmth and humanity – he packed several lives into one. I am lucky to have known him and so glad he was my friend.

Michael Buerk

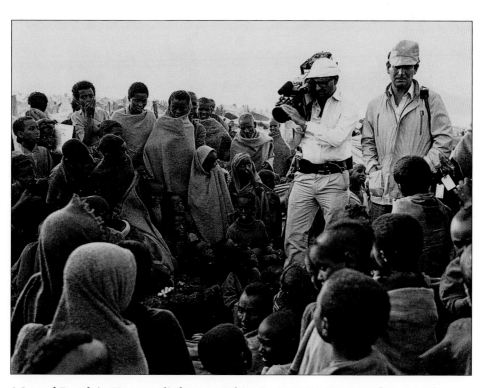

Mo and Buerk in Korem relief camp, Ethiopia, in 1984. He moved among the victims with 'ruthless compassion,' said the television reporter.

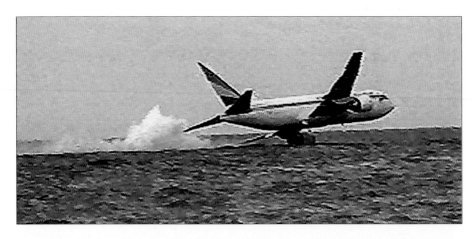

Pictures courtesy of Worldwide Television News.

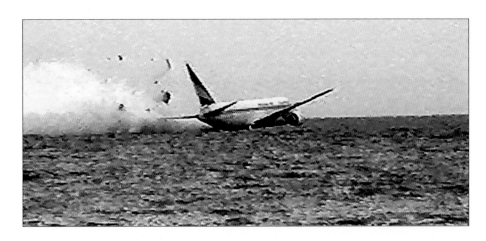

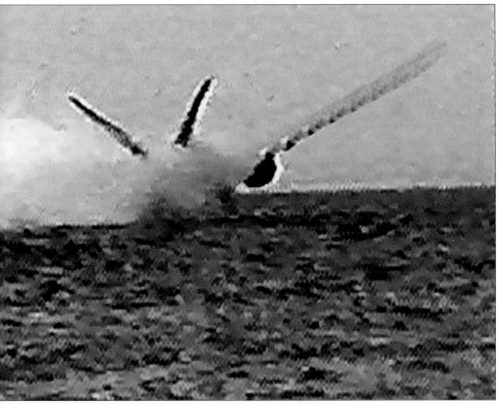

Final moments of Flight ET 961 on November 23, 1996. Above left: A wing tip brushes the surface as the hijacked plane ditches in the Indian Ocean. Above right: Seconds later, the stricken aircraft strikes a submerged reef and starts to break up, spewing luggage, wreckage and people into the sea. Above: Trailing a boiling wake of churning foam, the Boeing 767-200 begins its fatal cartwheel. Of 175 passengers and crew, just 52 survived. Mo and close friend Brian Tetley were not among the lucky ones.

CHAPTER 1

THE FINAL FLIGHT

'If you and I go together, and we get to the other side, you write the words and I'll take the pictures!'

MOHAMED AMIN TO BRIAN TETLEY, NOVEMBER, 1996

THERE WAS no pressing need for Mohamed Amin to visit Ethiopia on Friday, November 22, 1996. He had business to sort out but it could easily have been left to a later date. However, "Mo" was a man of the moment and as he paced his office in the Kenyan capital of Nairobi, he decided with characteristic spontaneity to go that very day.

For Mo, the run to Addis Ababa was little more than routine commuting. He had flown the route countless times, travelling with Ethiopian Airlines, for whom his media company produced the in-flight magazine *Selamta*. He would normally have been accompanied by his business partner Rukhsana Haq, but on this occasion commitments in Tanzania and elsewhere prevented her from making the trip. Also, she had family visiting from England and was anxious to see as much of them as possible during their brief stay in Kenya. This was one journey she could not make.

Irked by this turn of events, Mo made other plans and called across the room to his long-time friend and senior editor Brian Tetley: "Pack your bag, we're on the next flight to Addis." Despite being a reluctant flier, Tetley jumped at the chance of a change of scenery. He had worked for Mo for many years and this sudden decision came as no surprise.

Within hours the two men were touching down in the Ethiopian capital

where they made their way to the Addis Hilton. Mo had stayed there so many times during his extraordinary career as a frontline news cameraman that the hotel was almost a second home to him. As he left the airport, a taxi driver called out: "Welcome back, my brother!"

Such a warm greeting was not unexpected, for the people of Ethiopia had taken Mo to their hearts. This was the man whose penetrating lens had revealed the tragedy of the nation's starving millions and in so doing had shamed the world into the greatest single act of giving ever known. This, too, was the man who lost his arm and nearly his life documenting the country's struggle for freedom from a despotic regime.

In Addis that day, Mo's business, involving Ethiopian Airlines, was quickly resolved. This suited the photographer who, restless as ever, was keen to return to Nairobi as soon as possible where more work awaited him. As usual, Mo phoned the airport to check on his homebound flight. After years of flying in and out of the world's hottest trouble spots he knew better than to leave things to chance. He was told that everything was fine and his booking was confirmed. As he and Tetley checked out of the Hilton, smiling staff wished them a safe journey home. Less than 12 hours later both men were dead, killed along with 121 others when their plane was hijacked, ran out of fuel and plunged into the sea.

In normal circumstances air travel is reckoned to be the safest form of transport, but because Mo flew so regularly – he once estimated he had spent more than a year of his life in the air – he knew he had shortened the odds. Sensitive to the potential danger, he would never allow his son Salim to fly with him. He was also aware that hijackers had targeted Ethiopian Airlines before. But as he and Tetley took their seats aboard Saturday's flight ET 961 there was no inkling of the horror to come. Through a commercial arrangement with Ethiopian Airlines, Mo flew first class while Tetley sat nearby in business class.

Just minutes after take-off, as the Boeing 767-200 levelled out above 31,000ft, three young hijackers struck. One wielded a small axe kept aboard the plane for emergencies, a second brandished a fire extinguisher, also part of the aircraft's equipment, and the third carried a bottle of whisky and a suspected bomb. Other than a vague demand to be flown to Australia they gave no indication of political affiliation, enigmatically declaring: "We want to make history."

The hijackers – who spoke English, French and Amharic, the latter suggesting origins in the Horn of Africa – claimed they had recently escaped from prison where they had been held for opposing the Ethiopian Government. They had unspecified grievances and said they had been persecuted, though they did not say by whom. Threatening to explode

their device if anyone opposed them, they announced over the plane's p.a. system: "We have taken control of the plane. We have a bomb and are ready to use it. We are not afraid to die."

One wild theory suggested this was an assassination attempt on Mo, an attempt to get even by persons unknown, for some deal or deed Mo may have perpetrated in the past. The same could have applied to many other passengers for the roll of those on board read like a meeting of the United Nations. There were 163 passengers from 36 countries. A breakdown reveals seven Britons, eight Israelis, four Ukrainians, four French people, three Italians, two Cameroonians, two Djiboutians, two Swedes, two Americans, 18 Ethiopians and 10 Kenyans. Other travellers were from Austria, Canada, Congo, Germany, Hungary, India, Japan, Korea, Lesotho, Somalia, Switzerland, Uganda and Yemen. There were also unconfirmed rumours that American CIA agents and Israeli Mossad agents were among those aboard.

As the terrified passengers looked on in disbelief, the hijackers forced their way on to the flight deck and attacked 35-year-old co-pilot Yonas Merkuria, throwing him out into the main body of the aircraft. One terrorist grappled with pilot Leul Abate claiming he could fly the plane himself. Later, he ripped off Abate's headset, preventing the pilot from communicating with air traffic control as the jet approached the Comoros islands between Mozambique and Madagascar.

With his wicked sense of humour, Mo would have seen the supreme irony of the manner of his death. Caught up in inept air piracy, he was at the centre of the biggest news story of the day, yet he was powerless to do anything about it. That would have annoyed the hell out of him. He once joked with Tetley: "Brian, if you and I go together and we get to the other side, you write the words and I'll take the pictures." Typically, he was the only one on board to go down fighting. He was seen standing in the aisle of the first-class cabin, near his seat in the second row, arguing or negotiating with the hijackers right to the last minute. Earlier, he had been making notes, apparently against the possibility of his surviving the incident and chalking up yet another world exclusive. What is certain is that he did not sit idly by when there was even a slight chance that something could be done to save the situation.

It is hard even to speculate on what ran through the minds of those passengers as they faced almost certain death. Survivor accounts tell of panic, weeping and praying. Those who saw Mo say how calm he remained. All the indications are that he did not expect to die. More likely, he was planning the best way to market his account of that fearful journey, comforted by the fact that Tetley was with him and together they would

have a story for the front pages of newspapers across the globe. Among those terrified travellers Mo was unique in that he had coolly faced death many times before. Running away from danger was not his style.

Sitting in economy class was Kenyan Michael Odenyo. He was returning from a business trip to the Ethiopian capital and recalled the shocking moment when the hijackers struck. He said: "One of the men kept walking up and down the plane making sure people stayed in their seats. He wore what looked like a large black glove on one hand, tightly taped to his wrist. We all felt certain it contained a grenade or similar weapon. Nobody was willing to do anything. We thought this was the end. Then, shortly before the crash, Mohamed Amin came into our section.

"By now people were screaming, shouting and praying. Mohamed asked the male passengers to stand up with him and take on the hijackers because there were only three of them. A man sitting near me jumped up and was pushed back down. A lot of people felt that we should take our chances with a crash landing. But Mo's gesture was very brave because, throughout the flight, nobody else stood up. It was a sign of great courage."

If secret service men were on board flight ET 961, it seems odd that no one else tried to overpower the terrorists. But security experts have argued that such men were probably trained to deal with situations on the ground and not in the air.

Now events took another dramatic turn. Throughout the hijack, the terrorists had issued conflicting commands to 42-year-old Abate, constantly changing their minds about their ultimate destination. The pilot warned them the jet was running low on fuel, but they stubbornly refused to believe him and by the time they reached the Comoros the situation was critical.

Abate decided to land. Then, as the airliner was on its final approach, a hijacker screamed at him to abort the operation and gain height. The instruction sealed the stricken Boeing's fate. As it curved into the sky, the last dregs of fuel ran out leaving Abate with no choice but to ditch. Already the victim of two previous hijacks, the pilot remained cool to the last. He decided to put the plane down in the calm, azure waters close to a busy beach where help would be at hand. But as the jet drifted down, watched by horrified holidaymakers there was another twist of fate, one which Abate could not have anticipated. His chosen landing site concealed a submerged coral reef and, as the airliner began its final landing, a wing struck the reef and the plane cartwheeled into the water, breaking into three and spewing people, debris and luggage into a froth-filled ocean.

From the shore, a South African tourist videoed the last tragic moments of the plane. Only 52 of the 175 passengers and crew survived. Mo died as he lived – on camera. Odenyo, who had so admired the cameraman's

solitary defiance of the terrorists, was one of the lucky ones. He came to beneath the surface, still in his seat, shocked but relatively unscathed. As his senses returned, he thought he must have died and this was how the transition to the other side began.

He soon grasped the truth and kicked for the surface. His seat belt restrained him but he managed to free himself and head for the bright daylight above. On the way up, a hand grabbed his ankle and, after overcoming initial panic, he realised another passenger was similarly trapped. Odenyo freed him and together they swam to the surface where they found some luggage floating on the sea and clung on until rescued.

Mo and Tetley were not so lucky. The writer died of multiple injuries, still strapped into his seat. He made no secret of his dislike of flying, the fact that he could not swim and his fear of drowning. Mo died instantly from a broken neck. His partner and friend, photographer Duncan Willetts, was one of those left with the grim task of identifying the two bodies in the macabre surroundings of the makeshift Comoros morgue in a disused meat importer's cold storage room. Of Mo he said: "There was hardly another mark on him." The word "another" is significant, for when he died at the age of 53, Mo's body reflected the demands made upon it by his high-risk lifestyle. He had lost an arm in an explosion, been beaten up, tortured, shot at and injured in several car crashes. But none of these body blows had blunted his razor-sharp mind. Tetley once said that Mo believed celluloid and tape were ephemeral. Only the printed word would last. Having achieved so much, Mo was concerned to have the fact recognised for posterity. He was often unassuming but not especially modest and an autobiography was his certain way of knowing there was a lasting record of his considerable deeds.

On March 19, 1997, hundreds of people travelled from around the world to attend a memorial service for Mo at the spiritual home of Britain's journalists, St Bride's Church in London's Fleet Street. Tributes were both moving and heartfelt. Perhaps the most poignant was delivered by TV reporter Michael Buerk, who worked with Mo on many tough and dangerous assignments. In his closing comments he said that, above all, Mo was simply "a friend". In a BBC television tribute written and presented by Buerk, Mo is filmed on assignment with other journalists talking about death, and in particular his own. A colleague asks him who would write the obituary. "It won't be you," he jibed at Buerk, "no one could afford you!" No fees were charged that day at St Bride's. As Buerk said: "Mo would be thinking I'd learned nothing from him at all."

Mo need never fear obscurity. His name and achievements live on in the memory of millions just as surely as if they were written in stone.

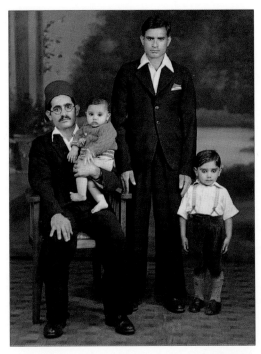

Left: Earliest picture of Mo with his father Sardar Mohamed. Standing is Mo's uncle Niaz and elder brother Iqbal.
Below: Family portrait: An early group photograph of Mohamed Amin's family, with mother and father, brothers and sisters. Taken in Dar es Salaam, the picture shows Mo back, centre.

Soon after his release from a Zanzibar jail, Mo was reunited with his girl friend and wife-to-be, Dolly Khaki.

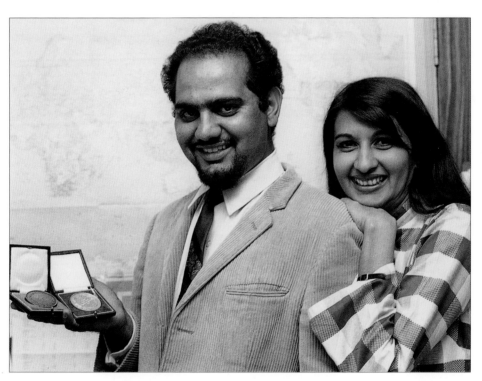

Proud moments for Mo and Dolly after the photographer received the British Television Cameraman of the Year Award in 1969.

A mean 'n' moody early self-portrait: The cigarette and hat were never used as props again.

Above: When Mo met Dolly, she was already a successful dress designer in Tanganyika who frequently modelled her own creations.
Overleaf: The couple were regular visitors to Nairobi Game Park and animal orphanage where, on this occasion, they posed with a pair of abandoned lion cubs.

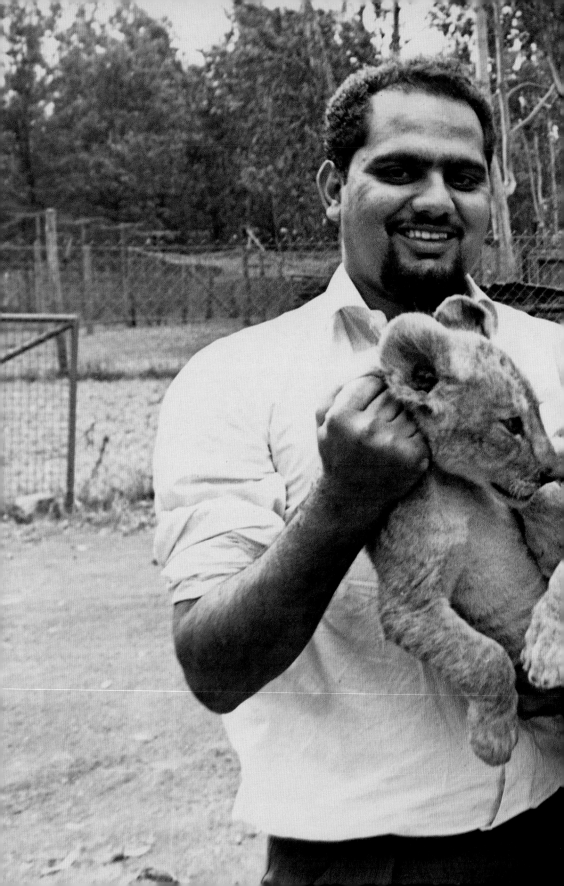

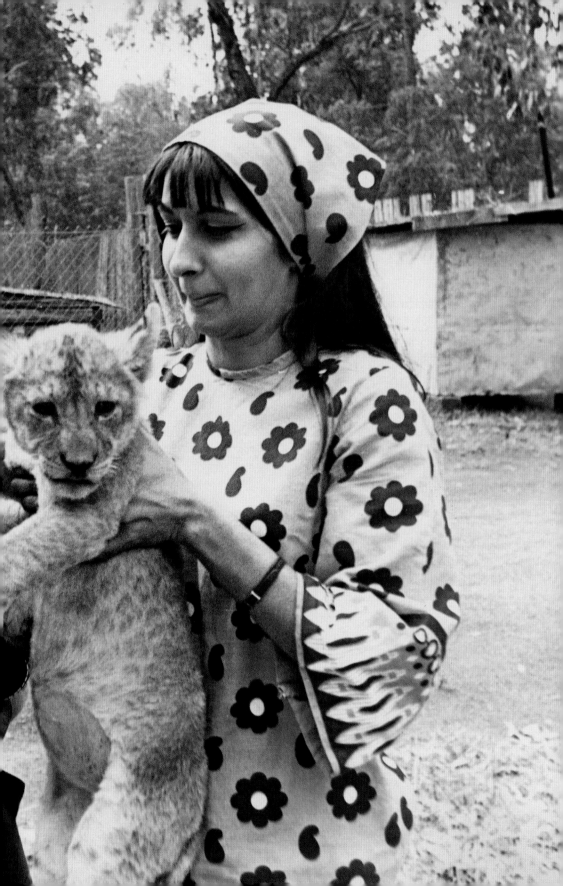

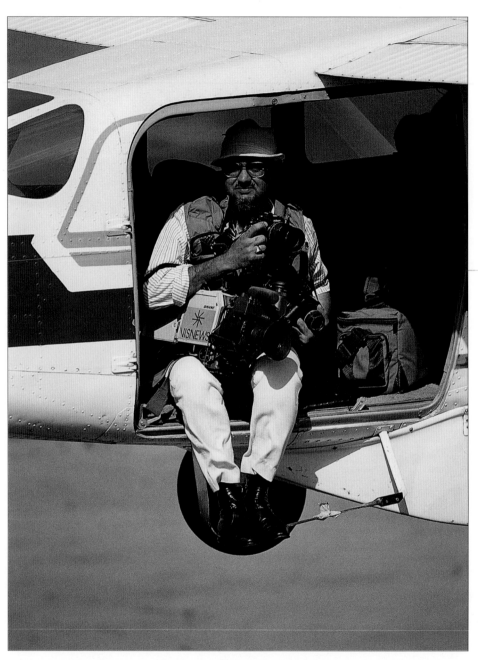

Above: Audacious as ever, Mo seems oblivious to danger as he perches precariously at the open door of a light aircraft chartered for an aerial shoot.
Right: It's early days, but a young Salim is already following in his father's footsteps, here during the East African Safari Rally.
Overleaf: A favourite father-and-son snapshot, taken while the two were on a break during a working safari in Kenya.

Above: Formal wedding portrait, Nairobi, 1994, with Salim and beautiful new bride Farzana, Mo and Dolly.
Overleaf: Light moment during the wedding festivities as Dolly feeds Mo a titbit while the cameraman holds his ever-present videocam to record the occasion. 35

*Above: Happy family shot of Mo, Dolly and baby Salim on a rare beach
break in Mombasa.*
*Below: Salim and Farzana's daughter Saher, born just 10 days after her
grandfather was killed. At the time of this picture Saher was one year old.*

CHAPTER 2

THE EARLY YEARS

*'When he made his mind up, nobody
was ever going to change it'*

MOHAMED IQBAL

MO WAS born on August 29, 1943, the second son of Indian
railway worker Sardar Mohamed who had migrated to East
Africa to seek his fortune. Sardar came from India's Punjab
province and lived in Jullundur, an area not noted at that time for its
commercial potential. In 1927, with the determination and enterprise that
were to characterise his son's life, he bought a passport for a mere three-
and-a-half rupees, journeyed to Bombay and purchased a one-way ticket
to Kenya aboard the British India Navigation Company's steamship *SS
Kampala.* He was just 17 when he docked at Mombasa and took a train to
Nairobi to start a new life.

What lured Sardar were the glamorous posters he had seen offering
opportunities in Britain's latest Crown colony. At that time, Kenya was
still very much an infant settlement with little of the infrastructure essential
to make it a thriving community. More than 30 years earlier, however,
British rulers had made a key decision which was to transform the emergent
nation, to run a railway from the Kenyan coast to Uganda. It was a decision
fraught with controversy, but there were pragmatic reasons to go ahead.
Firstly, there was the need to develop the interior, providing a vital route
to Africa's greatest lake, Victoria, 620 miles away across inhospitable terrain.
Such a link would provide an opening into what was described as the Pearl

of Africa, Uganda, which many wanted as a British protectorate. As well as commercial possibilities, a rail link had the advantage of offering swift transportation of troops should developing German interests in Tanganyika threaten Britain's East African territorial imperative.

At a cost which eventually exceeded £5 million the project went ahead. It was a daunting prospect, for the chosen way involved crossing desert, thorn and scrub savannah, scaling the wall of the Great Rift Valley and descending 2,000ft down the almost sheer wall on the other side before reaching the quagmire of swamp and black cotton soil that stretched to the shores of the lake. Along the way were hungry predators, endemic diseases hitherto without cure and very little water. No wonder its British detractors dubbed it the "Lunatic Line."

The demands of construction were phenomenal, requiring a massive battery of equipment and an army of personnel, from surveyors and engineers to thousands of skilled and unskilled labourers. Despite the enormity of the task, the first rail was laid in Mombasa in 1896 and three years later, the railway halted at Mile 327, the last flat land before the climb up the escarpment wall of the Rift Valley. The first handful of shacks and shanties appeared and soon the railhead had become a sprawling shanty town. It was from such inauspicious beginnings that Nairobi sprang up and, by the time Sardar arrived in 1927, it had already become a sizeable community. Sardar stayed only a few days on Nairobi's River Road, a thriving ghetto of cheap hotels and boarding houses on the wrong side of the tracks, before heading upcountry to work as a mason in Eldoret, two hundred miles north west of the town. He then moved further west still to Kakamega, and then back east again to the Rift Valley, where he joined the Kenya-Uganda Railway Corporation in Nakuru as a mason building bridges until, at the outbreak of World War II, he returned to Nairobi. In 1939, he went back to Jullundur to marry Azmat Bibi (Mo's mother, who still lives in Pakistan).

After returning to Kenya, Sardar was posted to Uganda. There followed a series of transfers, including three months in Jinja in 1941, where his first son, Iqbal, was born. Two years later, in 1943, during a stint in Nairobi, Mohamed was born. By then, his father was in charge of station construction and maintenance over a wide railway network, a job involving a great deal of travel to remote and sometimes dangerous places. It is probable that Mo, as he was quickly named, acquired his own taste for adventure during that time, for Sardar often took his two sons on safari with him.

Mo's father had other qualities which he inherited. He was a devout Muslim, stern yet fair, and immune from the temptations of bribery and

patronage, unlike so many of his contemporaries who saw such corruption as a way of life. Instead, Sardar believed hard work and integrity would win the day. Alas, it did not always work out that way, and, in 1952, he received a "hardship" posting to Dar es Salaam in Tanganyika.

Nearly 700 miles south of Nairobi, Dar es Salaam is a natural port, stiflingly hot, very humid and a lot less cosmopolitan. Its name means Haven of Peace and, though not to be taken literally, at that time it pointed up a stark contrast to the turbulence of Nairobi, where bloody change was imminent. There, the Mau Mau insurgency was in full swing with an indigenous army spearheaded by the charismatic Jomo Kenyatta battling the colonial forces for independence. In October, 1952, the British authorities declared a state of emergency, swooped on Kenyatta and carried him away to spend nearly 10 years in confinement in the north of the country. Thousands of Kenyans were arrested on suspicion of supporting the freedom fighters, and sections of Eastleigh – then home to Sardar and his family – became a concentration camp.

Transfer to Dar, therefore, was little hardship for young Mo. Indeed, it was a revelation. He and his family were the first people to move into a new railway-owned estate at Changombi on the outskirts of town, hard by bush country where the visitors were more often local wildlife than local people. It was from this time that we get the first glimpse of Mo's personality. His sister, Sagira, born in 1950, remembers him as being cheeky and full of mischief. With 10 people living in their four-bedroomed home, life was a crowded, bustling affair with Mo playing a leading part in any high jinks.

Sagira said: "My eldest brother, Iqbal, was the quiet one and Mo was always lively. He enjoyed playing practical jokes and kept us all amused. When I was eight, he was just 15 and already crazy about photography. He bought a scooter and, to make it seem more sporty, he took off the silencer. It made an awful noise and the neighbours hated it, but he didn't care. There wasn't much money about and Mo wanted to buy equipment for his photography, so he would get my mother to make sweetmeats and then he would sell them to his older brother. I think Iqbal knew exactly what was going on but he bought them to help him out. They were very close."

That special bond between the two brothers was to last throughout Mo's life and Iqbal still remembers those early days at home with fondness. He said: "We didn't have a lot of money; it was hard to come by and had to go a long way with such a big family. But what we had was spread fairly. Our father was a tough man and he ran the house with a good measure of discipline. "We were very happy and had a lot of fun. Our father was a 41

strong believer in family values and, whenever we could, we would do things together though he was out at work for long hours. But we always had a meal together in the evening at six o'clock.

"Mo and I shared a bedroom. We had bunks with Mo on top and me below. In such confines we got to be very close. We were more like friends than brothers. He was always more extrovert, taking the risks and chances. I think I felt the responsibility of being the eldest son. The others looked up to me and respected me, so I was not so frivolous. I also felt more serious about school.

"The one thing our father was totally committed to was education. Whatever else happened, we all had a good education. He was very proud when I pursued a career as an engineer, but I think he found it hard to understand Mo's approach. I know I was furious when he chucked school. I never wanted him to be a photographer. Somehow it didn't seem right, but when he made his mind up about anything nobody was ever going to change it. I think we both got that from our father. Mo was very strong-minded. I had a hell of a row with him about giving up school, but he just said it would be a waste of time to carry on. In the end, we had to agree to differ."

It was not unusual for Mo to see giraffe grazing the garden, an occasional elephant literally enjoying the fruits of Sardar's horticultural labours, and once the family witnessed a lion kill a zebra just outside their grounds. Beyond the compound ranged thousands of plains animals such as wildebeest and buffalo. It is not surprising that these close encounters instilled in Mo a lifelong passion for Africa's wonderful wildlife.

Education for Mo was at Dar's India Secondary School for Asian children, a segregated establishment which, while not oppressive, underlined the contemporary trend of colonialism and reinforced racial segregation.

It was at school that Mo's leadership qualities emerged. Even then he was a self-confessed "control freak" who was unhappy in team situations, preferring individual activities where he could exercise a degree of authority. When he was 11 he bought, for the princely sum of 40 shillings, a second-hand Box Brownie camera. It was arguably the most significant purchase of his life. From that moment his future career was never in doubt. Early family snaps give little hint of what was to come, but his enthusiasm for work was perhaps a guideline. Mo quickly acquired darkroom skills to develop, process and print his own material. He did not want others meddling with his art.

The school's Photographic Society boasted good facilities and Mo was determined to become a member. But the teacher in charge firmly turned

him down on the grounds of age and inferior equipment. Mo was in Form One and to join the society he would have to wait until Form Four. Besides, his camera was little more than a joke. This was a significant incident in Mo's life – it marked his first serious clash with authority. It also marked his first major success. Bureaucratic intransigence was anathema to him. If anyone told him it couldn't be done, he had to prove them wrong.

Mo recalled: "Since my Box Brownie did not impress anybody, I asked a friend whose father had a Rolleicord camera – in those days one of the best – to lend it to me. But the father said the camera was far too precious to be taken to school, so I persuaded my friend to borrow it for the day without permission and I'd make sure he got it back. Armed with the camera, I took it to the teacher and asked if he would reconsider my request to join the photographic society."

The surprised man relented and Mo returned the camera unused and undamaged, the same day. It was a small triumph for Mo and a small disaster for his friend after his father discovered the ruse. The camera was securely locked away and parental revenge was taken with a hockey stick to the backside. Mo said: "I never had access to the camera again. So whenever the teacher asked where it was I had to say it had been damaged and sent for repairs. In fact, I never saw it again."

As his enthusiasm for photography burgeoned, Mo spent many hours taking pictures of school events. The reason was twofold: it gained him valuable experience and made him money. The school would not permit commercial photographers on the premises. Instead, members of the Photographic Society covered events and sold the pictures to other pupils on a 50-50 basis, half for the photographer and half for the society. Not noted for being a spendthrift, Mo saved enough in three years to buy his own equipment.

Around this time, he joined the Scout movement and it was a combination of this involvement and his school photographic status that earned him his first professional byline and, more importantly, his first professional payment. During Scouts Bob-a-Job Week in 1958 the Tanganyikan Governor, Sir Richard Turnbull, invited members of the movement from the Indian Secondary School to meet him at Government House. Mo went along armed with the school's Rolleiflex and took the "official" pictures. Then it was straight back to school and into the dark room (a converted broom cupboard) to process the film. He made a selection of the best prints, put them in an envelope, jumped on his bike and took them to the office of the country's main newspaper, *The Tanganyika Standard.* They appeared on page one of the following day's issue, together with Mo's byline. When Brendon Grimshaw, a charismatic

Yorkshireman, became editor four years later, one of the first visitors he received was an enthusiastic Mo. He still recalls that encounter: "I never forgot our first meeting. There was this callow youth in khaki shirt and shorts and riding a bike trying to sell me pictures. To be honest, I thought it was a joke initially, but he soon put me right! His pictures were first class, well composed, sharp and interesting. I was also impressed by the fact that he had the initiative and business sense to see no one but the boss albeit that he received only one guinea a picture for his efforts."

It was the start of a long and happy relationship between the two men. After Grimshaw retired, he bought an island in Seychelles and went to live there in splendid isolation. When his own biography, *A Grain of Sand,* was published in 1996 it bore the Camerapix imprint and was co-edited by Brian Tetley.

Mo and Grimshaw remained friends for 40 years and just four weeks before Mo met his death he took time out with his family to visit Brendon's island, Moyenne, a reunion Grimshaw reflects on with poignancy. He said: "Mo never took time off so it was quite an honour for me to receive him at home. Everyone seemed relaxed and I cherish my memories of that day."

For an editor, the publication of two pictures and subsequent payment was nothing remarkable. For a raw 15-year-old boy it was little short of a revelation. Mo recalled: "I felt on top of the world. My first published pictures were on the front page of the leading newspaper of the country. Having those photographs published was as exciting for me as any of the world exclusives I obtained later. It was a tremendous boost. I carried the paper around with me for days showing it to all my friends and sending copies to others overseas. I must have bought about 50 papers that day and bored everyone silly with my antics."

After that, any doubts about the future were dispelled. All Mo's efforts in and out of school became focused on his ambition to become a professional photographer. He went nowhere without the ubiquitous camera, snapping and gaining experience as he went. The school's magazine, *Endeavour,* reflected some early success. The edition of February, 1961, page 33, records that Mohamed Amin was appointed the School Photographic Society's 'Photographer of the Year.' Twelve months later, the same publication noted that second prize in the Art and Craft Exhibition's photographic competition was awarded to Mo.

Already, traits were emerging that were to characterise Mo's entire career. He learned to plan ahead. While just 13 he acquired official accreditation to cover the Coronation Safari Rally, the forerunner of what was to become the world-famous East African Safari Rally, then only in its infancy. It was an event which he faithfully covered for the rest of his life. Recognising the

necessity of supplying information with pictures and a need to get around quickly, Mo soon made two important purchases: a typewriter and a Lambretta scooter. Clad in goggles and helmet and with equipment slung in his backpack, he became a familiar sight around the social functions and events of Dar.

By the time he was 15, Mo had had work published in the respected and influential black-consciousness magazine *Drum*. It was a telling moment in his career for at the time *Drum* was being run by the legendary Sir Tom Hopkinson, former editor of *Picture Post*. Hopkinson was the first man to recognise the potential power of the photograph and he went on to popularise it in the pages of his magazine. That his unerring eye for a newsworthy picture should light on Mo's work was a tribute not just to the young photographer's nose for a story but also to his technical skills. Spurred on by such early success Mo redoubled his efforts and soon his pictures were being published in Fleet Street newspapers such as the *Daily Express*, *Daily Mirror*, *Daily Mail* and *The Times*. Mo said: "I can at least say that I worked for every newspaper in Fleet Street while I was still at school!"

Understandably, the intrusion of the teenage tyro was seen by professional photographers as an invasion of their pitch. They did everything they could to deter him and it was not unusual for Mo to find his way to events barred by gatemen. Typically, he turned a seeming obstacle to his advantage. Such moves forced him to find other ways of doing the job, hardened his tenacity and perseverance and honed his ingenuity. These were vital lessons learned at a young age and over the years Mo would use and improve on them time and time again. As bemused rivals would testify, he would never take no for an answer and he would nearly always find a way to get what he wanted.

As the months passed, Mo became an increasingly familiar figure at all the main events in the Tanganyikan capital as he built up his impressive portfolio. He was now a regular contributor to all the country's principal publications and was quickly earning a name for himself. But already his ambitions were outstripping the parochial confines of Dar which offered few new challenges to his restless spirit. Never one to do things by halves, Mo impulsively chose to broaden his horizons in a dramatic and decidedly foolhardy way. Combining his love of action and adventure with his single-minded determination to make his way in the wider world, he decided to quit Tanganyika to travel overland to Britain.

Ahead of him lay 5,000 miles of rugged roads and a host of international border outposts, often manned by unpredictable guards. A well-equipped safari with sturdy vehicles and enough money to cope with unforeseen

emergencies might have completed such a "Mission Impossible." Mo took one friend, Thambi, his battered Lambretta, an even more delapidated suitcase and 500 shillings. This was one of the few trips he did not plan in advance. Instead, he left in the rainy season and had barely got beyond the outskirts of Dar when his trusty steed became bogged down in clay mud.

It was the start of a gruelling safari over roads punctuated by potholes and lake-sized puddles. Every mile or so the unstable scooter would slip from under them and they would slide across the slimy surface, pick themselves up and press on. Lurching into Morogoro, they found the local hotel too expensive but managed to persuade the station master there to let them spend the night in his office. One took the floor, the other slept on the officer's desk. Driving rain hammering down on the station's corrugated roof woke them at dawn and, with their spirits as damp as the day, they pressed on. Another impecunious night was spent in the bush under the stars where Mo recalled being woken by a snuffling sound. In the dark, he thought it must be Thambi so he gave his friend's sleeping bag a good thump, turned over, and went back to sleep. By the light of the early sun next morning they discovered the tell-tale pug marks of a fully-grown lion all around their camp. That was the last night spent in the open. They pressed on and a week later traipsed into Nairobi, very tired, very hungry and very, very muddy.

Mohamed Shaffi, Mo's young cousin (now a cameraman of international repute), recalled their arrival at his father's home. He said: "There was a knock on the door and these two half-drowned rats stood there in a terrible state. Mo's father had phoned and we half expected them. Dad had to pretend to be cross. He took them into a room and gave them a ticking off, but I think he admired them in a quiet way. I know I did. I was only eight but I was already in awe of my cousin, his adventures and his determination to succeed."

Undaunted by their previous travelling experiences, the two young men refuelled themselves and the scooter and set out once more, eventually coming to a halt at the Uganda-Sudan border. With little money, no travel documents and seriously blunted enthusiasm,they had reached the end of the road. They returned to Nairobi and thence to Dar, having covered 1,500 miles over appalling roads in less than a month. "My father seemed less impressed by the jaunt," admitted Mo. "He thrashed me and gave me a bloody good bawling out."

Mo was not to be discouraged and pressed on with his freelance career. Despite still being a schoolboy, he managed to get around to many events, taking pictures and selling them. His reputation grew and he was soon accepted at major functions and even at Government House. But his hectic

schedule made for some very tight deadlines. Even the battered Lambretta could not cope with Mo's increasing workload as he dashed from place to place. Mo had little choice but to buy a car. Using money raised from his rapidly expanding and increasingly lucrative hobby, he bought a second-hand VW Beetle, a rugged old bone-shaker which eventually came to a very sticky end.

Almost without knowing it, Mo was acquiring a network of contacts which would be crucial to his future success. He said: "In those days, Tanganyika was the centre for all the liberation movements and freedom fighters. These same people are now among the leaders of Africa. But at that time they were hanging around on the streets. Some of them I went to school with and others I got to know and befriend while I was taking pictures out on jobs."

His most significant assignment in those early days came on December 8, 1961, the day colonial rule ended in Tanganyika. Mo's teenage years had been mirrored by the steady moves toward independence set in motion by Mwalimu (teacher) Julius Nyerere. The fulfilment of the leader's efforts was a spectacular ceremony in Dar attended by world dignitaries and the international press. Up front, as Britain's Prince Philip handed over to Nyerere, was Mo, whose pictures appeared in *Drum* magazine, as well as newspapers in East and Central Africa and around the world. He was becoming a force to be reckoned with.

It is worth recording Mo's only effort at being an employee. In 1959, still 16, he saw an advertisement for a photographer to work on the *The Nation* newspaper. Mo applied for and got the job. He was still at school but contrived a schedule which, though precarious, would mean he could do both. Mo said: "I worked out that I could report for roll-call and the first school period at eight then leave for work at nine and return in time for the last period. Being a prefect helped, since I was hardly likely to report myself! I went missing, but it wasn't that blatant, although the teachers must have wondered why I was out of class so much."

In his youthful optimism, Mo had expected the job to be rich in experience and opportunity. Instead, he found it parochial and tedious and suspected he wasn't being taken seriously. The last straw for this not particularly even-tempered young man was being told to take pictures of workmen digging holes in Dar's main road. Mo could not see a valid news angle and thought the task a waste of time, but reluctantly carried out the assignment only to discover later that none of the photographs had been used. Angry, and certain that he had deliberately been made a fool, he asked his boss if there had ever been any intention of using the shots. He was given a blunt "no." Mo said: "To this day I don't know what he was

47

trying to prove, but I knew what to do." He cleared his desk, announced "Stuff your job," and stormed out not even bothering to collect his first and only pay packet.

Three years later, in 1962, he quit school as well. He said: "I was in the middle of exams and suddenly it dawned on me that there was no point to it. I knew what I was going to do and a piece of paper from school was worthless to me. I might have wasted four years going to college instead of gaining valuable field experience. Most of the best photographers I knew were self-taught. I didn't regret it. I made the right decision."

Mo never looked back. Soon after, in 1963, he was in business for the first time. In Dar, he rented half a shop from Aziz Khaki – later to become his brother-in-law – where he launched his first commercial venture under the name of Minipix. Perhaps it was because he was so conscious of the small scale of his operation that he was prompted to give his first business such a name. If so it didn't take him long to come to his senses. "Mini", with its suggestions of diminutive aspirations, was never going to suit Mo. On the way to register the company at a cost of 20 shillings he had second thoughts, reached into his pocket and pulled out the form and changed the word "Mini" to "Camera." The name Camerapix remains to this day.

To begin with, Mo embraced all aspects of his profession offering a full photographic service. But his first job quickly convinced him that he had made a mistake. He had only been open two hours when a young African walked into the shop and handed over a black and white roll of film for developing. Something had gone wrong and the negatives turned out blank. On reflection, Mo reckoned the roll was a dud for the frame numbers were visible and there was nothing wrong with his equipment or his technique. But he knew it would be difficult to convince his customer of the fact. He was right. When the young man returned, he refused to pay for the roll and stormed out. A chastened Mo hauled down his board which read "Studio, Press and Commercial Photography" and took it back to the signwriter. An hour later, he was hammering up the revised version which then read more succinctly "Press Photography Only." In just one morning the enterprising photographer had focused on precisely which direction his career would take for the rest of his life.

It was also during this period that Mo came to realise the value of cine film, spurred on by the knowledge that newsreel paid well. He soon got a chance to put theory into practice when he received a tip-off that two white South Africans, outspoken opponents of that country's apartheid regime, had escaped from jail in Pretoria and stolen a Cessna plane to fly to freedom. Nyerere, an acknowledged enemy of colonialism and racism, offered them sanctuary.

Mo borrowed a 16mm hand-cranked, clockwork Bolex which shot silent film and headed for Dar airport. This was seat-of-the-pants photography for his camera was restricted to little more than 30 seconds filming before it had to be rewound. Whilst it undoubtedly proved a handicap at the time, it did oblige the cameraman to film sparingly and concisely, training which stood Mo in good stead for the rest of his career. Mo shot stills first, then embarked on his first cine shoot with the Bolex. With no thought of protocol, he asked the two men if they would mind returning to the plane and re-emerging for his "movie film." They duly obliged and the results were successful, except that Mo had no market for his goods. A quick call to the British High Commission gave him the telephone numbers and addresses of the BBC, ITN, and other agencies, plus the information that "ITN pay best." Pausing only to provide copy for his scoop, Mo airfreighted his package marked "Charges collect" to London. His first film made ITN's peak–time bulletin and earned Mo a £25 cheque.

It did not take him long to realise that if he doubled up on stills and cine he could double up on fees. In fact, he didn't just double up, he often had so many commissions for the same job that he earned the rather unwieldy nickname of "Six–Camera Mo" by constructing a wide bar on which he mounted two cameras connected by a single central sighting device. This allowed him to focus and shoot simultaneously. Even as a young professional, he was not unknown for employing friends for a few shillings, teaching them basic photographic skills, then using them as auxiliary cameramen. During the 1965 visit to Tanzania by Chinese Premier Chou-En-Lai, Mo towed a flotilla of youngsters behind him, moving each one up as the other finished his film. By such multiple coverage he could earn multiple payment for minimal outlay. This was the kind of financial equation Mo liked best.

When he was not recording news events, Mo relaxed by taking pictures of the wildlife of East Africa and studies of the indigenous tribes, particularly the Maasai. Indeed, his passion for African culture and wildlife remained strong throughout his life and is reflected in his many publications and exhibitions of his work. It was also the spur for his world-first motor safari around remote Lake Turkana.

But Mo's career ended almost before it began when he had the first of an astonishing 17 car crashes. He was a notoriously bad driver and, in his last years, terrified more than one colleague by driving one-handed using his false arm. On this first occasion, he appears to have been unlucky. Driving home in his Beetle one night to prepare for an evening function, Mo was blinded by the lights of an oncoming Peugeot car and failed to see a broken-down lorry stationary in the middle of the road. He struck the

truck full on and was miraculously thrown out of his car as it ploughed right under the vehicle, its top completely sliced off.

The driver of the Peugeot was Eduardo Chivambo Mondlane, head of the Mozambique Frelimo guerrilla group, who was known to Mo. Mondlane lifted the unconscious photographer into his own car and drove him straight to the city's government hospital, where Mo was found to have concussion, a colourful array of bumps and bruises and chest injuries. Others arriving on the scene decided no one could have survived the crash and for a while Mo was believed dead until a photographer friend sought him out.

Mo said: "When I came round at the hospital I had a lot of pain in my chest but did not know if I was badly injured or not. I was put in a wheelchair and told to wait until I was examined. My friend lived close to my house and he was driving to the city when he saw the wreckage of my car. At the scene he was told 'The driver is dead.'

"There were a lot of people around the truck. Because I had been thrown out and taken away almost instantly, nobody knew what had happened and just assumed I was inside the mangled wreck. He finally found me in the hospital while I was waiting to be examined. Straight away he took me to the private Aga Khan Hospital in Dar, where I was X-rayed. I had two very painful broken ribs."

CHAPTER 3

TORTURE IN PARADISE

'I wept with frustration and hopelessness.
I did not believe I would leave that
prison alive'

MOHAMED AMIN

S HRUGGING OFF the car crash injuries, Mo discharged himself from hospital and soon afterwards headed for the exotic spice island of Zanzibar. Outwardly, Zanzibar and its near neighbour Pemba were a tranquil tropical paradise. Lying within sight of Dar, they have a chequered history. Zanzibar was the main staging post for interior expeditions during the era of African exploration and many of the famous names of the period set foot on its shores. Livingstone, Stanley, Thompson, Speke and Burton all made visits to recruit porters and buy provisions before trekking inland. It was also the centre for trade in slaves, the human commodity which brought great prosperity to the traders. Slave–trading was highly-prized and much fought over. The result was a constant political troublespot with permanent potential for upheaval.

As Mo boarded his flight that day in 1963, he could not have been aware of the dramatic effect the island was to have on his life in the very near future. On that occasion, however, the job was straightforward, the State Visit by President Nyerere. The event passed off peacefully and Mo returned to the mainland.

His next visit to Zanzibar was later that year on December 9, the day Prince Philip renounced Britain's guardianship of the island. Two days later, Mo followed the prince to Nairobi, where he filmed the official

51

ceremony ending British colonial rule in Kenya. That was the moment for which all Kenyans had been waiting. The struggle for independence had been long and bitter. Leading the feared Mau Mau freedom fighters, Kenyatta had forced the British authorities to realise their imperial sway was inexorably drawing to a close. Britain tried to stave off the inevitable by incarcerating Kenyatta and other Mau Mau leaders, but the people's hunger for freedom was too great to resist. Now, with Kenyatta a free man and the undisputed leader of his fledgling nation, came the moment when power passed from the old to the new. It was a glittering and emotional evening ceremony, studded with all the pomp associated with such a dignified occasion. But it had its lighter side. At the crucial moment, it was planned that floodlights should burst into life focussed on the Kenya flag unfurling at the top of its staff. But perversely, the halyard became twisted and there was a brief, embarrassing delay. Prince Philip mischievously seized the occasion, leant over to the Kenyatta and told him: "You've still got time to change your mind if you wish." Seconds later, the flag unfurled and Kenya was finally an independent nation. Mo was there, filming every minute from in front of the ceremonial stage, along with others among the world's press. His pictures of Kenyatta assuming control at midnight on December 11 were used around the globe.

Precisely one month later, Mo got a cryptic call from a trusted contact who stated: "If you want an exclusive, be in Zanzibar tomorrow." He shrugged it off, not judging a speculative trip worthwhile. Mo was to regret that decision, for the next day he got another call saying: "There's shooting all over Zanzibar! If you want an exclusive, get there fast." Mo didn't need a second reminder; he grabbed his cameras and caught the next flight to the island. But as the pilot made his final approach, he was refused permission to land and was forced to return to Dar. There had to be another way in, and Mo found it. Rounding up two colleagues, he drove to the old slaving port of Bagamoyo further along the coast and, in a frantic bargaining session, managed to persuade the captain of a dhow to make the trip.

The shooting was the start of a coup by 600 revolutionaries commanded by a Ugandan soldier of fortune, John Okello. They had stormed the police barracks and were running riot. Such was the ferocity of Okello's attack that even his allies were embarrassed and, after taking power, he was soon pushed aside. Even so, an incredible 12,000 to 13,000 people died in that brief bloodbath.

By the time Mo arrived, the Sultan of Zanzibar had fled and most of the shooting was over. Nonetheless, the bloody evidence was all too obvious and Mo went to work shooting graphic footage. He arranged to have his

film sent out by the dhow which brought him in and was able to telephone his girlfriend, Dolly Khaki, in Dar. Mo took the first official pictures of the revolutionary leaders, being asked to do so by Abdulrahman Mohamed Babu, the man who had first tipped him off about the coup and who had now been appointed minister for external affairs. He also filmed expatriates fleeing the carnage, mass graves and dhow funeral ships unceremoniously dumping their cargoes of death at sea, followed by a flotilla of expectant sharks.

As the crisis worsened the British ship, *HMS Owen,* arrived to evacuate about 150 British nationals. Among them were seven newsmen being deported as "prohibited immigrants" and who earlier had expected summary execution after being lined up against a wall. Their fears had proved groundless for the Zanzibaris merely wanted to take their pictures to ensure they could be identified if they ever tried to return.

Filming the departure of those newsmen at the harbour, Mo felt a hand on his shoulder and turned to find it was now his turn to be in the firing line. He recalled: "There were two dishevelled soldiers, both carrying machine guns. One tried to grab my cameras, but I clung on to them. I had seen what these people were capable of so I decided it was time to get out."

Taking a huge gamble, Mo jumped into the launch carrying the newsmen and crewed by a squad of Marines. He said: "The rebel soldiers raised their guns at me and I thought this was it. Then the Marines in the launch challenged me. They said they had been told to take only British subjects. I reached into my bag and waved my British passport at them, and that was it. They took me to safety."

Throughout the incident, Mo relentlessly carried on filming. The footage arrived in London where it was eagerly carried by CBS, UPIN and Visnews. It was an important feather in the cap of the ambitious young 20-year-old. This was Mo's first proper experience of the frontline, an environment in which he was to flourish and make a name for himself as a clinically efficient operator who outwardly manifested no fear in his pursuit of major news stories. He had mixed it with the best in his field and emerged triumphant. It did not go unnoticed among the hard-bitten professionals both sharing the frontline with him and in newsrooms thousands of miles away. Here was a young man who instinctively seemed to know what to do despite his relative lack of experience, who used his ingenuity and thought on his feet. He didn't just get the pictures, he got them out to where they counted and he got them there on time. The pattern was set for the future.

Visnews, UPIN and CBS all used and praised Mo's footage. Meanwhile,

the activity in Zanzibar had a ripple effect on the mainland where the army mutinied and, in the ensuing turmoil, widespread looting took place. Mo was in the thick of it again when he was arrested and taken to Dar's central police station. Luck was on his side; the cells were already full so he was put in a small office, behind the counter. He said: "It was total chaos. Outside on a desk I could see my cameras, unguarded. I tried the door and it was open, so I just walked out of the office, picked up my equipment, threaded my way past the milling mob and left." To avoid detection, Mo shaved off his beard for the first and only time in his life and returned to the action.

Fighting now polarised around Colito Barracks, the original flashpoint of the army rebellion. Mo later told Tetley: "Touring the town late in the evening, I saw some British officers coming ashore at the presidential jetty. I decided I must be ready for action early next day. Around sun-up, I heard the thump of heavy gunfire and small arms from the direction of the barracks eight miles away and headed in that direction. A mile short, I was stopped by British Marines."

Mo flashed his ITN card and was allowed through to film the action, to the wry comment of one of the Marines that it was "bloody dangerous in there." Using his Bolex, Mo filmed as loyal troops in low-flying helicopters first appealed to the soldiers to surrender, then fired on them. By then, the rebellion was verging on total collapse and Mo, who up to then had been operating on his own, was joined by the international press corps with their back-up crews. They had flown in from far and wide with the latest cameras and sound equipment, baggage carriers and producers. Mo looked at their sophisicated kit and then at his own old-fashioned Bolex, his sole camera. He realised he was not competing on a level playing field. He said: "They had everything, all the technology you needed to make a good story. I filmed what I could with what I had."

Finally, as the rebels turned to flight, the barrack gates were opened for the journalists to record the mopping-up operation. So far so good, but as the news crews departed, they were stopped outside the barracks by Tanganyikan Special Branch agents who confiscated all their film. One cameraman hid his film by slitting open the rear seat of his hired car and stuffing the reel into the upholstery, but this too was uncovered and taken. As Mo watched this disquieting development, a helicopter landed in the barracks.

Mo said: "It was one of a number of British helicopters. Because the barracks were under British control Tanganyikan special forces weren't allowed inside. I dashed across to the pilot and shouted at him 'I've got to get this film on a flight to London, and there's one leaving very soon. Can

you give me a lift to the airport?' The pilot replied 'For ITN? Any time. Jump in.'"

Moments later, Mo was exultantly whirring above the heads of the opposition, one of whom shook his fist at him in naked fury and frustration. Mo cheekily replied with a V-sign. Within the hour, the film was winging its way to London. The postscript to this audacious piece of one-upmanship came two days later after CBS news chief J. Segal had watched Mo's footage of the mutiny, the only film record of the drama. Speaking to his London office, he was heard to remark: "Who do you say this kid is?" "Mohamed Amin," came the reply. Segal barked down the phone: "Well, make sure he stays on our payroll. I'd hate him to work for the opposition."

For Africa, this was a decade of cathartic political change, often wrought by bloody revolution as freedom movements sought independence. Oppressive regimes were toppled in a series of bloody duels between the old and the new. But freedom came at a price. Those countries still in thrall to the colonial yoke became targets for the frontline states where guerrilla warfare raged like the Congo, Angola and Mozambique.

These struggles for power and ideology soon attracted wider interest and it was not long before China, Russia, East Germany and Cuba were reaching out the hand of friendship. Such alliances spelt out ominous messages in other parts of the world and soon the US and Europe were focusing a wary eye on emergent Africa. Mo documented the troubles in many parts of the continent, his reputation with the international news agencies growing as he consistently delivered top quality film and pictures, whilst building a graphic pictorial profile of those troubled times.

Boasting a brand new Bolex, he and two freelance colleagues from Dar again flew to Zanzibar in March 1964, to cover the visit of British Commonwealth Secretary Duncan Sandys. Reluctant to waste any of his time on the island, Mo decided to shoot film of detainee camps, still thronged with thousands of Arab prisoners held after the coup. He employed the old trick of flattery to charm his way past the guards and, together with his colleagues, began filming.

Unknown to the newsmen, someone had run a check on them and, just as they were about to leave, a telephone rang. It was answered by one of the guards who up to then had been all smiles and accommodation. Mo said: "Suddenly, we had guns in our backs. We were made to stand out in the sun for hours until we were close to collapse. The temperature was around 34C (93F) with 85 per cent humidity. I was nearly at the point of total exhaustion. Finally, a Cabinet Minister arrived and accused us of being imperialist spies, spat on us and kicked and slapped us. We were

then locked in a room and our cameras, bags and film confiscated." The three men were held for 48 hours before their release with Mo earning a 'prohibited immigrant' stamp on his passport. When they returned to Dar the other two newsmen, furious with Mo for exposing them to such danger, abandoned news camerawork as too risky. Mo's new Bolex and the rest of the trio's confiscated equipment was put to good use by the authorities and ended up being used to form the island's first film unit. Personal safety notwithstanding plucky Mo, now 21, was back in Zanzibar a month later with borrowed cameras to record the union between the island and Tanganyika which formed modern Tanzania.

Mo was rapidly establishing East Africa as his personal fiefdom. He covered every and any story in both stills and cine, and woe betide intruders. With his fanatical approach to work he increasingly regarded the possibility of being professionally beaten on his own doorstep as a personal affront and went to great lengths to make sure he was always first. It is true to say that for the next 25 years Mo was barely "scooped" once by his rivals. He patrolled his patch like a watchful predator, marking his territorial boundary with picture stories, features and film that constantly reaffirmed his dominance.

So when his father decided to leave Africa and make his home in Muslim Pakistan, taking his family with him, it was inevitable that Mo would stay behind. He explained: "Africa was my home. I knew nothing of Pakistan or any of the Indian sub-continent. My life was here. There was nothing else for me. My father had been given one-way tickets on the steamer home for all the family as part of his terminal benefits. I didn't want to hurt his feelings so I took my ticket and told him I would come later. We both knew this would never happen."

Mo could be a charmer using his quick wit and open smile to beguile those who stood in the way of a story. But even he was capable of overstepping the mark in his determination to get the footage he wanted. During the 1965 visit to Ethiopia by Queen Elizabeth and Prince Philip he achieved what is probably a still unbeaten record of being at the wrong end of a royal rebuke twice in one week.

He recalled: "I was filming Prince Philip talking to some schoolgirls, but gradually I got more interested in what he was talking about than actually filming. So I got closer and closer, pretending that I was filming. Unfortunately you can hear the drive on a 35mm cine camera and mine was not switched on. I was just fascinated by the idea of listening to one of the Royals talking. But Philip soon twigged what I was up to, turned round and, in a very quiet voice said to me: 'Why don't you fuck off?' "

Some days later, from the back of one of two 10-ton trucks being used

by the press, Mo was filming the Queen driving through the Sudan desert near Khartoum. His view became frustratingly blocked when the road narrowed to a single lane and his truck took the lead position. Determined to get the pictures he needed, Mo ordered the lorry to stop so he could climb down and photograph the Queen as she approached. Unfortunately his driver would not continue without him and, as a result, the royal convoy ground to a halt. Oblivious to the chaos he was creating in the heat and dust, Mo carried on filming until the Queen leaned over the side of her vehicle and shouted: "Get yourself out of the way and take that truck with you!" Mo went on many royal safaris after that and became something of a familiar figure around the entourage whenever the Queen travelled in Africa. Years later, he was to meet her personally when he went to Buckingham Palace to receve his MBE. Neither mentioned the earlier incident in Ethiopia.

But not all Mo's jobs were ordered. To broaden his scope and keep the coffers filled, Mo frequently embarked on speculative assignments. He seemed to have an innate barometer for stories with commercial potential.

On one occasion, in 1965, Mo received a tip that the guerrilla movement Frelimo was operating a training camp at the old slave port of Bagamoyo, up the coast from Dar. In those days of Communist bogeymen, this was a sensitive issue and Mo reasoned that photographic evidence would be highly marketable. First he had to locate the camp, but in a relatively small town that was not too difficult. He discovered the guerrillas' makeshift barracks converted, appropriately enough, from a former British country club. The problem was how to get in. Those running the camp were just as conscious as the photographer of the delicate nature of their operation and had deliberately chosen an obscure site.

Mo tried the obvious way first, and knocked on the front door. He was turned away. So he chartered a light aircraft and flew over, hanging out of the open door, camera at the ready. But the camp was hidden by thickly foliaged palm trees and he failed again, his film failing to produce any evidence of the barracks. His next attempt was by dhow under cover of darkness, and this bid was no more successful as he could not find anywhere to land on the rocky shoreline.

Nothing if not persistent, Mo gave it another shot. This time, he forged a letter of introduction from the Frelimo guerrilla leader Eduardo Mondlane – the same man who had rescued him from the Dar car crash two years earlier – and went back to the front door again. His ruse worked and he got in to spend the day filming 300 freedom fighters being trained by instructors from the Soviet Union, Cuba, Egypt, Algeria and China. The ensuing pictures appeared around the world evoking surprise and

outrage in the Tanzanian parliament. Some MPs demanded Mo be tracked down and punished, so the cameraman took a month off to go on safari until the storm blew over. By his determination, he was making a significant mark on his profession and earning friends, and enemies, in high places at the same time.

It was with a certain inevitability that Mo became mixed up in Zanzibar politics again, though his next visit did not presage what followed. In November 1965, Mo was bound for the island to cover Land Distribution Day, an occasion when, to the accompaniment of due ceremony, plots were distributed to the landless by the president of Zanzibar and vice president of Tanzania, Sheikh Abeid Karume. The ceremony was as much symbolic as it was practical and underlined the revolutionary nature of the island's current rulers. There was talk of Zanzibar being used as a Soviet submarine base and some reports spoke of a massive military build-up going on with large shipments of army personnel and supplies arriving nightly from behind the Iron Curtain. Any confirmation of these activities would be political dynamite in the US and a major news story for the agencies.

Driving to the ceremony, Mo saw a newly made road cut into the jungle and followed it – straight to a military training camp. Eastern Europeans were drilling local soldiers dressed in Cuban and East German uniforms; nearby were Russian armoured personnel carriers. Mo was stunned. He knew he had stumbled across a major story. Instinctively he began filming, taking footage of heavy machine-guns, anti-tank weapons, grenades, anti-personnel mine training and ammunition boxes with Soviet markings. It was all there and Mo knew it was red hot. Fearing his film might be confiscated at any moment, he was careful to hide exposed reels every few minutes. Astonishingly, no one tried to stop him until finally someone decided it was time to ask questions.

Mo said: "I was filming close-ups of ammunition boxes with Russian markings on the sides when I was stopped by a couple of Russians who asked if I was working for the Zanzibar government." Mo said he was there to record the arrival of Mr Karume for the land distribution ceremony and, when told he was in completely the wrong place, declared: "This is a dreadful mistake. I've wasted all my film. I'll be in terrible trouble with my bosses."

The angry Russians threatened to detain him, but Mo kept his cool and told them: "If you let me go, I'll give you all the film I've taken. You can open it up and throw it away but please, I beg you, leave me my unused film so I can do my job and film the ceremony when it takes place." The Russians weakened and finally, as Mo shredded roll upon roll of film before

their eyes, became convinced. The film was, of course, unused. The Russians' last suspicions centred on Mo's two Bolex cine cameras. Mo insisted he had hardly used any of the film in the cameras and that what was left was needed to record the distribution ceremony. The excuse was not good enough so he offered to remove the film himself. Without the Russians noticing he then removed the film spool with the unexposed film, keeping the used film on the take-up spool. Astonishingly, the Russians seemed satisfied and moved on. Mo said later: "I never knew whether it was just my manner, or the name Karume and the official invitation which finally persuaded them to leave me alone."

The land distribution ceremony did take place later that day but by then Mo was pulling prints from the developer in his Dar dark room while the newsreel was already on its way to Europe.

Next day, the London *Times* led with the story using Mo's pictures while CBS and Visnews eagerly syndicated the film. Mo could never have imagined how much embarrassment his pictures caused in Communist countries. Such irrefutable evidence of Russia's presence in the Indian Ocean caused debate in both the British Parliament and the US Senate. On the information sheet attached to Mo's film was his name. One of the networks which received his story was Russian television in Moscow. Mo's name was duly noted and passed to Soviet security men who sent it to their East African comrades. They, in turn, sent a confidential report to Ibrahim Makungu, head of Sheikh Karume's security forces. In Zanzibar, Mo was now a wanted man.

Few individuals make quite such an impact on their profession at the age of 22, but Mo did not have time for career reflections. He was extending his field of operations and steadily building his reputation. A perfect example was his next major assignment in August 1966, when French President Charles de Gaulle visited the then French Somalia. This postage stamp of sand, wedged between Somalia and Ethiopia, would have been worthless but for its strategic position on the Horn of Africa. De Gaulle's visit to its only town, Djibouti, was intended to reinforce France's foothold in the area.

There was little sign of what was to follow as de Gaulle arrived in the city's main square en route for lunch. A large press corps locked their equipment in their hire cars and followed the VIPs inside the main hotel. Typically, Mo turned down lunch, adjourned to his room in the hotel and began cleaning his cameras. Meanwhile, below his balcony, a large crowd was gathering in the square for the president's scheduled speech. Then a shot was fired and pandemonium broke out. Nervy French Legionnaires fired indiscriminately into the crowd mowing down dozens of people.

Mo said: "Around midday, somebody fired a shot. It seemed to come from the crowd. At this point, the French Foreign Legion opened up with their machine guns, shooting randomly into the crowd. I did some quick takes from the balcony and then rushed downstairs to film the massacre. People were lying dead at the side of the road. Others were dying, their legs and arms ripped off by machine gun bullets. Then a Legion ambulance drove up and the locals loaded the wounded into it.

"A big Legionnaire came along shouting at me in French. I think he was telling me to get the hell out of there, but since French is one language I don't speak I ignored him and in the confusion he didn't actually do anything. This man ordered the Legionnaires to throw all the wounded out of the ambulance – about a dozen were critically or fatally hurt – and the bodies were hurled out like sacks of potatoes. Everybody was told that the ambulance was for the Legion and not for the locals."

Most of the other newsmen, who had been in the hotel restaurant, were without their equipment as it was still locked in hire cars whose drivers had fled for fear of being killed by the Legion. As a result Mo had a virtual exclusive which he filed to CBS, RMSNEWS. He subsequently received herograms from both news agencies for his work. That was not his only coup. Days later, at Addis Ababa's Bole Airport, he was approached by a *Time-Life* correspondent and asked if he had pictures of the Djibouti massacre. Mo replied that he had shot some rolls of colour film but wasn't sure what was on them. It was enough for the *Time-Life* man who immediately offered to buy the film and asked Mo to name a price. Mo departed the airport $1,000 dollars richer and some time later had the satisfaction of seeing his pictures in a *Life* magazine spread.

Reassuring as they were, Mo had little time for such plaudits from the agencies. He was back at work. The following month, together with three other pressmen, he flew to Zanzibar for what seemed an innocuous event – the State visit by Egyptian President Gamal Nasser. In the course of his work, Mo had been to the island 20 times in the past two years, never spending more than a day there. This time his trip was to be considerably longer. At customs, immigration checked him off against the official press list, stamped his passport for a formal 24-hour visa, and allowed him through.

As Mo stood waiting for the president's flight to arrive, an African in a three-piece suit walked up to him and asked if he would mind accompanying him. It was discreet and unhurried and Mo believed he would be asked to help in press arrangements for the impending visit. Outside the airport, far less discreetly, they were joined by three more men who hustled the cameraman into a waiting car and drove him away. This

was one State visit Mo would not be covering. His past had finally caught up with him.

For anyone who had crossed the Zanzibari authorities, the name Kilimamigu struck terror in their hearts. Its reputation as a brutal and verminous jail was richly deserved and spread well beyond the horizons of East Africa. Those who lived to tell the tale spoke of torture and extreme conditions that left their mark on inmates for life. Mo knew of Kilimamigu's infamy, and it was there he was taken.

Inside, he was prodded down a narrow passageway and locked in a maximum security cell. All he had been able to do was persuade his taciturn keepers to allow him to write one letter. He sent it to Mohamed Fazal, the Tanzanian Government press officer with Nasser's official party. "Help me urgently," he wrote, "I'm being held for no reason in Kili Prison. I was arrested this morning and am locked in the maximum security political section. If you have no luck with the Zanzibar authorities, please advise my clients CBS in New York and AP and Visnews in London. Also tell Dolly what has happened. Tell everyone to do what they can. I'm desperate – Amin."

Mo requested a phone call to the Canadian High Commission in Dar, which looked after British interests following Tanzania's break with the UK over Rhodesia's Unilateral Declaration of Independence. He was refused, then marched back at gunpoint to his dark, bare cell. His fellow prisoner was an African who, months earlier, had fled Mozambique (then a Portuguese colony) and sought sanctuary in Zanzibar. The island authorities' response to his plea was to throw him in jail. He was still there when Mo was eventually released.

The sequence of events which followed left an indelible mark on Mo. His captors played good guy, bad guy. At first one guard gave him cushions on which to rest. But almost immediately they were snatched away by a bearded interrogator named Yusuf who replaced them with a filthy, ragged sheet. At midnight Yusuf returned and, together with his cameras, Mo was hauled off for questioning. What worried Mo was the three-inch thick file on the desk in front of him labelled "Tanzania People's Defence Forces – Top Secret – Mohamed Amin," which his questioners referred to from time to time.

Aged just 23, and alone in the depths of a notorious prison facing an armed interrogator, Mo knew real fear for the first time. "I thought I was going to be shot," he said. "I had never been so frightened in my life. This was a situation over which I had no control. I didn't know if anyone outside was aware of my plight or if my letter had been delivered or destroyed. It was the awful thought that I might die here without anyone knowing it

had happened." Which was exactly what Yusuf wanted. Mo said: "He told me to write down a list of everything I had with me, then I was marched into another room and stripped naked. My trousers were eventually handed back but everything else was taken. Then I was taken back to my cell and locked in again."

By then his companion had been removed to another cell, and Mo began the worst ordeal of his life. For the next 16 days this was his home, a bare cubicle some six feet square without furniture or sanitary facilities. The fetid air was only eased by a tiny ventilator and a peephole in the door. With no bed, Mo slept on a crude straw mattress on the concrete floor using the grimy sheet as inadequate protection from the clouds of mosquitoes that gorged on his body. His days were dogged by the flies which thrived in the filthy conditions. Mo only cried three times in his life: there in the cell, once when his father died and later in his career when filming the Ethiopian famine. He said: "I wept out of frustration and hopelessness. I did not believe I would leave that prison alive."

Life followed a crude routine. Before sunrise, Mo was allowed five minutes to use the primitive toilets, but for the next 27 days he was prevented from washing or cleaning his teeth. If he wanted to use the toilet during the day he had to call the guards who didn't always respond. Twice he had to defecate in his cell. Food was brought twice a day, at 7.30 in the morning and 3.30 in the afternoon. The morning meal was *ouji* – a flour porridge – and beans, and in the afternoon, *ugali*, a flour and maize mixture. It was virtually inedible and for 13 days Mo ate almost nothing. Drinking water came from the lavatory flush.

One day, he refused to sweep his cell so he was stripped and beaten with a broomstick. On other occasions the guards forced him to crawl naked in the prison compound, often at midday when the temperature topped 35C(95F). Another form of humiliation was to make prisoners dance and sing while naked.

On day 16 of his ordeal, Mo woke to the sound of the door being unlocked. It swung open and a man was pushed in. In the dim light he made out the form of Abdul Aziz Twala, Zanzibar's finance minister (later he was killed by order of Abeid Karume). That afternoon, Mo was moved to another cell which contained two Arabs and two Africans. One of the Arabs had been detained for almost a year after voicing opposition to the new government. The other had been incarcerated for eight months because government agents found a toy gun during a search of his house. The two Africans had been held for six months and had no idea why.

It was a powerful reminder to Mo of his predicament. Next, he was
interrogated by East German inquisitors. They quizzed him over his

photographic work, pressed him about what sort of pictures he took in Dar and demanded to know where he sent his material. He told them his main outlets were US and Britain, especially London and New York. That only further incensed his captors. They accused him of spying on Zanzibar for Britain and the US and threatened to kill him unless he told the truth. The ordeal went on for hours in blistering temperatures. They wanted to know exactly how many pictures Mo had taken of Zanzibar and what he had written in his captions. When he showed reluctance they brought in an African wearing a ragged white coat who announced he was a doctor and promptly prescribed a white pill. Mo refused to take it, so was beaten again.

By now, he was in bad physical shape and losing almost a pound in weight a day. His mental state was also taking a beating. Mo said: "I think being in prison, especially in those circumstances, is about as bad as you can get. We're all different in many ways. Some people get depressed over petty things because that's the way they are. Others can take a lot more before they get really down. But somewhere along the line we all have the potential to get depressed. Feeling threatened and frustrated is one sure way." Dealing with this nightmare called upon all of Mo's inner resources. Where others would have quietly given up in despair he plotted his escape, regardless of the consequences of failure. Recalling his plight and that of his fellow captives, he said: "None of us ever thought we were going to leave that place alive. We all believed we were going to be killed. Even one of the trusties, a guy who had been inside for more than two years, was convinced he would never see the outside of the prison. My only hope lay in escape."

Together with the trusty and another prisoner, Mo hatched a plan to overpower the night guard, steal his revolver and scale the outside wall. One of the new detainees had been forced to leave his car outside. Mo intended to commandeer it, get to the coast and bribe a dhow captain to take them to the mainland. The day of the breakout was scheduled for October 22.

What Mo did not know was that powerful forces had been working on his behalf outside Zanzibar. His arrest had been witnessed by another journalist who alerted Mo's agency bosses. They contacted newspapers, the US State Department, colleagues of the young photographer and the British authorities. Dolly had also been informed. Together they mounted a persistent campaign of protest, lobbying Tanzanian President Nyerere almost daily. On October 19, a guard ordered Mo to wash his clothes, the acknowledged prelude to very good news or very bad. He was fortunate. He was taken to the officer in charge and asked to sign a statement denying

any ill treatment. Two days later, and 28lbs lighter, he was taken to the airport and put on a plane to Dar. In the seat next to him was a CIA agent who questioned him about his experiences and about what was happening on the island.

Even now, Mo's troubles were not over. As soon as he landed in Dar, an immigration officer served him with a deportation order and he was put straight on to another plane and despatched to Nairobi. That evening, an aide from President Nyerere's office telephoned to tell him there had been an error and he should have been allowed to stay 48 hours in Tanzania. Uncertain whether this was a trap, but knowing that if he was not to return permanently to Tanzania he needed to put his affairs in order, he accepted the offer and went back to Dar.

Impatient as ever, he was soon back in action in early 1967 covering the slaughter in Aden which at the time was gripped by social unrest and intense guerrilla activity. This was serious frontline coverage where Mo frequently found himself teetering on a knife-edge of danger as he daily put himself at risk. Among his no-holds-barred footage was film of two men being beaten to death. Mo was never afraid of shooting pictures that the world might prefer not to have seen. His was a clinically impartial lens that focused sharply on the ugly or the beautiful just as long as what he recorded was the truth. He never shirked from capturing images which were a painful reminder to us all of man's worst excesses. By such raw honesty he compelled us to watch and witness these actions, and at the very least to reflect on the causes and effects. In the case of the Ethiopian famine his film did a great deal more.

Yet his credo was pragmatic. Years later, he reflected: "If there were bodies lying in the street I just filmed them. If people were being beaten up, I just filmed them. In many situations I should have been dead. But what I say to myself is 'Well, I'm in this situation and I'll cover this story as best I can.' At the same time, I'm looking round to find out how I'm going to get out of there. There's no point in getting shot in the back while running. If you run, you're more suspect."

In mid-March that year, 1967, he paid another visit to Djibouti to report on the referendum over whether French Somalia should keep ties with the mother country. France had decreed that just 39,000 out of 125,000 citizens were eligible to vote, and when the result went predictably in favour of retaining French links, the inevitable happened and rioting broke out. Troops cut off the African sector with barbed wire and in the ensuing battle 11 Somalis died and 20 were injured.

During the fighting, a hand grenade rolled near Mo and exploded. He caught shrapnel in the knee but continued to film. In the same incident

his friend and colleague Dennis Royal took a hit in the groin. Mo later remembered: "Dennis went down with total fear in his eyes. He thought he'd lost everything which made life worthwhile! Then he realised it wasn't perhaps as bad as he first thought. He got slowly to his feet, warily unfastened his trouser belt, unzipped his fly and dropped his trousers to examine the damage. I took a picture of him at that point, and his relief at finding that it was only a minor wound stopped him losing his cool. Later, when I gave him a souvenir print of the picture, he roared with laughter." It was their last assignment together. Royal was killed in a helicopter crash in the early 1970s during a Nato exercise.

Djibouti gave Mo ample scope to demonstrate his adaptablity and quick-thinking under fire. In one riot, he was singed when demonstrators set oil drums on fire. Later, these same people began pelting the French troops with pebbles, fired with deadly accuracy from sling shots. When a colleague had his glasses smashed and received a bad facial cut, Mo decided to swap sides. Being a brown-skinned Muslim fluent in several of the languages spoken in the Horn of Africa, he calmly crossed the lines and joined the mob.

This proved a perfect example of Mo's resourcefulness in taking a calculated gamble, balancing the odds between getting the story and getting killed. BBC veteran Ronald Robson told Tetley: "There was no percentage in remaining on the receiving end of the barrage of stones, so he crossed the lines and filmed from the viewpoint of the slingers. This worked well until the French forces opened fire.

"A French rifleman tried to draw a bead on a slinger to Mo's right. The slinger ran across the stage, as it were, passing Mo. The rifle's muzzle swung with the target and when the soldier pulled the trigger, the man was in line with Mo's left shoulder. It was obvious that Mo was watching this take place through his camera but he never stopped filming. He didn't even duck although a fraction of a second's difference in the timing of the shot could have ended a promising career. The French troops were professionals." Mo had taken a calculated risk. The cameraman's subsequent footage earned him the Visnews 'Film of the Month Award.'

From Djibouti, Mo moved back to Aden which, on July 3, 1967, became the focus of world attention. The troubled British protectorate had been beset by clashes with demonstrators opposed to Britain's presence and, on June 20, 400 freedom fighters stoned the key commercial and residential area known as the Crater.

Lieutenant Colonel Colin Mitchell of the Argyll and Sutherland Highlanders was brought in to sort it out. "Mad Mitch", as he was known, basked in publicity and took care to brief the press on his intention to

retake the Crater with minimum casualties on the morning of July 3. Mo was at that press conference and next day he was alongside Mitchell as he walked into the Crater with machine gun fire ricocheting around.

The operation called for courage of a high degree. Mitchell, who insisted on being piped into battle, declaring that it was an appropriate way to confront a bunch of "flyblown terrorists," was a cool professional with more than a touch of the showman. As he advanced on the enemy and the machine guns opened up, he observed with wry detachment the behaviour of the press corps, who he did not necessarily expect to handle the situation with the same sang froid with which he himself was blessed. He recalled that "everyone bit the dust, with a few notable exceptions." Mo was one of those exceptions. His stills and film of this extraordinary display of bravery were shown around the world. Film crews from the BBC and ITN flew in to cover the event the next day.

But Mo was already on the move again. Back in Kenya, he covered a space rocket launch, then set off for Nairobi. But barely had he left than he was involved in a serious car smash, sustaining a badly broken leg. Emergency surgery resolved the problem but he was in plaster for weeks. Undaunted, he returned to work, and was a conspicuous sight at news events with his right leg plastered from thigh to toe. When it was removed, Mo went back on the road.

With his leg healed, and more or less in one piece, Mo took off for Rwanda to film a band of 2,500 mercenaries – mutineers from Mobutu Sese Seko's Zairean army – who were on the run together with 100 Europeans. They were led by the infamous Belgian 'Black Jack' Schramme and were being sheltered in a heavily guarded camp. Their presence in Central Africa posed a serious threat to the region's stability and all eyes were on this isolated spot.

Mo attempted to get in by charter aircraft, but was turned back to Nairobi. Undeterred as usual, he tried again, this time hiring a Land Cruiser and painting it with Red Cross symbols. He got into the camp but before he could shoot a single frame he was rumbled and turned back, the officials deaf to his claims of being "Red Cross Press." Three days later, on November 13, 1967, Mo went back to film the Organization of African Unity's delegation arriving in Rwanda to try to resolve the stand-off.

Settlement was reached when the mercenaries agreed to sign a document pledging to leave Africa and never return. Up to that point the soldiers of fortune, and in particular the charismatic 'Black Jack', had still not been seen. Mo knew the story would be substantially diminished without pictures of the central players. When he learned that OAU Secretary General Diallo Telli and the Rwandan foreign minister were to fly to the

camp in a helicopter to deliver the verdict, Mo saw his chance. He managed to persuade the secretary general to take him on the helicopter, leaving the furious foreign minister to go by road. It was a major coup. The assembled ranks of international pressmen waited in the Rwandan capital of Kigali while Mo recorded the meeting between the OAU and 'Black Jack.' Another Visnews 'Film of the Month' Award.

Scarcely pausing for breath, Mo flew into Port Louis, the capital of tropical Mauritius, to record the celebrations for the island's independence. It was a turning point in Mauritian history. After years of colonial rule by Portugal, France and Britain the 780 square-mile island finally achieved freedom on March 12, 1968, after bitter clashes between rival groups.

In stark contrast with the elation in Mauritius, Mo's next major assignment was the Biafran struggle for independence from Nigeria. On a continent which was no stranger to bitter conflict, this war in West Africa was in a league of its own. Acts of barbarism against civilians and large-scale atrocities were commonplace and all of it was set against a background of famine.

In Nairobi after another trip to the Biafran frontline, Mo met close friend and colleague Priya Ramrakha who was heading back to the war. Mo decided to join him and together they flew to Sao Tome, the tiny West African island where Biafran secessionists received their arms supplies. At the time, there were no planes bound for Biafra so Ramrakha, impatient to get back to the fray, jumped on a flight to Nigeria and decided to go in on the side of the government forces. Mo felt better coverage would come from the Biafran angle and waited until a Dakota DC-3 took him on a perilous night flight deep into the jungle. He emerged several days later with gripping film of the depredations of the war and flew back to Nairobi. Several hours later, Ramrakha also returned – in a body bag. He had been caught in the cross-fire between two detachments of government troops and died in a hail of bullets.

Mo had no time to muse on the tragedy. He was off on a rush job to Uganda where, as he walked to the terminal building from the aircraft, he was detained by immigration officials and, for reasons he did not know at the time, questioned about the legality of his passport. Bob Astles, Uganda's director of information and later famed for his association with Idi Amin, ordered his immediate expulsion from the country.

On page 17 of his passport, Mo now carried the damning indictment 'Refused facilities in Uganda.' Reciprocal arrangements between the three member states of the East African Community – Kenya, Tanzania and Uganda – meant that this stamp could ban him from either of the other two. As he sat on the plane returning to Nairobi, he carefully tore out the

offending page and, with apprehension, passed safely back into the country. News of his deportation, however, made a few column inches in the local papers.

Mo was furious and went to great lengths to get to the bottom of the story. He believed that rivals had tipped off the Ugandan authorities about his problematical status, and reckoned photographer Mohinder Dhillon, an established Kenyan freelancer and a friend of some years standing, was responsible. Mo shared his office and they had agreed on territorial rights with Mo retaining his interests in Tanzania through Dolly's brother and pledging not to encroach on Mohinder's interests in Kenya.

Mo maintained Mohinder had acted out of jealousy of the cameraman's success in Kenya. Mohinder denied this. He said: "It's true that I was annoyed by some of Mo's antics. We had agreed some ground rules and he broke them. He poached some of my clients and I was not happy. I felt he had let me down. When he came to Nairobi after the Zanzibar business, I gave him office space and helped him get set up. But he was so ambitious and energetic that he encroached on my area and it soon became clear we could not work from the same office, so he left."

As a result of the stormy confrontation, the two men parted in such bad blood that they didn't speak for years. In the end, mutual friends engineered a reunion and they buried the hatchet during an emotional lunch in a discreet Nairobi restaurant.

Mohinder was one of the few who did manage to pull a fast one on Mo. He explained: "Until the Uganda incident we were good friends. We would meet socially at least twice a month and he would come to my house and play cards. He was a good poker player and usually beat me. One night, we were playing when the phone rang. It was UPIN. They told me that a boy who had been kidnapped in Djibouti was flying to freedom in Nairobi within the hour and they wanted me to cover his arrival at the airport.

"I told Mo I had to slip out for a while, dashed to the airport, did the job and wired the pictures to London, then went back to my house and continued playing cards. Mo stayed for supper and left late. When he got home his phone was red hot. Visnews and AP wanted to know where the hell he had been and why he hadn't covered the job. He was furious. He rang me the next day and said 'Mohinder you're a bastard. Why didn't you tell me?' I said to him 'Let me ask you one question; if the situation had been the other way round would you have told me?' Without a moment's hesitation he said 'No.'"

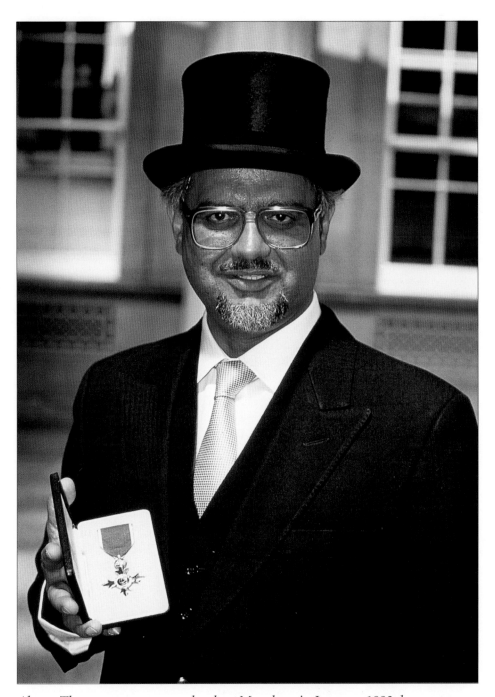

Above: There was no one prouder than Mo when, in January, 1992, he went to Buckingham Palace to receive his MBE from the Queen.
Overleaf: Mo surveys a selection of Camerapix titles during the 1990 Frankfurt Book Fair. Most of them were photographed by Mo and, inset left, Duncan Willetts, and written by Brian Tetley, inset right.

Above left: Mo and producer Brian Eastman, of Carnival Films, with their Bafta awards for the television drama series, Traffik.
Below left: Being interviewed by Sue Lawley in 1992 during recording of BBC radio's long-running show, Desert Island Discs.
Above: Filming with Stephanie Powers and animal conservationists in Kenya.
Below: Film star Stephanie Powers, who now champions the cause of animal rights.

73

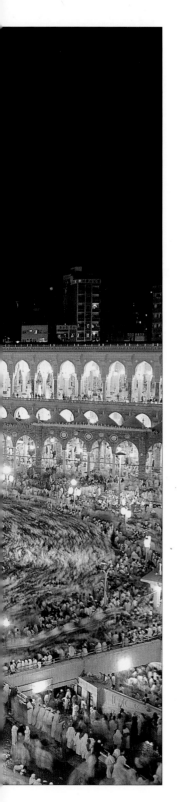

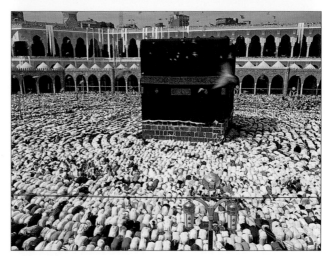

Mo risked a fortune and his reputation to publish his seminal work, Pilgrimage to Mecca, *in 1978. The visually stunning book was an outstanding success. Here pilgrims pray at the holiest of holy shrines, the Ka'bah. Above: The book was also a personal fulfilment of Mo's duties as a Muslim. Here he carries out the gathering of the stones before the ritual stoning of the three obelisks. Left: Time-lapse night photography provides a fascinating portrayal of pilgrims circling the shrine.*

75

Above: Mo's compelling pictures of the Ethiopian famine were the inspiration which persuaded the US government to pledge an immediate two billion dollars of aid for Africa. In 1985, Mo, Dolly and Salim were guests at a White House ceremony when vice president George Bush officially presented the cameraman with a symbolic cheque for the country's massive donation.

Below: Mo adjusts a microphone on former US president Jimmy Carter when he visited Africa.

*Above: Mo was a regular visitor to Seychelles and an acquaintance of
ex-president Sir James Mancham.*
*Below: South African president Nelson Mandela chats to Mo during an official
visit to Kenya.*

In 1976, President Kenyatta was very much the elder statesman of Africa. He is pictured here in full regalia as head of Nairobi University during a campus ceremony.

Above: Never far from the forefront of Kenyan newsgathering, Mo was a familiar figure to President Moi.
Below: The photographer receives a warm welcome from the then head of state in Tanzania, Julius Nyerere.

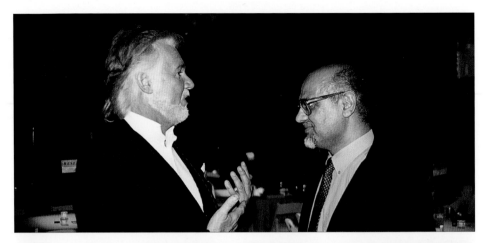

Above: With singer Kenny Rogers in Los Angeles in 1995.
Middle: Preparing Ugandan president Yoweri Museveni for a televised interview.
Below: Friends of many years, Mo and Tanzanian president Benjamin Mkapa.

Above: Pope John Paul II receives a personal copy of Journey through Kenya, *during his visit to the country in 1974. Middle: With Namibian president Sam Nujoma in 1994. Below: Mo and Mohinder Dhillon share a joke with the then British prime minister, Ted Heath.*

81

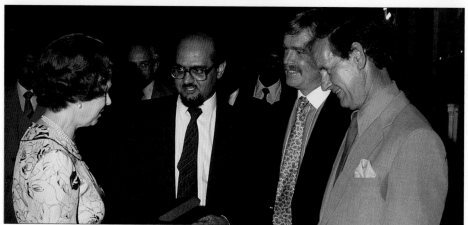

Above: On assignment with the Aga Khan in 1980. Middle: Mo, Willetts and Tetley present Queen Elizabeth with a leather-bound copy of Journey through Kenya. *Below: Mo and brother Iqbal meet Princess Alexandra as she opens Mo's Turkana expedition in London in 1981.*

82

Above: With President Zia ul Haq of Pakistan. Middle: Princess Anne greets Mo and Mike Buerk when they received Bafta TV awards for Best Actuality Coverage, 1984. Below: Mo with Quincy Jones, second left, Ken Kragen, third left, and guests at the 10th anniversary of USA for Africa in 1995.

Above: Vast crater of Kenya's Rift Valley volcano, Mount Longonot.
Below: Graceful oxbow sweep of Tanzania's Rufiji river.
Previous page: Mo in action in Pakistan in 1988 against the awe inspiring
background of the High Pamirs.

Above: Snow-bound crater atop Mount Kilimanjaro.
Below: Pattern of Maldives islets make a colourful aerial study.
Following page: Despite a score of injuries caused by frontline action and car crashes, Mo proved his fitness by scaling Mount Kilimanjaro, seen here in the background.

Above left: One of Mo's favourite shots - el-Molo boy emerges triumphantly from Lake Turkana with his catch. Below: Ornate Ethiopian costume. Above right: Luo medicine man in full regalia. Below: Maasai moran in resplendent head dress.

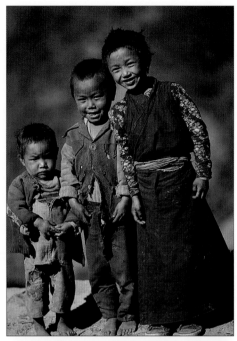
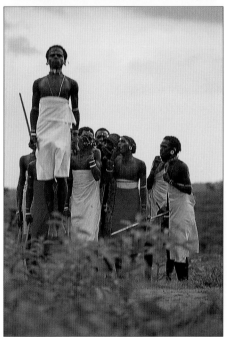

Above left: Devout Nepalese demonstrates his religious fervour.
Below: Samburu warriors perform their leaping ritual dance.
Above right: Endearing study of Nepalese children.
Below: Startling Nepalese ritual mask.

91

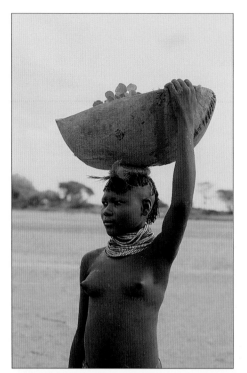

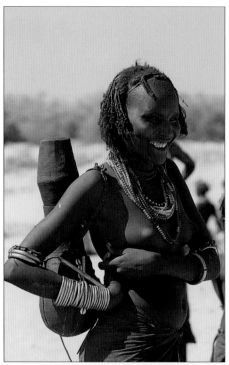

Above left and right: Smiling Turkana women make a vivacious subject.
Below: Lengthening shadows over the Indian Ocean provide a perfect
tropical sunset.

CHAPTER 4

NOBODY BEATS ME
ON MY PATCH!

*'Getting the best pictures and getting them
out was always a priority. If anyone got in
the way he took no prisoners'*

MICHAEL BUERK

A FTER MO left Tanzania following his release from jail in October, 1966, he put Dolly's brother, Bahadur Khaki, in charge of his business, said his goodbyes and returned to Nairobi on a five-day visa. It was to be home for the rest of his life.

First, his residential status needed clarifying under the East African Community rules by which anyone deported from one country was automatically banned from the others. By virtue of his birth in Nairobi, however, Mo was entitled to resident status without needing a work permit. Never daunted by officialdom, he pressed his case and was finally granted an official Kenya Resident's Certificate on January 11, 1967. It was "valid for the life of the holder."

For the next 30 years, this East African country was to be for Mo the source of a succession of dramatic photo opportunities, the base from which he launched himself into the cauldron of competition, the hub of his business and, most importantly, the place to which he would always return to recharge his energy levels before the next assignment.

Despite his Asian background, Mo always considered himself first an African and foremost a Kenyan African. He loved the people in all their variety and the frisson of excitement and danger of living in a country struggling to make its way in the modern world after years under colonial

rule. Above all, he loved the rich, natural beauty of Kenya which afforded him the opportunity of occasional peace and solitude, away from the high tension world of his professional life.

It was not long after settling in the country that Mo began travelling the length and breadth of its terrain, familiarising himself with all its facets, discovering the short cuts, quick routes and byways which could give him the edge on rivals when the time came. In late January 1967, he was on assignment travelling to the hostile frontier between Kenya and neighbouring Somalia to film the ill treatment of civilians caught in a cross-border dispute. These were areas where nomads had roamed for hundreds, possibly thousands of years. They had paid no heed to boundaries imposed by the 19th century imperial powers in the great scramble for Africa, and continued to ignore them.

At this time, Kenya and Ethiopia were being plagued by roaming bands of brutal robbers known as the *shifta* who had spurious affiliations with the North Eastern Province People's Progressive Party which was seeking alliance with Somalia. These ruthless killers favoured no one and their depredations attracted the attention of government forces from Kenya and Ethiopia. Unfortunately, the soldiers sent to crack down on the *shifta* were indiscriminate in their targets and troops were said to have carried out reprisals on civilians. In those bad lands on the Horn of Africa, Mo excelled. He followed the action for several days, recording graphic scenes of brutality, especially to women and children. It was a pocket war but so compelling were Mo's images that CBS used his film in prime time bulletins and *The Times* featured his pictures in a half-page spread.

Hardly had he touched base before the call came to another border dispute, this time at the Namanga crossing between Kenya and Tanzania. The two countries were ideologically poles apart, stretching their uneasy alliance to the limit in a series of tit-for-tat actions. As forces gathered, Mo was on the scene to record the looming confrontation. The activities of the young cameraman provoked anger among older professionals who thought that he was in breach of their agreement not to muscle in on their territory. Feelings were running high. Whether Mo was unaware or simply did not care is uncertain, but either way he did not let it bother him. Perhaps he should have done. He could hardly expect the established freelancers to view kindly someone who so blatantly undermined their livelihood, and later there were to be disturbing consequences for him.

The same year that Mo received his official resident status he went on assignment to the coast to cover the launch of a jointly-sponsored space rocket, the result of co-operative efforts by the US, Italy and Kenya. The launch site was at Formosa Bay, north of the pretty Kenyan resort of

Malindi, and the control rig was a pontoon five miles offshore. Mo was denied access to the rig by a US Nasa official but, as usual, this merely made him more determined. At dawn on launch day he hired a dugout canoe and, together with soundman Jitty Singh, paddled his way to the pontoon where they were reluctantly hauled aboard.

Mo said: "We found a spot on top of the control tower next to the public address system. The countdown was played over the speaker to give people their cues for the various phases of the run-up to the launch. But Jitty was having trouble. The sound quality wasn't good and the countdown didn't come over clearly. So I told him to wire straight into the public address system, which he did. What we didn't know was that we had disconnected the speakers! Suddenly it all went silent.

"It was extremely close to lift-off and the count was down to 18, rocket raised and all systems go. But the controller had no option but to put the launch on hold. Jitty and I cottoned on very quickly what was wrong and he quickly changed the wiring back to the way it was. But it was too late. By the time the launch controllers were satisfied everything was working as it should be, they'd missed the launch 'window.' It was several days before there was another!" Mo and Jitty discreetly collected their gear and beat a shamefaced retreat.

It wasn't the last they saw of Nasa. Travelling back from Malindi in Mo's car, the cameraman lived up to his reputation as the worst driver in Africa when he collided with an official 'launch' Land Rover. Mo was badly injured, breaking his right leg in two places. Recalling the accident, he said later: "It looked very bad. In one place the leg was only held together by the thinnest margin of flesh and skin. There was blood everywhere. They took me to the local hospital where an expatriate doctor was in charge, but he insisted on payment before operating. I was desperate and pleaded with him to get on with it, but he wouldn't start without the money. All I had was 200 dollars from my last trip to Aden so I gave him that and promised more later. He agreed, stuck a chloroform pad over my face and got to work."

In fact, the doctor did a good job. Mo paid the balance of his bill and was sent back to Nairobi where his own doctor supervised his recovery. He was then obliged to rest for several weeks while the injury healed. Convalescence, however, was anathema to Mo. He was soon back in the game parks and reserves, photographing wildlife and selling the results to newspapers around the world. And while he was still not back to full mobility, he decided to learn to fly, reasoning that he could save on charters and fly to trouble spots himself without having to persuade reluctant light aircraft pilots to do the job.

Alas, his abilities behind the joystick were little better than those behind the wheel, and his first solo flight was almost his last. Mo was instructed to make for Naivasha, a lakeside town some 25 minutes flying time from Nairobi, turn around and fly back to Wilson Airport, the capital's light aircraft centre. It was a beautiful day so when he reached Naivasha, Mo decided to land and have a brief walk by the lake. He strolled round his aircraft and was mentally preening himself over his success when he noticed storm clouds gathering over the Escarpment. The Rift Valley is notorious for its sudden weather changes and, realising the danger signals, Mo hurried back to his plane and hastily took off. Seconds later, he was flying blind in a torrential downpour.

He said: "I was supposed to be flying visually but I couldn't see a bloody thing beyond the propeller. I dropped to 50ft to see if I could spot a landmark but there was only bush and a few huts. I must have flown for an hour without knowing where I was and all the time the fuel gauge was getting lower and lower."

Reluctantly, Mo called Nairobi air traffic control. He had been loath to do so in case it would be marked against him, but now he had no option. However, Nairobi couldn't find him on their radar and told him to regain altitude. Eventually they got a fix on him and discovered he was on his way to Tanzania, miles from his intended route. Air traffic control guided him back and he landed safely at Wilson with little more than vapour in his tank.

By that time, the not so intrepid aviator had had enough of flying and was enjoying the reassurance of feeling his feet back on solid ground. But his instructor refuelled the plane, climbed aboard with him and made him go back to Naivasha to sort out what went wrong. Mo did eventually gain his private pilot's licence but the Naivasha experience blunted his enthusiasm. Soon, he was back to chartering planes.

In 1968, Mo broke into the movie world when he was hired as cameraman on the Swahili film *Mrembo*. It was an unhappy production which descended into squabbles and bitter recriminations between actors and producers ending in a protracted legal dispute. But Mo used it as a stepping-off point which provided him with the experience to film a US educational programme called *The Brave Boys*, a 90-minute adventure of two youngsters on safari.

Mo continued to focus his lens on political developments within Africa and more particularly on Kenya where, in 1968, the government Africanised jobs. Those hardest hit by the decision, a policy more spectacularly enacted a few years later by Idi Amin in Uganda, were the Asian community. Many were obliged to leave the country with little more than the clothes they

were wearing. As a Kenya-born citizen, Mo was unaffected by the move, but he was able to use his contacts within the local Asian network to assist in coverage of the event. His film formed the backbone to a British Granada Television *World In Action* documentary screened on March 4 to an audience of eight million.

Just how hard it was to keep Mo off the scent of a story was amply illustrated the following year, when the big news in Britain was the investiture, as Prince of Wales, of heir to the throne, Prince Charles, at Caernarfon Castle. The Welsh national flower, the daffodil, was not in bloom at the time so an enterprising freelance journalist based in Nairobi dreamed up the idea of having an African child send the Prince a bunch from a Commonwealth country.

The reporter duly bought 48 blooms from the city market, drove to a friend's house, stuck the stems back into the ground, then photographed a pretty Kikuyu girl picking the flowers. He tutored the girl in writing a short note, added his own story and sent it all off marked "exclusive" to the London *Daily Mirror*. As an afterthought, he sent a copy to the local *Nation* newspaper which ran the story the day the *Mirror* collected the pictures from Heathrow airport.

Scanning the local papers that morning, Mo spotted the story on page three of the *Nation*. Strolling across town, he went into the *Nation's* office, bought a print and got busy. Next day the furious freelance had a lot of talking to do to explain to the *Mirror* why the *Daily Mail* was running the same story and picture as their "exclusive."

It was yet another example of Mo's dictum that "nobody beats me on my own 'patch'." By now his 'patch' in particular was Kenya, but he had widened his scope to encompass most of East Africa and had set his sights on the rest of the continent. His assignment list for that year was formidable and included stories on people, places and activities which were to play a major part in later life.

In January, Mo filmed riots at the University of Nairobi with disturbing images of students being clubbed by over-zealous police. A month later, he took time away from the frontline to record the moving story of Richard Amiani, a 32-year-old humanitarian who spent years travelling to remote parts of Kenya performing eye operations on thousands of afflicted people. In the same style, he accompanied a group of blind students from the Outward Bound Mountain School at Loitokitok, to the 19,340 ft summit of Africa's highest mountain, Kilimanjaro.

Soon afterwards, Mo filmed a mercy flight by the Flying Doctor Service to Moyale, on Kenya's border with Ethiopia, where a seven-year-old boy had been snatched from his bed by a hyena and badly mauled. It gave the

photographer an opportunity to see just how good the service was and made a two-minute slot on CBS news. It was his last piece for the US network after working for them for seven years. Later, he would have cause to thank the Flying Doctor Service for their vital role in saving his own life when he lost his arm in the Addis Ababa explosion in 1991. On that occasion, they risked a war zone to fly in and pluck Mo to the safety of a Nairobi hospital where his condition was stabilised. The heroic rescue led, two years later, to a donation of £25,000 from Mo's employers Reuters.

In the summer of that memorable year of 1969, a telephone call put Mo on the track of one of the most momentous events in his country's history. It came as a bolt from the blue and was destined to establish him as one of the leading news cameramen of the day.

Mo was at his flat in Mfangano Street, Nairobi, on the morning of Saturday, July 5, when he took the call. A contact told him: "Get to Government Road. Tom Mboya's been shot." Mo needed no second asking. He grabbed his equipment and ran. Mboya was a prominent figure in Kenyan politics, with a national and international reputation as a trade unionist. He was pivotal in forming the Kenya Local Government Workers' Union of which he became Secretary–General. He had become powerful in Kanu, the leading political party, and was instrumental in drafting Kenya's Independence Constitution. Many tipped him as successor to the ailing Jomo Kenyatta who had recently suffered a stroke. Popular with the people, especially his native Luo tribe, Mboya was Minister of Economic Development and Planning.

Within minutes, Mo was at the scene where Mboya lay sprawled in a pool of blood in a pharmacy doorway. Two bullets had been fired at him from close range. One struck him in the shoulder, the other ripped through his heart severing the main artery. By chance, Doctor Mohamed Rafique Chaudhri, a health ministry official and friend of Mo's, was passing the pharmacy when he saw a commotion, recognised Mboya's car parked nearby and ran over. A keen photographer and occasional agency stringer himself, Chaudhri quickly took charge. As he did so, he told a friend to phone Mo. Even in such a crisis he recognised a major scoop in the making.

Chaudhri, now 78, remembers the day with clarity. He said: "I had just left work and was driving through the city centre when I saw a crowd rushing to the Government Road pharmacy. Then I saw Tom Mboya's car and I knew it was serious trouble. I jumped out and ran to the shop. Tom was lying on the floor at the entrance, exactly where he had been shot. I pulled him inside and examined him. I knew immediately it was bad but did what I could. Then I saw a guy who sometimes worked for Mo and told him to get the photographer as soon as possible. Mo arrived and I

98

made him my assistant. He filmed everything. He was very calm under the circumstances because the crowd was getting very excited. I gave Mboya mouth–to–mouth resuscitation, even though it was pointlesss. But I dared not pronounce him dead at the scene because the mob would have turned on me.

"When we got Tom into the ambulance I could see Mo struggling with his Bolex. One of the spools had broken, but he solved the problem and shot as much film as he could. At Nairobi Hospital they were not really prepared for what had happened. But when the nurse realised it was Tom, she rushed around organising people and clearing a way through for us. I took him into casualty and another doctor was summoned. He checked him out briefly, then shook his head and walked away.

"We had quite a job keeping the angry crowd at bay. I called the police and told them that the situation could get serious and they should bring as many men as they could as soon as possible. The hospital had placed guards at the entrance, but somehow a gang got in. They wanted to take Tom's body. At one point, they came into the room where we were but, thank God, they saw one empty bed and went away. We were hiding behind a screen with the body. I hate to think what would have happened if they had found us."

Minutes later Chaudhri, with Mo still filming, supervised the transportation of the body by ambulance to the nearby morgue. By then the crowd had swollen to several hundred, but Chaudhri had organised it well. An armed guard was set up to line the route and the vehicle completed its journey with no further trouble.

As fast as he could, Mo dashed to the airport and despatched his film to London. His footage and stills, all exclusive, led TV news bulletins and front pages of newspapers across the world, earning him widespread kudos. Some critics privately expressed the fanciful view that, because he was on the scene so quickly, he must have had links with the assassin. But few took these accusations seriously and Mo's film gained him the 1969 award of 'British Television Cameraman of the Year' in the hard news silent category. It also brought him his first staff contract with Visnews.

Mboya's death at the hands of an assassin (Njenga Njoroge, a member of the majority Kenyan tribe, the Kikuyu, was subsequently convicted and hanged for the murder, the motive for which is still unknown) was the touchstone for months of unrest in the country. Now the Great Rift, which geophysically splits Kenya, opened into a more tangible schism, as tribalism, particularly between the Kikuyus and Luos and never far from the surface of national politics, reared its ugly head.

Kenyatta, a Kikuyu, moved swiftly to calm the country. He appointed

Luo cabinet ministers in Mboya's stead and embarked on a series of rallying tours. But the feelings of the Luo, under the leadership Oginga Odinga, a long-time opponent of Kenyatta, were running high. Mo filmed a series of clashes between government troops and protesters. When he travelled to Mboya's funeral ceremony, held on Rusinga Island on Lake Victoria, not far from Kisumu, Kenya's third largest town and the heartland of the Luo, it was estimated that more than 100,000 hostile people had followed the cortege. After Mo left the scene, he found that his Land Rover bore fist-sized holes from rocks thrown by the crowd. Mo sensed that government retribution could not be far away.

That same year, 1969, a new hospital was due to open in Kisumu. By that time, the Luo were deeply hostile to the Government whom they blamed for Mboya's death at the hands of a Kikuyu, as well as for marginalising Odinga and Luo interests. The situation was tense. The entire line–up of KPU MPs was there, having travelled from Nairobi, where parliament was in session, to be in the reception party when Kenyatta arrived, and elaborate arrangements had been made for the official presidential visit.

Mo realised it would be an ideal opportunity for the president to read the riot act to the Luos, especially as Oginga Odinga had personally spent much time fund-raising. Here was Kenyatta's chance to publicly put down the troublesome Luo leader in front of his own people.

Mo caught up with Kenyatta and his entourage shortly before they arrived at the hospital. Waiting there were Odinga and thousands of his disgruntled followers. With barely disguised animosity, he and Kenyatta greeted each other and sat down on the VIP dais. Several hundred Luos had managed to gatecrash and as Kenyatta stood up to speak, pandemonium broke out. Chairs were used as weapons and a widespread battle began.

John Platter, former UPI bureau chief in Kenya, recalled: "Somehow, Mo gained the protective inner circle next to the president and I followed. He was filming the carnage until an official, berserk with rage, spotted him, shoved a pistol in his face and shouted 'Open that camera! Give me that film!'

"Unfazed despite the mayhem about him, Mo obliged and surrendered the film. But he was far too old a hand to have been defeated like that. Seconds after the first shots were fired, and the bodies began to fall, he had changed his film and kept on changing, simultaneously handing me the exposed reels for safekeeping. I didn't want to be seen as the plumber's mate just then, but my pockets contained another Mo scoop."

Platter once said that he felt more comfortable when Mo was on a story

with him. "If he was there, things were always more likely to happen and yield copy. If he wasn't there, things had a habit of happening elsewhere, and you could be scooped. Usually by Mo." It was, he said, the same in dangerous situations: "In any contretemps, we courageous scribes would push Mo to the front to argue it out with fuming political worthies, fiery soldiers and rioting mobs. He would usually win them over." This was one occasion when Platter doubted the wisdom of his own words.

Kenyatta, surprisingly calm in the thick of it, was surrounded by his armed presidential guard. As the fighting came closer, they prepared to defend their leader, brandished their weapons and began firing. Kenyatta managed to grab the microphone and appeal for calm. Order of a sort was restored and, while the president addressed the people, medical staff carried patients into the new hospital.

But the riot was not over. Kenyatta and Odinga swapped insults and violence erupted again. The bodyguards decided it was time to evacuate the president and shot a pathway through the crowd. Mo followed their initiative and made his escape. Fifteen people were killed and 80 were treated for gunshot wounds. And Mo had another exclusive. In time, political order was restored when Kenyatta called a general election that October. After being restored to power he made major changes to the government's personnel.

Mo's presence as the only cameraman at the debacle added to his growing reputation as a man with an uncanny ability to foresee the big news story before it had actually broken. Some called it luck, and indeed there were times when Mo was grateful for his lucky star. But more often than not, he made his own good fortune by careful planning and by keeping his news antennae constantly scanning. He would never take situations at face value, always looking for undercurrents with more import even if they might seem mundane on the surface. Referring to the Kenyatta incident, Platter recalled: "Mo had sniffed out a possibility, it was no more than that. But while others were content to dismiss a routine presidential trip and take off for a weekend at the coast, Mo was ready to rise with the dawn and head the other way."

By now, Camerapix was growing steadily as Mo accrued business. He increased staff, expanded his darkroom and upgraded his equipment. The young man who had committed his future to the country just three years earlier was enjoying the fruits of his decision to take residential status. And now he had the added impetus of an emotional commitment, having married his sweetheart Dolly Khaki in 1968. They met in Tanganyika when both were teenagers and she stuck by him during his Zanzibar ordeal. When he was kicked out of Tanganyika, Dolly demonstrated the strength

of her attachment to the young cameraman by joining him in exile. Two years later, in June 1970, Mo's happiness was complete when Dolly gave birth to a son, Salim. But domesticity and routine office work could never overcome his restless spirit, and when he was offered a dangerous assignment in the Middle East he jumped at the chance.

It meant leaving his wife and newborn child at home, but Dolly was resigned to the capricious ways of the man she loved. She said: "Mo was always leaving me to travel abroad on jobs, but when I married him I knew this was the price I'd have to pay."

In this case it was Mo who almost paid the ultimate price. He had secured a risky trip to a PLO secret training camp close to the Israeli border. During his stay with the guerrillas, Mo joined them on a hair-raising mission into Israel from neighbouring Jordan. He later described it as one of the most frightening experiences of his life. Inside Israeli territory, his companions spotted a bus and opened fire. Israeli guards instantly responded. The accuracy of their fire was so good that Mo was convinced he would be shot dead. Dodging bullets, he crawled on his stomach through thorn scrub to safety in Jordan. He said: "Those guys don't miss. I thought 'This is where I'm going to buy it.' I crawled like hell. I was covered in blood and my clothes were shredded, but at least I made it in one piece. That's the only time I can remember being totally shit-scared."

Mo then organised a tough safari into southern Sudan to cover the 'Forgotten War,' a secessionist battle between the Christians and animists of the south and the Government-backed troops of the Muslim north. This bitter struggle had been going on for 13 years and was still no closer to being resolved. Mo's route took him and his crew of Nairobi journalists, including Henry Reuter and BBC Television reporter Peter Stewart, on a five-day trek with porters through steamy jungle across Uganda and Zaire and finally into Sudan. There, they linked up with freedom fighters who were camped out in the trackless bush. In fact, there was little fighting to be seen. The only scuffle that occurred was between Mo and Stewart who clashed en route and which resulted in Mo giving the reporter a right-hander. Throughout the rest of the trip they never spoke again.

On his return to Kenya on February 6, 1971, Mo survived some rough handling by local police when he went to photograph the arrival at Nairobi airport of Prince Charles and his sister, Princess Anne. As Mo jostled for position to get a good shot he was kicked and punched by security men and a set of lights was smashed. Mo shrugged off the incident, considering it a hazard of the job. As was the custom on some royal visits, a 'pool system' was operated whereby only one photographer from the scores of pressmen was allowed on more intimate sections of the itinerary. His brief

included sharing his pictures with all his colleagues. Mo was selected to accompany the prince when he flew an aircraft of the Queen's Flight to Lake Turkana. Mo followed this by covering the Archbishop of Canterbury's trip to Kenya, the residence in exile in Nairobi of Miriam Obote – wife of the deposed Ugandan president Milton Obote – and her family, and the state opening of the Kenyan parliament.

There were many years during Mo's career when he spent more time out of Kenya than in it, and hence more time away from his family than might be seen as helpful to domestic bliss. But he was a private man with no intimate friends with whom he might have discussed the effects such extensive travel was having on his personal life. It is significant that prolonged foreign assignments were often followed, where possible, by periods of consolidation within the country. Mo would spend time taking wildlife pictures for his extensive portfolio, family snaps of his young son and compiling material for his first book, his subject Tom Mboya. This project was described as a photo tribute and, though by no means a best seller, received favourable reviews and cast the die for yet another facet of Mo's ever-widening career.

For Mo, the natural splendours of his adopted country were an enduring balm to the turbulence of his life in the great world outside. Often, in an attempt to get that magical shot which caught nature in the raw, he would study one particular animal for an entire day heedless of the passing hours as he devoted himself totally to the task in hand. One early notable result of this painstaking attention was a picture sequence of a lioness and her cub taken in Nairobi National Park in February 1967. It was so impressive that the London *Times* used three shots spread across half a broadsheet page.

On rare occasions when Mo was between jobs, his thoughts still focused on photography and his cameras were his constant companions. His wildlife and travel books bear ready testimony to his industry as does his picture library in Nairobi, acknowledged as the largest and most comprehensive pictorial record of 20th-century Africa in existence.

He once said: "I spend three days in a game park. Sure, it's a holiday, but I come in with 60 rolls of film. Every one of those pictures I can sell. That's not the initial motivation to get me there. I go because my family wants a holiday. I say 'Fine, I'll come along with you, but I can't go without my cameras because I would just be bored to death.'

"I probably enjoy the trip more than them because, you know, they've seen a lion and they aren't bothered about seeing another one. But I am. I love studying all animals in their natural habitat. And at the same time, I photograph them thinking that I'm going to make some money out of

this. I photograph because I like doing that, just like any other tourist. They take pictures but don't make any money out of them. I can put my pictures to bloody good use because I have the infrastructure and resources to make something out of them."

Applying that policy in 1974, Mo went off on the trail of an ancient elephant named Ahmed who was the first wild animal to become the subject of a presidential decree. The story began when two wealthy US hunters were rumoured to have laid bets as to which of them would shoot the ageing beast. The elephant was colossal, of great age and possessed of spectacular tusks. Three years earlier, a European film maker and conservationist named Christian Zuber had filmed extensively around Ahmed's home in Marsabit and developed a great affection for the old leviathan. When Zuber heard of the callous bet he took up cudgels on Ahmed's behalf, rallying support around the world for the elephant's protection. Such was the outcry that Jomo Kenyatta issued an order for Ahmed to be provided with round the clock armed guards.

Mo decided to record Ahmed's story and went with writer Peter Moll to the elephant's territory on the forested slopes of Mount Marsabit, spending two days filming him. Despite his advanced age, ill health and the 200lb weight of his prodigious tusks, Ahmed resented Mo's intrusion into his quiet domain and finally charged him and Moll who had to beat a hasty retreat.

Flight proved something of a farce and nearly a full-blown tragedy when Mo and Moll ran their separate ways, either side of a giant Podo tree. Unfortunately, in their haste they forgot they were still attached by the flex of the sound recording equipment Moll carried which was linked to Mo's cine-camera. Mo kept running which brought Moll to a sudden halt, whiplashing him round the tree and almost into the oncoming tusks of the angry old bull. Life was rarely dull around the photographer.

It was the tusker's swan song; a few days later he died of old age – something rare for a wild elephant – and Mo's footage made headlines on many news bulletins around the world as a fitting obituary. It was yet another occasion when his intuition placed him in the right place at the right time.

Then it was off to Pakistan to record political unrest before returning to one of his favourite jobs, the East African Safari Rally. During the five-day, 3,500-mile event, Mo and his Camerapix crew would work flat out to deliver on time. Often they slept out in their battered Land Cruiser, miles from the beaten track, in order to claim the best position for filming. Mo covered this gruelling test of endurance for more than 25 years and his film reports of the rally achieved legendary status. Sometimes, in his desire

to get as close as possible to the action, he made the news himself.

In March 1978, he parked his vehicle next to a flooded track and, together with his new partner, Duncan Willetts, set up his tripod and camera on the roof to capture the cars as they sped past at 80 mph spewing sheets of water on either side. For Willetts it was a dramatic introduction to his first Safari Rally. Suddenly Japanese driver Yoshio Iwashita arrived on the scene and broadsided out of control. The careering car hurtled off the road, rammed into the Land Cruiser and pitched Mo and Willetts into a mud-filled ditch. The incident left Mo with a broken wrist, but typically he kept his cameras running throughout to provide the evening television bulletins with some spectacular footage. His professionalism led to Iwashita receiving an anxious phone call from his wife in Tokyo. Not wanting to worry his wife, Iwashita had not told her about the crash, but thanks to Mo, and Visnews, film of the incident had been screened in Japan.

Sometimes in his enthusiasm to be first or to get a saleable shot Mo would stretch the rules. John McHaffie, then chief sub editor of *The Nation*, recalled: "During the late 1970s there was great local interest in the Safari Rally because some of the best drivers were Kenyan. On the first morning of the rally Mo appeared in my office about 10 minutes after they had flagged off the cars from Nairobi's city centre. He presented me with a stunning picture of Kenyan driver Shekar Mehta in a remote part of the country, sluicing through a stream against a wonderful backdrop of wildlife and Mount Kilimanjaro.

"I said 'That's an amazing pic Mo, especially as he only drove off 10 minutes ago!' For a second Mo looked nonplussed, then he shrugged and said 'But he'll be there tomorrow.' And he was. Mo had driven out into the bush on the drivers' practice day and shot his picture. I think he knew I would spot it, but he also knew it was better than anything his rivals were offering. I used it on page one.

"The good thing about Mo was his ability to identify markets for his work and sell successfully to them. He did this by always delivering on time, and if other photographers were competing Mo would get his pictures back first and they would get used. He didn't waste our time, or his, by offering pictures he knew we were unlikely to use. So when he came into the office you always knew he had something worthwhile."

Mohinder Dhillon recalls another time when Mo bent the rules. He said: "Mo and I were covering an anti-British demonstration at the High Commission, but it was all very tame. There were about 100 people and they were doing a bit of shouting and not much else. Then Mo went over to them, had a chat and I saw him point to the Union Jack. Next thing, one of the demonstrators shinned up the pole, dragged the flag down and

then they burnt it. We got some good pictures then!" Mo celebrated the 21st year of the Safari Rally by producing a book, *East African Safari Rally Comes of Age,* and followed this in January 1973, with a photographic exhibition of pictures he and colleague Masud Quraishy had taken of Kenya's wildlife.

As if the perils of the job were insufficient, Mo continued to hold an almost fatal attraction for danger on the roads. In 1974, he was a passenger in a four-wheel-drive vehicle travelling in up-country Kenya when it skidded on a slippery unmade road and rolled several times. Mo's leg was badly damaged and the Flying Doctor Service had to be called in. He was flown to Nairobi Hospital where X-rays revealed multiple fractures. The surgeon who had tended Mo when he broke his leg the first time was again in attendance and gave the cameraman a stark choice – six months in traction or an operation with a limited success rate but a much quicker recovery. The second choice had a rider: if it failed, Mo could lose his leg.

He took option two and emerged from several hours of surgery with his leg spliced and wired together. Post-operative treatment called for a significant period of rest, but Mo ignored orders to stay in hospital for six weeks and left after two, never giving the bone a chance to heal. The result was one leg shorter than the other and the characteristic lop-sided gait which became such a part of the Mo persona. Whatever the consequences, it did not appear to affect his mobility for he subsequently climbed Africa's two highest peaks, Kilimanjaro and Mount Kenya, with no ill effects.

Over the next few years, Mo spent more time out of Kenya than in. During a phenomenally rigorous workload he covered the madness of Idi Amin's Uganda and Bokassa's Central African Republic; the excesses of white rule in Ian Smith's Rhodesia; a bitter and barbaric civil war in Sudan, and made documentaries on Pakistan and his pilgrimage to Mecca. But Kenya was never far from his thoughts, and throughout he returned to chart the country's emergence and development under the charge of its founding father 'Mzee' Kenyatta. With his imposing presence, formidable personality and benign paternalism, the old man straddled his national stage like no other, and for his countrymen he was the living embodiment of the nation state. Life without him was almost unimaginable.

But even giants must fall, and on August 22, 1978, Mo got a call from Kenyatta's press secretary Kinyanjui Kariuki. Mo said: "He was very vague, but told me to stand by for a big story. He told me to listen to the Voice of Kenya. I was intrigued. I knew Mzee was staying at State House in Mombasa but Kinyanjui was ringing from State House in Nairobi. I phoned the Mombasa State House. The switchboard operators were stunned and you could tell something was seriously wrong. I decided to drive to State House,

Nairobi, and when I found Kinyanjui he confessed 'Mzee's dead.' They'd flown Kenyatta's body up from Mombasa and still hadn't announced anything. Kinyanjui prepared the announcement but, when he rang the director of broadcasting at VoK, the man told him there was no way he'd broadcast the news unless he was given a signed order."

The country went into deep mourning for its favourite son and Mo covered the state funeral and swearing in of Kenyatta's successor and former vice president, Daniel arap Moi. Many had predicted a bloodbath in the wake of Kenyatta's demise, but it is a tribute to the people of the country and to the dignified way Moi affected the transition of power that Kenya remained quiet and stable.

Mo was kept busy with a variety of assignments in and out of Kenya. Some were run of the mill, some projected him into theatres of war and some brought him into contact with world leaders. Three months after a visit to some of the country's more remote areas, Mo covered the visit to Kenya of Pope John Paul II. As usual, looking for the odd angle which would lend a different perspective to the story from that offered by his rivals, Mo decided to attempt to get a picture of the pontiff – then a keep fit fanatic – enjoying his morning swim.

With photographer Duncan Willetts, he went to the pope's residence in the Nairobi residential area of Lavington where, surprisingly, friendly guards let them through the gates. Finding the house open, the two men wandered from room to room without hindrance until they ran into burly Archbishop Paul Marcinkus, known as 'God's Banker.' Marcinkus was so furious at their intrusion that he was moved to the uncharitable response: "What the hell are you doing here?" Mo cheekily replied: "Father, this is a holy house. Don't be so angry." "How did you get in?" asked Marcinkus. "Father," said Mo, "we came in through the front door." The Archbishop calmed down, but resolutely refused Mo's first request to film the pope swimming and his second to picture him taking breakfast.

But all was not lost. The two men were still inside the grounds of the house and this allowed them to steal a march on the opposition. As the pope was due to drive to a mass rally at Uhuru Park, Mo cunningly placed his Land Cruiser in front of the papal convoy of vehicles led by the pontiff himself. It allowed Mo to shoot exclusive pictures as, once again, other cameramen looked on asking themselves "How on earth did he get there?"

Later, the papal nuncio, whom Mo knew quite well, brought the pope over and introduced him to the two cameramen. Mo, a devout Muslim, said: "His Holiness gave us each a gold and ruby rosary. I treasure mine."

After tracking down deposed Idi Amin to Saudi Arabia in May of that year, Mo turned to his publishing interests and attended the Frankfurt

Book Fair where he showed the manuscript of his book about the Lake Turkana expedition, *Cradle of Mankind*, to potential buyers.

In January 1980 Mo headed north on a ground-breaking expedition into the interior. His destination was the shores of Lake Turkana where man's ancestors took their first, faltering footsteps more than two million years ago in what is now known as the cradle of mankind – the title of the book which Mo later produced. Turkana is a 2,500 square mile stretch of water, alkaline and barely drinkable, sometimes calm and unruffled, more often turbulent and dangerous. It boasts an astonishing variety of wild life, including 350 species of birds and the largest remaining colony of crocodiles. There, too, are six tribes of hunters and nomads who live today much as our forebears did.

Sometimes called the Jade Sea, the lake was formerly known as Lake Rudolph after an Austrian prince. Two Austrians, Count Samuel Teleki von Szek and Lieutenant Ludwig von Hohnel, were the first white men to venture there 100 years ago. Mo said: "My journey to Lake Turkana was an experience of time removed. It's a bleak place, a devastated landscape of searing heat, the ground burned to a cinder and reduced to grey ash over large areas. That life which persists has learned to survive extremes and clings tenaciously to its existence. This applies as much to the people as to the flora and fauna.

"I knew all of this before I planned my expedition. I'd been to Turkana in 1968, the year that progenitor man was discovered in the area at Koobi Fora. On that trip, I photographed the people and landscape for a personal record of vanishing Africa. The idea of a book, a public record, came later after many return visits.

"In 1979, the book was close to completion but I'd had to leave gaps which I now wanted to fill in. I had nothing on the Suguta Valley in the south and nothing on the Omo River across the northern border in Ethiopia. It seemed logical, therefore, to make an expedition round Turkana, and in doing so it became the first motor circumnavigation of the lake."

It took Mo months of preparation, including protracted negotiations with the Ethiopian authorities in Addis Ababa. Another problem was time – the timing of the expedition and the time anyone could spare to join the party. Eventually, a five-man team was selected and set off at midnight on Thursday January 17, 1980. Mo said: "My budget ran into thousands of pounds. Equipment included a station wagon and pick-up truck (both four-wheel drive), plus a 250cc trailbike for path-finding, as much of the journey was in uncharted territory without recognised tracks. We took a fridge, generator, two gas cookers, three tents, 800 litres of petrol, 275 litres

of drinking water, a quarter of a ton of photographic equipment and half a ton of spares. There was also a power winch, sand ladders, special three foot jacks and an inflatable dinghy."

The party's first disaster came only a few hours out of Nairobi when the overloaded station wagon rolled, injuring Tetley, the safari's writer, who was sent to Nairobi Hospital. While he recovered, the vehicle was repaired. It was so badly damaged that it had virtually to be rebuilt and travelled the rest of the expedition without windscreen or windows which proved to be welcome ventilation. A few days after the accident, they set out again and following several hundred miles of gruelling off-road travelling, arrived in the Suguta Valley, one of the hottest places on earth. The team stayed for four sweltering days, enduring noon temperatures of 50C(137F) before trekking on towards the Jade Sea. Travel was slow and water was running low, with both vehicles and men taking a punishing battering from the hostile terrain. But Mo doggedly filmed all he needed as they progressed around the lake.

For days they bumped, ground and winched their way across featureless scrub with little evidence of life, occasionally losing their way. Events took a dramatic turn when they attempted to cross into Ethiopia and were promptly arrested. Mo said: "The expedition had been cleared by the highest authorities in Addis and, just to make sure, the day before taking the team across I visited the Ethiopian border post at Namuruputh. I was greeted warmly and told we would be welcome. When we arrived, they stuck rifles in our backs and arrested us. The letters and visas meant nothing. I persuaded the guards to let us use our radio telephone and got through to the Ethiopian Embassy in Nairobi who contacted Addis. In turn, Addis sent a message to the guards at the border post allowing us into the country. It had taken us 48 hours. Now we confronted the biggest obstacle of the expedition, the meandering waters of the Omo River which we had to cross."

In the 1960s, there had been a ferry point at the village of Kalaam, where the river was more than a quarter of a mile wide. But in the Marxist Ethiopia of the early 1980s, it had fallen into disrepair. The ferry had originally consisted of a steel platform on top of 25 oil drums. Now the drums had corroded into a mesh of holes and the pontoon lay half-submerged. The party had to abandon plans to cross at this point and drove 14 miles upstream to a second ferry – a series of planks on top of three fibreglass dinghies. Mo said: "The banks were steep and to overcome this problem we dug tons of earth out of both sides to make ramps for the vehicles. One member of our team scrounged a broken-down outboard motor and managed to get it working while we set about strengthening

the ferry, a job that took a day and night of hard labour. We inched the station wagon aboard and set off across the river. Then the outboard seized in mid-stream and the ferry finally arrived at the opposite bank 400 yards away from our intended landing point. We had to hand haul the ferry to a place where the truck could be disembarked. The crossing with the second vehicle was made without mishap. After all the trouble with the guards I didn't want to spend longer than necessary in Ethiopia so, after an overnight camp on the eastern shores of the Omo, I decided to head for Kenya. Thirty miles later, we sighted a new Ethiopian border post and, as we approached it, two soldiers came out aiming their rifles at us as they ran down the hill. They waved vigorously directing us into the border post, but I told the driver to put his foot down and we sped over the line into Kenya and safety. After that, I set a leisurely pace down the lake's eastern shores.

"We camped at various places including Koobi Fora, where a team of scientists led by Dr Richard Leakey had unearthed the earliest known human remains. It took us most of three weeks to get that far. In all, we covered around 1,800 miles of some of the toughest terrain in the world made up of a tangle of tracks and unmarked paths, muddled together with volcanic boulders, precipitous slopes, lava sand and scrub desert. In 27 days we really felt we had achieved the impossible, and by the time we arrived back in Nairobi the drivers were near to exhaustion.

"And now I had my book, a permanent record of Lake Turkana and its people as they were. I also had my hope that Kenya in the rest of this century might allow this unique piece of living pre-history to retain its integrity and mystery."

Cradle of Mankind was published the following year. It is a phenomenal record of the expedition, studded with dramatic pictures which later formed the basis of a highly acclaimed exhibition which Mo took round the world.

He then decided on another book, *Journey through Kenya,* but before it could even be researched properly he was suddenly faced with bloody carnage on his doorstep. Mo was celebrating with friends in a Nairobi suburb on New Year's Eve, 1980, when they heard a massive explosion which shook the walls of the house even though the blast was three miles away. Mo immediately phoned police who didn't know what had happened, but calls to the fire brigade pinpointed the five-star Norfolk Hotel. Mo dialled the Norfolk only to find the line was dead. There was another number for the hotel callbox in the phone book which Mo promptly dialled. A voice answered, pleading "Help! People are dying here. I've lost my leg. For God's sake come quickly."

Mo rushed to his office, grabbed his equipment and hurried to the

hotel. He described the scene: "An entire wing was blown apart. Bodies were everywhere and there were injured people lying dazed on the ground. The bomb had exploded in the restaurant which was ablaze and took hours to bring under control. I shot film of bodies being brought out of the restaurant and of the wounded, some of whom had their hands and legs blown off."

Fourteen people died in the explosion and one more three days later in hospital; many more were injured and Mo's pictures of the bloodshed were used extensively. No one ever claimed responsibility for the attack but popular theory pointed the finger of blame at a Palestinian organisation exacting revenge against the Block family, the Jewish owners of the Norfolk who had helped Israel with arrangements for the 1976 raid on Entebbe when Israeli commandos stormed a hijacked jet on the tarmac at the airport of the Ugandan city.

Publications were a major theme in Mo's life during this period, but news work still regularly called him into the field of action. In 1982, Mo returned to Saudi on assignment for Britain's *Sunday Express* colour magazine which wanted pictures of Idi Amin for a "Where Are They Now?" feature. Returning to London, he handed over his interview and rolls of film and caught a Kenya Airways jumbo back to Nairobi on the night of July 31. That very evening members of Kenya's air force attempted a coup.

On board the plane, the passengers were told they were on final approach. Seat belts were fastened, cigarettes extinguished. The jumbo descended lower and lower, then suddenly applied full power and surged back into the air. The pilot announced they had lost contact with Nairobi and were diverting to Mombasa. Immediately after touchdown, Mo went straight to the flight-deck where he learned of the coup and was told that, due to fighting, Nairobi airport was closed. Wilson Airport, the civilian and light aircraft centre in Nairobi, was also in rebel hands.

Mo said: "I was determined to get back to the capital as fast as possible, so I left the plane and walked across the runway to where a young Asian pilot was sitting by his light aircraft. I asked him if he would take me to Nairobi and he said 'Why, what's happening, Mr Amin?' He'd recognised me and thought I was on a story. I didn't disillusion him and said I just wanted to get back to Nairobi as quickly as possible, claiming my international flight had been diverted to Mombasa because of bad weather.

"So he agreed to take me and I remember sitting reading the *Financial Times* to appear as if all was normal. After an hour, the pilot received a radio call from Mombasa saying that there was trouble in Nairobi and he should return. He told them he would have to ask his passenger. I told him to go on. Now I thought I had better tell him the whole story. He was so

angry I think he would have thrown me out of the plane if he could. Neither of us was really sure what to do from there but, in the end, we decided to land at Wilson and take our chances."

As they taxied in, six soldiers armed with machine guns surrounded the plane and ordered them out. Mo said: "They asked us where we had come from and I said 'Mombasa. Is there a problem?' One of them replied 'You don't know what has happened?' I said 'No, we were told there was a problem and it was bad weather.' He said 'It's a lot bigger than that; we've taken over the government. Everything has changed.'

"They told me they had been there since midnight and had eaten nothing since. They were very hungry. It was clear to me they didn't have a clue what was going on so I told them they could get breakfast at the Aero Club. They'd tried there but without success, so I went to the staff quarters, dug out the chef and got him to knock up burgers, chips and tea."

With their bellies full, the rebels relaxed and gave Mo and the pilot permission to go. Mo found a phone and began calling friends to come and rescue him, but none would brave the streets with bullets flying everywhere. Eventually he got through to Willetts who agreed to help. Willetts took a circuitous route on back roads and arrived half an hour later.

The two men took the pilot to his father's house, then carried on to Mo's home. After a quick shower and change of clothes, they went to their office to pick up their equipment. Now Mo was beginning to make sense out of the chaos – the air force had attempted to take over the government but the army had stayed loyal and was fighting to restore order and halt the wholesale looting that was taking place.

Driving into the centre of Nairobi, Mo and Willetts were stopped at a roundabout and hauled out of their vehicle at gunpoint. Mo said: "I recognised the colonel in charge and after chatting to him for a while he agreed to give us an armed escort of three soldiers. Two joined us inside my Land Cruiser and one sat on the roof. We kept them for the rest of the day while we filmed the troubles.

"The scale of looting was so incredible that if the looters had had another day I reckon they would have completely dismantled the 28-storey Kenyatta Conference Centre brick by brick. In the brief hours the rebels and local people had to themselves during the attempted coup, they were so thorough they managed to clean out almost every shopping centre in the city."

Mo and Willetts filmed the events for three days until flights out of Kenya resumed and they could despatch the footage to Visnews in London.

In that time, practically every member of the air force was arrested and more than 1,000 civilians were charged with a variety of offences. Official estimates recorded 150 deaths among the rebels and 100 among civilians.

The year 1984 turned out to be the most extraordinary of Mo's extraordinary life encompassing as it did the awful human drama of the Ethiopian famine. It started peacefully enough with a trip to Uganda to film a BBC special, followed by a three-week assignment in Nigeria for Danish TV. This was followed by a 10-day safari which Mo came to regard as one of his all-time favourite assignments. He was commissioned to film an episode of *Lifestyles of the Rich and Famous*, a US TV show, starring Brooke Shields.

Locations included the private reserve in northern Kenya of millionaire arms dealer Adnan Khashoggi, and other spectacular examples of Kenya's beautiful countryside. Mo did such a good job that the production team promptly hired him to film a second episode of the series in India, an assignment which included lunch with the Maharajah of Jaipur, a potentate known as Bubbles after all the champagne consumed to celebrate his birth. Mo filmed the Maharajah taking part in a polo match played on elephant-back, then flew on to do location shots in Kashmir and at Tiger Tops in the Nepal jungle.

Soon afterwards, Mo had occasion to meet the pope again when the pontiff returned to Kenya for his second visit in 1986. On this trip, John Paul II made history by visiting an African wildlife sanctuary and blessing an orphan rhino calf. Mo had already filmed the rhino's difficult journey by air from its protected home in northern Kenya to the Maasai Mara National Reserve, but was told that the pope's tour of the Mara was off limits to the press. It was to be a private visit.

This was the sort of challenge Mo could not resist. Out came the contacts book again, and he was suddenly the recipient of a personal invitation to photograph the event, courtesy of "an old friend," the minister for tourism. It went down in the Visnews log book as yet another Mo exclusive. Remembering the rosary the pope had given him on his last visit, Mo was able to return the gesture by presenting him with three of his books; appropriately *Run Rhino Run, Journey through Kenya* and, as a testament to his own voyage of faith, *Pilgrimage to Mecca*.

The last 10 years of Mo's life were spent less hectically, as he concentrated on his flourishing publishing empire and, latterly, with *Africa Journal*. The books were rewarding inasmuch as they gave Mo the opportunity to express his art in a different way, especially in the field of wildlife photography in which he was widely acknowledged to be among the finest in the world. But their production lacked the zest and spice which were essential to his 113

driven personality. Mo was always alert to news possibilities and had for some time been following events in beleaguered Afghanistan where guerrilla armies waged an incessant war against the invading forces of the mighty Soviet machine.

By 1989, it was clear to Mo that the Russians were on the run, their dreams of extending Soviet influence in ruins. Their disaffected troops were unable to cope with the hostile territory, unbearable extremes of heat and cold and a ruthless and shadowy enemy who harried them at every turn.

The unforgiving terrain, which made it virtually impossible for outsiders to enter the country, and Russia's obsessive desire to conceal its bungled attempts at domination made this almost a secret war. Few Western journalists had ventured beyond the capital, Kabul, to report the realities of the struggle from the viewpoint of the partisans though Sandy Gall, working for Reuters in 1982, had travelled the country and reported on the situation. He saw thousands of refugees fleeing to safety in neighbouring Pakistan and later wrote a book about his experiences.

It was a situation tailor-made for Mo. Using his extensive network of contacts in Pakistan, he linked up with the freedom fighting Mujahideen who agreed to take him in. Mo took two colleagues, Tetley and Mike Sposito, a cameraman/producer from Visnews.

If life on the edge was what Mo demanded of a job, then this one certainly met his criteria. The three men had to abandon Western attire and dress in the style of the guerrilla bands with whom they travelled. They entered the country via the Pakistan border and trekked for miles through passes guarded by snipers, and across a diversity of war zones. Each carried a machine gun and sported bandoleers of bullets across their chests. The resulting film ran extensively across the world earning Mo yet another exclusive.

Some months later, Mo upstaged his rivals again when he became the first journalist to enter Iraq during the Gulf War of 1990. Tony Donovan, then head of news operations at Visnews, working out of Oman, had the tough decision to make as to whether the company should risk sending in a crew. He said: "Mo was pushing hard to go in and we knew that John Simpson of the BBC was very keen to go, but it was a situation fraught with danger. Iraq had invaded Kuwait on August 2 and Saddam had taken European hostages. He had paraded some of them before the cameras of his own media, but no one knew the whereabouts of the others or if they were even alive. There was a considerable risk to foreign journalists entering the country. No one knew how Saddam would react. I agonised over the decision and consulted David Kogan in London, and in the end we agreed.

It was largely because of Mo's insistence. He was absolutely determined and they became the first TV crew to enter Baghdad. They were able to cover events fairly freely, took pictures of the hostages and their exclusive film was shown around the world. Mo and Simpson were kindred spirits, they enjoyed the sense of danger and got a kick out of producing good results in a tough situation."

Mo stayed in Iraq for 10 days before the company pulled him out. Donovan added: "In the end it was the right decision to go in. It was important because their pictures were the only independent ones coming out of the country."

Within Kenya's borders Mo was an instantly recognisable figure. By mere reputation he could gain access to people and places out of the reach of lesser mortals. Popularity could also have other benefits. One Sunday evening in June 1989, Mo was working late at his Camerapix office when he remembered that he had not collected his mail from the post office, a short distance away. He locked up, walked across the road, picked up his post, returned to his car – and was kidnapped by three gunmen.

Mo said: "I'd just completed production of a major television documentary on Kenya's 25 years of freedom and was not really aware of what was going on around me. As I got into my car, a man with a gun in his hand threatened me through the open window. There were two other guys with him. It was like watching a video film of the real thing, only it was happening to me.

"The gang drove me to a suburb, robbed me of about £50, took my wedding ring, then told me to get out. I was still shocked by what was happening but I was also very angry so I asked them what they were going to do with my car. Big mistake! They told me I had blown my chances and they were going to take me out of town and finish me off. Just as we set off, one of them recognised me. He said I had done a lot of good for Kenya, so they stopped on the way and gave me back enough money to get a taxi home! It was a nice touch. I was very lucky."

Truth to tell, the luck was of his own making. Mo's efforts on behalf of his country, the whole of Africa and the attendant publicity made him a respected and familiar figure in and around Nairobi. And on a continent voracious in its appetite for consumption of media information he was a legend.

Mike Buerk said: "It was a revelation to be with Mo on home territory – which meant most of Africa. Officials would recognise him everywhere, usually as a result of a previous confrontation. But he overwhelmed all obstacles. Problems he just brushed aside. To see him spirit his caravan of silver camera boxes through the airports of Africa was one of the great

theatrical performances of our time. But on the road he could be a ruthless companion. Getting the best pictures and getting them out was always the priority, and if anyone got in the way he took no prisoners."

It was a theme echoed by Mo at one of his last public appearances in Kenya. Speaking to students in Nairobi on a media productions course, he told them: "I want to give you some advice given to me 40 years ago which still holds good today. You will only succeed by anticipation, persistence and planning. Never take no for an answer and always make sure you stay one step ahead of your rivals."

Ever keen to press the cause of Africa, he added: "Make it your pledge to keep Africa on the front pages of the world's newspapers and television screens. And not just the bad news, but also the good news, because great and good things which take place on this continent often go unrecorded."

CHAPTER 5

MURDER, MAYHEM
AND MASSACRE

'You cut down the risks by doing the

right sort of planning beforehand'

MOHAMED AMIN

W HEN, IN 1992, Mo appeared on *Desert Island Discs* on BBC
Radio Four, presenter Sue Lawley asked him how many lan-
guages he spoke. With little pretension to modesty, Mo replied:
"I speak 14 languages fluently." Colleagues have since pondered on which
languages he meant but, allowing for the many Asian and African dialects,
it is possible. Certainly his linguistic ability was remarkable and it often
paid dividends when he was in the field.

This talent, combined with Mo's established reputation and origins,
was why Alan Hart of BBC TV's Panorama current affairs programme
asked Mo to go with him to cover the East Pakistan conflict in 1971. Initially
Mo refused because he had many other jobs on his books at that time, not
the least of which was the annual East African Safari Rally, a lucrative
assignment for which he had many orders. But Hart pressed him and asked
Mo to name his fee, which he did – £1,000 a day with a minimum guarantee
of 10 days work.

At a time when average daily rates were approximately £100 to £150,
this represented a small fortune. It meant that Mo could afford to pay
others to cover the rally for him and still make a handsome profit. The
deal was for just the two of them to go in with no soundman. Mo was
comfortable with this arrangement. He knew it was a dangerous job –

reports of atrocities were becoming commonplace, and the fewer the people the safer it would be.

The conflict began after the Bengalis of East Pakistan sought to break their political union with the Punjabis of West Pakistan and form a new country, Bangladesh. Talks between the two sides broke down and guerrilla warfare ensued. The resulting struggle was long and bitter with official reports estimating the dead at between 200,000 and a million people, with another seven million refugees fleeing to safety in India.

Mo recalled: "We flew to Karachi that evening. We wanted to go to Dacca and work on the side of the Pakistani army. But the doors were absolutely shut tight and nobody was prepared to give us permission. So we took a Japan Airlines flight to Calcutta, one of the most pleasant flights I've had – with Alan you flew first class all the time.

"We arrived quite late at night. There was a transport strike which was apparently quite common in Calcutta, so there were no taxis or buses. But the JAL crew gave us a lift in their transport, an armoured vehicle they had requisitioned from the airport police.

"Hundreds of newsmen waiting to go in to cover the rebellion were staying at the Palace Hotel. We spent the night at another hotel, the Hindustan International. I always prefer to stay away from the pack. You tend to worry about what the others are doing and can't get on with the job. You're also influenced by what everybody else is doing.

"Alan asked me to arrange a vehicle to the border. The strike didn't make life very easy, but eventually I found a Sikh who agreed to take us to Banapur. We set off at six in the morning. When we reached the border post the officials refused to allow us to enter, but after a lot of talking said we could carry on without our passports being stamped.

"We refused to accept that. If we had been arrested by Pakistani troops when we were in the country illegally, we reckoned we could be lined up in front of a firing squad. At the least, if we were in the country with a legal stamp in our passports we'd have a chance of talking.

"After more haggling they agreed to stamp our passports but, understandably, the taxi driver refused to come with us. We gave him some money and told him to wait, saying we'd be back at any time in the next two or three days."

For Mo and Hart, transport became the biggest headache as they crossed into East Pakistan. There were virtually no vehicles at all in East Pakistan. At first they commandeered a rickshaw, but the driver found it almost impossible to break through the human tide pressing in the opposite direction. Eventually, Mo spotted an ancient fire engine crawling along with the refugees. He tried to hire it, but the firemen refused. Finally he

negotiated a price for the old workhorse, and Hart duly handed over $1,000. They drove slowly into one of the main towns of the region, Jessore. On the way, Mo and Hart saw at first hand the savagery unleashed by ethnic tensions when they witnessed the brutal murder of a dozen West Pakistanis, including priests.

Mo told Tetley: "We passed evidence of several massacres – men, women and children slaughtered in their own homes. We filmed this gruesome evidence as we drove towards Jessore. It wasn't clear who had done the killing, but the locals told us Pakistani soldiers had been responsible. It was also evident that there was a lot of killing by Bengalis as well.

"It took me time to realise that this was a war between Bengalis and Punjabis. Since my parents were Punjabis, I knew if I spoke in that language I might get slaughtered too. So whenever I was asked where I was from, I said Africa, which was easy enough to prove. And since they had never seen an African before, they were quite happy to accept the fact.

"All along the route the stench of decomposing bodies hung heavily in the air. When we rolled into Jessore, we met some East Pakistani rebels who took us to a house which was their headquarters. There, we saw a group of prisoners with their hands tied with rope. We then drove around the town photographing the carnage and destruction. On the way back, we drove into a square in Jessore, where we saw a mob setting about the prisoners we had seen earlier. They were literally being beaten to death with sticks, stones and knives. Their bodies were still twitching. I filmed the scene from a distance. It was one of the most gruesome things I've ever seen."

There was nothing to be done but record the incident and get away before the mob turned on them, so they headed for the border. On the way, they saw the firemen from whom they had bought their transport, and tried to sell the vehicle back to them. But the men did not want to know, so the fire engine was abandoned at the border. Hart returned to London and the film, with Hart as anchorman, went out as a special the day he landed. There was an instant outcry.

Soon afterwards, the two men returned to the fray to put together a more complete film for the full Panorama programme. Hart flew back to Calcutta to be met by Mo, and the pair moved on to East Pakistan. But, for editorial balance, interviews were needed in West Pakistan. This presented logistical problems. The film they had shot in the East stood a good chance of being confiscated in West Pakistan, so the obvious answer was to ship it out via India. Unfortunately, the BBC was then banned in India, so Mo eventually flew back to Nairobi, put the film on a plane to London and returned to Karachi by the same flight. Meanwhile, Hart had set up a series

of interviews, including a highly sensitive one with opposition leader Zulfiqar Ali Bhutto who had played a leading role in negotiations between the warring factions.

Arriving in Karachi exhausted, Mo had further frustrations with Pakistani customs, who refused to allow all his equipment in without an official letter. Yet more to-ing and fro-ing ensued before Mo dropped off to sleep in his room in the capital's InterContinental Hotel. Minutes later, Special Branch were knocking on his door. They threatened him with arrest, tried – but failed – to take his passport, then confined him to the hotel.

Meanwhile, Hart had arranged a crucial interview with Bhutto for that evening which he could not complete without Mo. With both entrances to the InterContinental guarded, Hart bribed kitchen staff to let Mo out of a side door and the meeting went ahead. During filming, one of Bhutto's aides took some stills of the event, an action which was to have serious consequences for Mo.

Desperately short of sleep, the cameraman returned to his hotel room by way of the side door and service lift and, in the early hours of the morning, headed for bed. Hardly had he dozed off than there was an almighty banging on the door. Mo recalled: "I had kept the security chain latched, but outside there were five very angry men shouting that I should open up. I said 'Hold on,' and immediately rang a good pal in Pakistan, Ronnie Robson, asked him to tell Alan Hart, then threw some clothes on because they were still banging on the door and shouting. If I hadn't opened the door, they would have smashed it in. All five stormed in to my room, stuck a newspaper in my face, and said 'You're a spy. How did you get out of here last night?'

"Before I could answer they opened the paper and showed me a picture of myself together with Alan and Bhutto. The man I had assumed to be Bhutto's private photographer had, in fact, been from a newspaper. I realised that at this stage there was no point in giving the Special Branch any old spiel so I just said 'Well, what's the problem? I went down to the lobby to look for your men but there was nobody around. I assumed you realised you had made a mistake in the first place by putting me under arrest since there was nothing I had done to deserve being treated like that.' They didn't believe me, called me a liar and insisted on taking me away."

For once, the colour of Mo's skin seemed to be working against him. The current situation had to be seen against a background of Pakistan's deep distaste of the international media, who were believed to portray the country in a poor light. West Pakistan had imposed a virtual news blackout on the troubles. Yet here was a representative of that dangerous breed, and

one of Pakistani origin to boot. In official eyes, there was an element of treason about Mo's actions. If it was discovered he was responsible for filming the East Pakistan massacre, it was likely that under martial law he would be jailed for up to seven years.

Fortunately, Robson arrived at the hotel and insisted on going with Mo. He feared that, if left on his own, Mo might never be seen again. In the event, Mo was interrogated for several hours, quizzed on his work for the BBC, then deported. At the airport, his equipment was carefully scrutinised. Mo used his usual ploy of swapping reels of film and had marked four empty reels "Bhutto interview." As he had expected, they were confiscated. The correct film was still in the camera.

He said: "They told me they would send the film to the Pakistan High Commission in London where it would be processed and viewed and, if it contained nothing offensive, I would get it back. Otherwise it would be censored before being returned. Naturally I made vigorous protests about Press freedom, but they just waved me away."

Back in London, Hart quickly put together the 55-minute Panorama special on East Pakistan. Mo learned later that the Pakistan High Commission paid £250 to have their film processed, then assembled the staff around a hired projector to view the footage and censor it. Like the film they watched, the comments of the High Commissioner were not recorded. The next day, the Panorama special was broadcast.

In Nairobi, Mo was working on his own version of the story for a series to be published in *The Nation* newspaper when the Pakistan High Commissioner telephoned and demanded a meeting. Mo refused his peremptory request before eventually agreeing to meet at a Nairobi restaurant where the High Commissioner told him not to publish his report.

Mo said: "He told me I was taking the Bengali side and it would be unwise to print the story. I told him it was none of his business to tell me what I should be doing and we parted on distinctly unfriendly terms. Later, I got a call at my office from him in which he said 'Your parents live in Pakistan, don't they?'" Mo reported the conversation to Kenya's then foreign minister Dr Njoroge Mungai and later received another call from the High Commissioner, this time in a spirit of rapprochement.

The postscript to the East Pakistan affair was left to Hart. Months after the Panorama special had been screened, he got a call from BBC storekeepers asking him to return a fire engine he had bought. That one took some explaining!

Following his sojourn in Pakistan Mo spent many months working in Kenya before Ethiopia, in its many facets, became the focus of his lens. In

1973 he travelled to the country to witness scenes of hunger which were a chilling foretaste of what was to come more than a decade later. Working for Visnews with David Nicholson, he filmed sickening scenes of the results of drought-induced famine. An estimated 100,000 victims had already died yet there was little relief. Indeed, the Ethiopian Government seemed to have kept the situation quiet to avoid political embarrassment – a charge it always strongly denied.

Either way, the evidence in human terms was all too evident and world reaction to it became the catalyst for the downfall of the Royal House of Ethiopia and Emperor Haile Selassie who traced his lineage back 3,000 years to the House of Solomon.

Mo knew the Emperor through previous assignments, the most notable of them a documentary entitled *To Build a Nation*, commissioned by Selassie's Cabinet as a present for the leader on his 80th birthday in 1972. Mo and his team were loaned a Dakota DC-3 and travelled the length and breadth of the country filming the people, flora and fauna. Producer Keith Hulse recalled one particular trip to the infamous Danakil Depression, where they recorded temperatures of 40C(110F) in the shade.

He said: "The heat even got to Mo. We were visibly wilting in the sun when these Danakil warriors shimmered out of the heat. We were terrified because they have a fearsome reputation as fighters, but I think it was too hot even for them to be aggressive. It got so intense that when we went to a sulphur mine I watched Mo walk under a shower fully clothed, and as soon as he walked out he was dry again! My metal watch strap branded my wrist.

"We all needed water but it was undrinkable at the mine and by now our soundman had collapsed from heat exhaustion. We had a schedule of filming to complete around the Danakil, but we cut it out and flew instead to Asmara. We were at the point of total dehydration. If we had stayed in that heat any longer we would have died."

Mo remembered the occasion well. He said: "We were so dehydrated we cancelled all our other plans and flew to the nearest city Asmara. When we got to the hotel, I drank 26 Cokes one after the other and I was still thirsty. I reckon another hour and we would have passed the point of no return."

On another occasion, Hulse recalled how Mo's determination to get the pictures nearly cost him his life. Hulse, then a BBC current affairs producer, went out to Addis with a four-man team – Mo as cameraman – to record the activities of the Dergue Revolution which was ultimately to bring about Selassie's downfall. At that time, in March 1974, the ageing Emperor had moved to forestall his political demise by rewriting the

Constitution and bringing in new civil rights. It was too little too late. Rioting and protests had become commonplace and the students were already in revolt. By the time Hulse and his team arrived, the Emperor was in his final days. Mo took the last pictures of him as he walked, a solitary figure, in the grounds of his Addis palace.

The Dergue revolutionaries were ruthless and when they gained power launched a regime of fear and oppression which ranked alongside the worst in Africa. One of their tricks was to shoot a suspect, then send the victim's mother a bill for nine birr, the price of the bullet. Hulse said: "At one point, we were under house arrest at a hotel when we heard that 400 students from the university were being taken to the national theatre for indoctrination and Marxist self-examination. The finale to this stage show was to be the shooting of 100 recalcitrant students as an example to others to toe the party line.

"Obviously we wanted to film this, so we managed to dodge our minders and sneaked into a cafe next to the theatre. After the lecture, we saw the guards taking the 100 students out the back. We had managed to steal some Communist badges and insignia and were posing as East Germans. Mo was filming when we were spotted. The guards grabbed us and threw us against a wall with AK-47s pointed at our heads, and started shouting that we were spies. I was reasoning with them and making some headway when, in a lull in all the fuss, we heard this whirring sound. The guards looked at Mo and there he was, still holding his camera down by his side, still filming.

"They went apeshit. I nearly killed Mo as well when I realised he had kept the film running. The guards were about ready to shoot us when reporter David Lomax spotted a cab driving along. He stepped into the road, flagged it down and we calmly climbed in and drove off. The guards were so stunned by our audacity we got clean away."

On March 5, 1974, Mo filmed Selassie giving his address to the nation. Days later the Emperor was deposed and disappeared forever. It was not until the Dergue Government itself had been overthrown that Selassie's remains were found buried in his palace.

Less than a year later famine again called him back. No one knew at the time but this was the start of a decade of drought which culminated in the 1984 tragedy. Even then, half a million people were believed to be starving to death. In the Ogaden, a woe-stricken region of the country, Mo filmed an English nurse, Ruth Thomas, cradling a dying child. Ruth, who worked for Oxfam, later became the wife of Mike Wooldridge, the BBC radio reporter with whom Mo organised coverage of the 1984 famine.

The next two years saw Mo handling a series of international

assignments which took him to trouble spots around the world. One of the major developing stories in Africa was the rise of Uganda's Idi Amin, a scenario in which Mo was very much involved as one of the few photographers allowed access to the dictator. But he demonstrated his news instincts perfectly in 1976 when he chose not to go to Uganda at the time of the Palestinian terrorists' hijacking of an Israeli jet which had been forced to land at Entebbe.

At the time, Mo was in Mauritius for an Organization of African Unity summit during which outgoing chairman Idi was to hand over to Mauritian Prime Minister Sir Seewoosagur Ramgoolam. Mo wanted to get to Entebbe to film the hijack and saw his ideal opportunity when Idi flew in aboard his presidential jet. He knew two of the despots personal aides and got them to persuade Idi to allow him to travel back with them. The following morning, he was up early with bags packed, ready to travel with Idi after the conference proceedings had been brought to a close.

But Mo's sixth sense was ringing alarm bells to him. That intangible radar built deep into his psyche told him all was not well in his plans. He weighed up the situation; by flying with Idi he would be taken straight to the flashpoint and almost certainly steal a march on his rivals. But at what cost? It didn't feel right to the cameraman, so at the last moment, he changed his mind.

Later, he explained: "I'd been worrying about the job all day, from the moment I woke up. I knew the Israelis were too smart and tough to take the hijack lying down and must be planning some kind of reprisal. I have to calculate my chances right from the beginning to the end of a story. You can never be absolutely sure about situations, but you can cut down the risk by doing the right sort of planning beforehand.

"There are times I haven't gone into a war zone straight away but waited instead for a day, two days, maybe even a week, because I knew it was too dangerous and the chances of going in and coming out with the story were pretty much zero. In this case, I decided on the way to the airport that Idi's movements were no secret and it would be very easy for an Israeli jet to bring down his plane. I reckoned it was an unreasonable risk."

Even before Mo reached the airport he had made up his mind not to go. But he still filmed the dictator's departure, tailing him as he strode to his plane. As the Ugandan leader climbed the steps to his aircraft he turned to Mo and asked him "Are you coming with me?" Mo told him: "I'm sorry, sir, but I have been asked to stay on and cover the rest of the conference." For a moment Idi looked puzzled, then shrugged and walked into the plane calling over his shoulder "OK, it's your decision. We'll meet again soon."

124 The next morning, Mo turned the radio on to hear the BBC World

Service announcing the Israeli attack on Entebbe just hours after Idi's jet landed. Mo said: "If I had gone with Idi, I would almost certainly have gone to Entebbe, and almost as certainly I would have been killed. Neither Idi, nor anybody around him, would have hesitated. That public loss of face was his biggest humiliation. Anyone trying to film the raid for the world to witness would have been dead."

Mo's instincts served him well on that occasion but he was soon back to his old ways of taking calculated risks when he set out on his next big story. He flew to Rhodesia, having been commissioned by Danish TV to film an hour-long documentary on the freedom fighting against Ian Smith's regime by rebels based in Mozambique. But getting in to the country was easier said than done. Anticipating trouble, Mo separated from his two colleagues, particularly as the producer he was working with, Peter Dhollof, was Danish and the authorites knew Scandanavian money was being sent to the liberation movements. Mo explained: "We couldn't hide the fact that we were a television crew because of all our equipment, but I thought it better to go in without Peter being with us. In fact he went straight through and me and the soundman, Saif Awan, were held back. We waited for half an hour before being given a 24-hour visa. Then we had to report to the ministry of information who sent us to a colonel in charge of army public relations. When we told him we wanted to film the protected villages, he said it would be no problem and he'd get immigration to give us visas for another week. After that we went to the Salisbury press club and told other journalists our story. When they heard it they just laughed and said they had been told exactly the same and they'd been in the country for months. I knew we'd been taken for a ride so I went back to the ministry of information where they were very apologetic but no more helpful.

"After a lot of messing around when they promised us anti-landmine vehicles, then went back on the deal, we left, supposedly heading for the capital again." But Mo took the first turning they came to off the main road and only stopped when they came to a European farmer's house where they were living under siege conditions with guard dogs, guns and electric fences. The farmer told them of a protected village further down the road so they drove down a dirt track and finally came to Keep Seven, the village run by a 20-year-old South African. Mo talked his way in and they began filming the degrading conditions.

But as they were leaving their luck ran out. Army officers appeared, backed up by armoured vehicles and they were arrested and taken back to Salisbury. Mo was asked to hand over his film but refused saying he had done nothing wrong. Eventually they were told to report to the ministry of information so, on the way, Mo used his old trick of swapping film

canisters. At the ministry Mo angrily threw down two rolls of seemingly used film and stormed out. The authorities promised to return the film when it had been processed and checked. Mo calmly packed, taking his used film with him and left the country.

At that time, Rhodesia could not process his film and had to send it to South Africa which took 10 days. So it was that, less than two weeks later, Mo heard via Visnews that he and his colleagues would never be allowed to enter Rhodesia again. It was an edict that Mo instinctively ignored, and although he bided his time before returning, he did go back many times. Some of his last visits, after independence, were with his closest colleagues Willetts and Tetley, when they photographed and wrote the books *Journey through Zimbabwe* and *Spectrum Guide to Zimbabwe*, both published under the Camerapix imprint.

Animal magic: Mo was never happier than when he was photographing his beloved African wildlife. Above: Happiness is a contented rhino.
Below: Budding film starlet makes her point with the cameraman.
Right: Ahmed, the only animal to be the subject of a presidential decree.
Mo filmed the magnificent tusker shortly before it died on its home territory at Marsabit, Kenya.
Previous page: Kenya is at the forefront of the fight against ivory poaching and, as a symbolic gesture, President Moi set fire to this enormous pile of confiscated tusks.

Above: Infamous Ugandan dictator Idi Amin in full, passionate flow during his reign of terror. Below: 'My people love me,' declared the despot and, to prove it, he drove around Kampala in an open Jeep. On this occasion he chauffeured another notorious tyrant, Mobutu Sese Seko of Zaire.

130

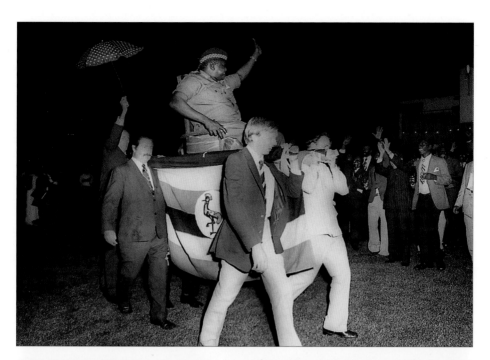

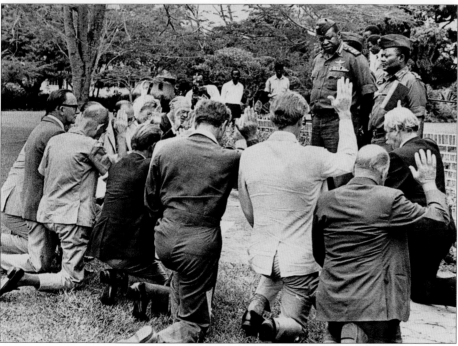

Above: Outraged expatriots claimed Mo faked this picture of British businessmen carrying Idi shoulder-high on a litter into an official banquet. Experts swiftly vindicated the cameraman. There were further humiliating scenes when Idi ordered white residents of the country to kneel before him and swear an oath of allegiance.

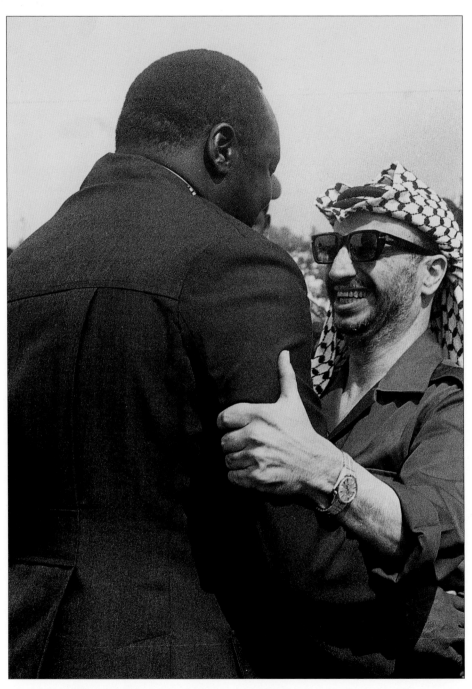

PLO leader Yasser Arafat greets his friend Idi Amin on arrival in Uganda. Later the Palestinian was best man at the dictator's fifth wedding.

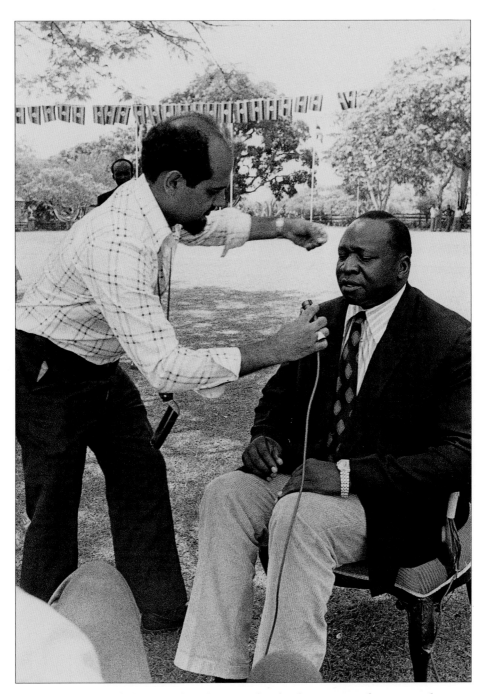

Above: Mo wires Idi for sound as the Ugandan leader prepares for yet another extraordinary interview.

Following page: In the see-saw world of Ugandan politics, power was a commodity often backed up by the bullet. Here, members of Tanzania's liberating army dispense rough justice to loyal Amin supporters as they sweep into Kampala. 133

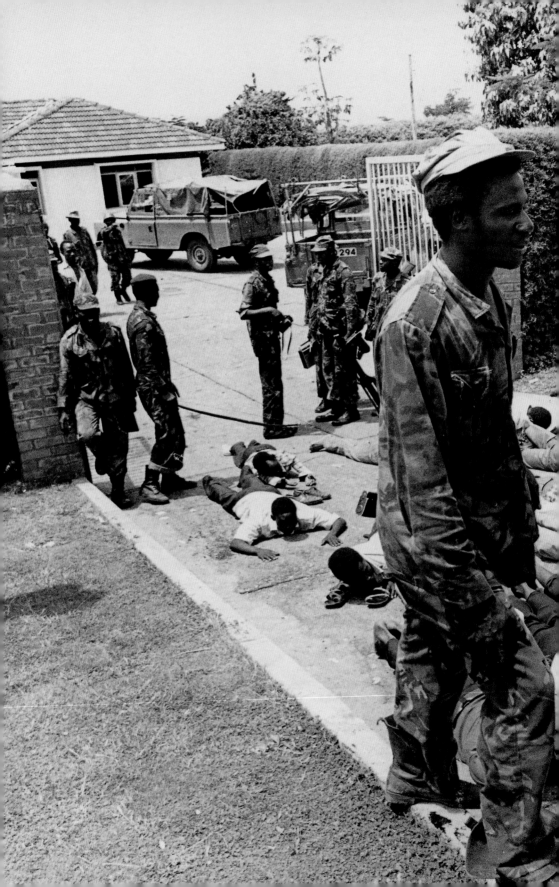

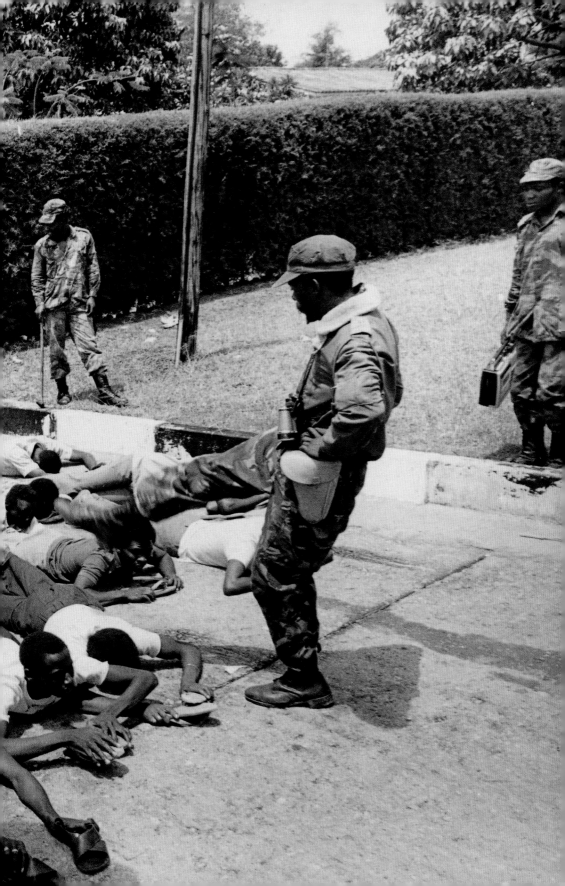

Civil war in Somalia saw four of Mo's colleagues killed and his cousin badly injured. Mo's soundman Anthony Macharia, above, was one of those beaten to death in 1993 by an angry mob.

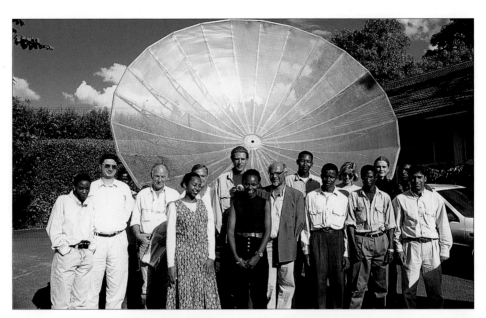

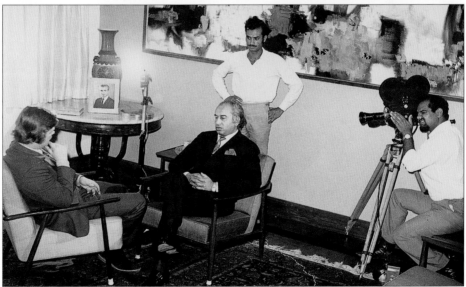

Above: Members of the original Africa Journal *team pose in front of a satellite dish at Mo's studios in Nairobi.*

Below: Caught in the act. Mo is pictured filming the then Pakistani opposition leader Zulfiqar Ali Bhutto as he was interviewed by the BBC's John Osman during the 1966 East Pakistan war of independence. The shot appeared in local newspapers next day and the furious authorities kicked Mo out of the country.

Following page: 'Mujahideen Mo' slots into his role as an Afghanistan freedom fighter with consummate ease while on a risky trip to the war-torn country. Despite the disguise, writer Brian Tetley, with fag on, is unmistakably himself.

137

Suited statesmen of Africa in a quiet moment during an Organization of African Unity meeting. Left, Jean Bedel Bokassa, the then head of the Central African Republic, now a convicted killer. Right, the diminutive but dignified figure of Ethiopian emperor Haile Selassie, subsequently murdered by Marxists insurgents who overthrew him.

Soon after returning to active service, Mo was covering a heads of Commonwealth conference in Harare in 1991 when the then Prime Minister of Britain, John Major, warmly welcomed him back to work.

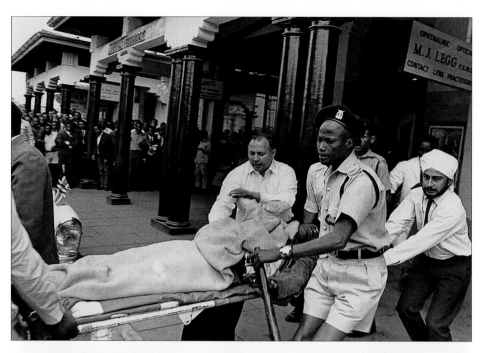

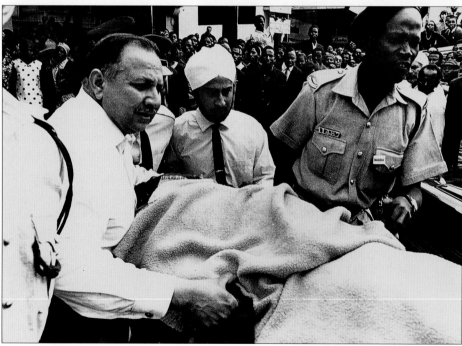

Assassination on the streets of Kenya: Dramatic moments following the shooting in Nairobi of politician Tom Mboya. Doctor Rafique Chaudhri, above centre, and below left, supervises Mboya's removal to hospital watched by a restless crowd.

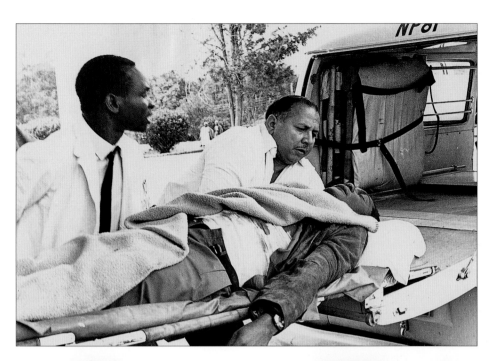

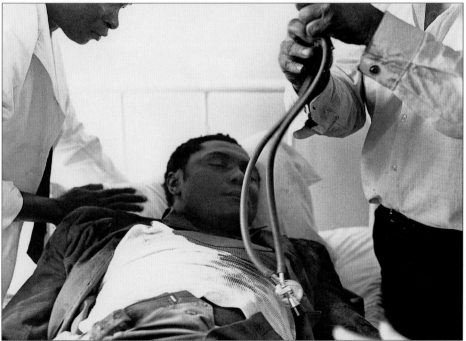

Above: Dr. Chaudhri tried mouth-to-mouth resuscitation but for Mboya it was all in vain. A bullet fired at close range had pierced his heart.
Below: The stethoscope is all-but redundant as a second doctor confirms the verdict. Mo's film of the incident earned him 'Cameraman of the Year' award.

Above: One of Mo's favourite assignments was the shooting of the US television series Lifestyles of the Rich and Famous, *starring Brooke Shields, pictured next to Mo during a break in filming. Below: The long and the short of it. When it comes to comparing tongues, this friendly giraffe has Brooke well and truly licked.*

Above: Competitor in the gruelling East African Safari Rally negotiates a rain swollen river. Mo rarely missed covering the event in 30 years.

Below: With colleague Mohinder Dhillon, Mo was on hand to record soccer star Pele's visit to Kenya in 1970. The Brazilian footballer, far right, toured townships and coached underprivileged children.

Overleaf: After a long and bitter struggle, Kenya finally achieved independence on the stroke of midnight, December 11, 1963. The first president of the new republic, Jomo Kenyatta takes the formal oath of office.

145

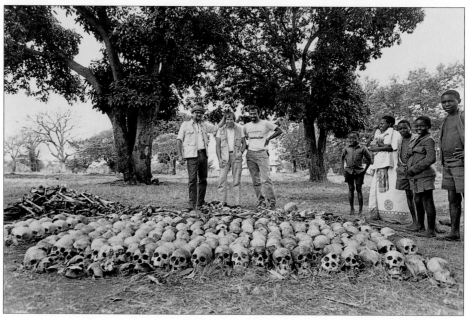

Above: Chairs, fists and bullets flew when President Kenyatta opened a new hospital in Kisumu. Mo filmed the action from within the president's security cordon. Below: Serried ranks of skulls bear grim witness to the excesses of Idi Amin's brutal regime. Hundreds of thousands of people are believed to have died in unremitting ethnic cleansing.

Right: Man of action Mohamed Amin: with camera bags and typewriter at his feet, the young cameraman holds a sten gun as a British helicopter in Aden prepares to take off on patrol.

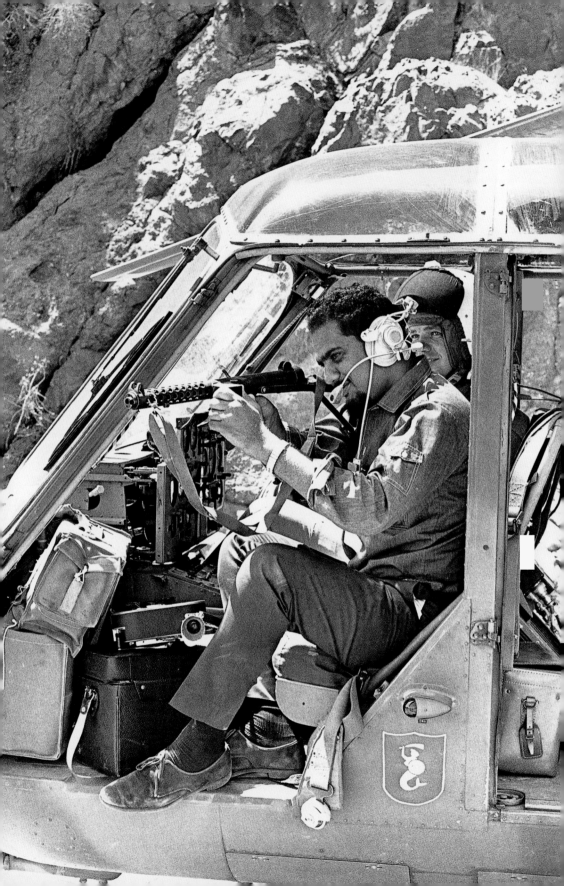

*There was every reason for Mo to be in full morning dress for the 1978 coronation
of Jean Bedel Bokassa, despite the searing heat. The leader of the Central African
Republic decreed a simple choice for those attending the ceremony: wear formal
attire or have an ear cut off!*

150

DOWNFALL OF A DICTATOR

*'He was a superbly gifted photographer
who was also quite fearless'*

BRIAN BARRON, BBC REPORTER

J UST AS Zanzibar seemed to beckon Mo in his early career, so Uganda
gradually exerted its own lure. In later years, Ethiopia would play a
similar pivotal role in his life. As early as 1969, Mo took a welcome
break from covering scenes of violence and horror, spending time with
the BBC as a production manager for a unit filming the lavish TV series
Search For The Nile. The story told of the European obsession with the
discovery of the source of the world's longest river, finally achieved by
John Hanning Speke in 1858, when he looked upon the headwaters of the
great river at Lake Victoria. Slavery was still rampant at that time and
explorers met with fierce opposition from the traditional ruler of Uganda,
the Kabaka.

The BBC job, a welcome change for Mo, involved much lucrative work
and took him to remote Lake Turkana, which held a fascination for the
young photographer. The original intention was to use the exact locations
in Uganda but the premier, Milton Obote, ignoring his country's history,
refused permission to film on the grounds that there had been no slavery
in Uganda nor had a Kabaka existed. Irked by such ideological absurdity,
Mo managed to sneak in with one actor and a make-up girl to film the
moment when Speke discovered the great river's source. It was his way of
responding to Obote's ban. The rest of the series was filmed in Kenya, 151

with Mo prominent in location and camera work. Obote's political aim was to create a united republic by dispensing with the Kabaka, and abolishing all the other kingdoms within his territory. This was achieved after an horrific massacre in 1966. While the Kabaka was forced into ignominious exile in the UK – eventually dying a lonely death in a humble flat in the Bermondsey docklands of south London – Obote set about eradicating all other kingdoms within the territory. Although this was done under the watchword of 'One Nation, One People, One Parliament,' unsurprisingly it distanced him from the bulk of the people.

As he struggled to keep control of his country, Obote found himself relying more and more on the head of his army Major General Idi Amin Dada. It became clear that Obote's civilian administration could not continue effectively without the heavy-handed support of Idi's troops. For five years, Uganda limped along as the country became increasingly unstable. Obote's once-proud dream of a democratic country was now reduced to a brutal regime as he fought to quell opposition. Finally, on January 25, 1971, Idi seized his opportunity and took power in a bloody coup.

The news was delivered to Obote as he flew back to his country after a Commonwealth Conference in Singapore. His plane was diverted to Nairobi, where Jomo Kenyatta, who had little in common with Obote and no wish to invite adverse international comment, ordered him out of the country as quickly as possible. Mo got wind of the story and hurried to Nairobi's Panafric Hotel, where he had learned the deposed leader was ensconced, occupying the entire top floor. He filmed the intense security and several of Obote's ministers, but aggressive guards blocked his path as he tried to film the premier and his entourage leaving the hotel to catch a plane bound for Tanzania. Nonetheless, his coverage of the diplomatic furore made international headlines, despite Obote's only being in the country for five hours.

At the airport, Mo could only film the East African Airways Super VC-10 leaving Kenyan territory, a straightforward conclusion to the story. Behind the scenes, the situation had been far more sinister. Before take-off, EAA's Captain Colin Skillett had been given a terse briefing by Vice-President Daniel arap Moi. "You will fly them to Dar es Salaam."

Skillett: "And if Dar doesn't want them, do I bring them back here?"

Moi: "No! Take them anywhere but don't bring them back to Kenya."

Skillett: "And if I run out of fuel?"

Moi: "That's your problem."

On touchdown in Tanzania, Obote told pressmen: "There's no question of a take-over."

Mo knew the real story lay within Uganda and resolved to get there as soon as possible to film Idi taking the reins of power. He booked a charter flight, but the pilot would not risk such a trip without clearance from the Ugandan capital of Kampala – a reasonable request in the circumstances as Idi's troops had already shelled Entebbe Airport, killing two people and causing extensive damage.

An undaunted Mo explained what happened next. He said: "At the charter company, I booked a call to the Command Post in Kampala. I hoped I might be able to contact someone with authority to give me landing permission. Eventually, I got through and gave it my best shot. I said 'This is Mohamed Amin. Can I speak to General Amin?'" Mo was asked to hold on, then a voice came quickly on the line. "This is General Amin." Mo said: "I was knocked out. I'd got through just like that. I've always believed they thought I must be a relative. Anyway I wasn't going to waste an opportunity, so I said 'Sir, I am Mohamed Amin. I'm a news cameraman. I have just heard the news and I would like to come to Uganda now and record the events. Can you help me?'

"He said 'Yes, you are welcome in my country. Everything is fine here. The people are very happy that I have taken over.'

"I explained that we needed permission from Entebbe control tower. So he took the number of our plane and said 'That's OK, you can come and there will be transport to meet you.'"

The new dictator was as good as his word. When Mo's light aircraft touched down, it was met by soldiers who escorted the journalists to an armoured personnel carrier which took them on a sweltering 90-minute journey to Idi's command post in Kampala.

Mo recalled: "After a few minutes, this massive man, Idi, came out of a door and I started filming. Then, suddenly he said 'I'm sorry but I can't talk to you any more as Tanzania has just invaded me. I must go to the front line to command my troops.' And he disappeared."

After Obote's brutal regime, the giant figure – outwardly charming and seemingly benign – was like a godsend to Uganda. He promised deliverance from years of political oppression and the Ugandan people welcomed him with a warmth that only those who dream they have seen a saviour to lift them from despair can display. Tragically, that dream was soon to be exposed as a cruel illusion. Uganda was merely swapping one tyranny for another in a nightmare that would take years to resolve.

The international community was eager for information about this new head of state and Mo's footage of the unfolding drama was eagerly analysed for clues to the future of the benighted nation. The day after arriving in Kampala, Mo filmed Idi taking the salute at a military parade.

The event began inauspiciously when Idi's tanks failed to move and had to be bump-started. Then, when they rolled past the new leader, they threw up a huge cloud of dust which covered the VIP party. Afterwards, Mo spotted Idi climbing into the driving seat of a Jeep. Bold as ever, he asked him where he was going and was told he was off for a swim. As always, looking for an opportunity to steal a march on his rivals, Mo asked: "Can I come with you?"

Idi invited him to climb in the back of the Jeep and they drove to a hotel where Mo filmed the Ugandan leader cavorting in the pool. They were among the most famous images of a man soon to be seen as a brutal buffoon with an iron grip on power but a tenuous hold on reality. After the photo shoot, the two Amins chatted together for some time. The Ugandan took a shine to Mo and throughout his rule allowed the photographer free access to the country. Indeed, during Idi's last two horrific and chaotic years, Mo was the only cameraman officially let in.

In between, Mo was still working for the producers of *Search For The Nile,* who asked him to revisit Uganda for essential film of the Nile itself. He was accompanied by Tetley. In his book on Mo, published 17 years later, Tetley recorded what happened soon after they crossed the border.

He wrote: "We drove down a dirt road and suddenly seven armed soldiers ran out from beneath an acacia tree and blocked our way. One jabbed his rifle barrel at the door and ordered me out. As I opened the door, he cracked me across the head with the rifle butt and, when I stumbled, jabbed me in the ribs, knocked me down, kicked my knees from under me and put his boot on my chest. Then he pushed the barrel of his rifle against my chest and began squeezing the trigger.

"At that moment Mo, who had seen what was happening, came round the car and began shouting at him in Swahili. It did the trick, at least for me because the soldier turned on Mo and jabbed the butt of the rifle into his chest. He kept on talking and defused the situation until they eventually let us go. Later, I learned the soldier had broken two of Mo's ribs, but at least we were alive. I wanted to get the hell out of Uganda, but Mo insisted on completing the job."

Two days later at Murchison Falls, a game ranger told Tetley that State troops were massacring people in North Uganda. It seemed hard to believe, coming so soon after Obote, and given the hopes the international community placed in Idi. But the following night an Acholi tribesman working behind the bar at the local hotel took Brian and Mo to a backwater of the Nile and showed them the bloated corpses of hundreds of Acholi and Langi tribesmen who had been machine-gunned from the bridge over the Karumu Falls. Others confirmed the slaughter and Tetley's story ran

on the front page of the British Sunday newspaper *The Observer* on March 14, 1971. There were many who doubted the truth of Tetley's account, scarcely able to comprehend such barbarity, but he remained adamant. It was to be seven years before the whole horrifying story emerged and finally confirmed Tetley's version.

Uncharacteristically, Mo declined a byline. He knew that he would have to return and did not want his name associated with this, the first report of the real menace behind the mask of Uganda's clown prince.

His next visit to Uganda was not long coming. In June, 1972, Idi summoned his army to Tororo Barracks near the Kenyan border and announced he had been visited in a dream by God who had issued him with a divine instruction to expel the Asian population from his country. "Asians came to Uganda to build the railway," he said at a Kampala press conference. "The railway is finished. They must leave now." He gave them 90 days.

Mo flew to Uganda and filmed the sorry queues of Asians applying for passports at the British High Commission, the shuttered shops and For Sale signs and, on August 31, the first Ugandan Asians flying away from their home country for the last time.

The activities in Uganda sent shock waves through Kenya's Asian community, who could see only too clearly what the message spelt for them. Sure enough, in January 1973, the Kenya Government followed suit, setting a June 1 deadline for 418 Asian shopkeepers to sell up and get out.

The following month, Mo filmed the second of several interviews with Idi and covered a multitude of assignments for various news agencies, the most notable of which was the installation of General Gowon – the Nigerian head of state and victor of the Biafran War – as chairman of the Organization of African Unity.

Idi's eccentricities always made headline news and each time a story emerged from Uganda it seemed more disquieting than the last. In 1974, fearing for his life, Idi's foreign minister, Wanume Kibedi, fled the country and gave interviews which revealed yet more evidence of the dictator's unbalanced state of mind. Questioned on British TV by Ludovic Kennedy, Kibedi said that Idi had now awarded himself the MC. For the people of Uganda it did not stand for Military Cross. Instead, they claimed it meant Mental Case. Kibedi also promised that the forthcoming OAU summit in Kampala would be an 'interesting' occasion.

Before this took place, Mo filmed an interview between Idi and Canadian reporter Martin Burke in which the paranoid Ugandan leader voiced his anger over media coverage of his country, ominously blaming journalists based in Kenya. He rambled on about the US Watergate scandal

and a cable he had sent to President Richard Nixon wishing him a speedy recovery from his political troubles before approving Mo's suggestion of taking a tour of Kampala to prove his popularity. Without bodyguards, he walked freely among the people while Mo filmed it all. Bearing in mind Idi's capacity for revenge and the presence of security thugs, it would have been astonishing if any of the public had shown dissent.

Idi saw the forthcoming OAU summit, a lavishly stage-managed scenario, as an opportunity to enhance his international status. He did it in his own inimitable way. When Mo arrived, he was met by the sight of Idi wearing a colourful T-shirt depicting him in uniform adorned by all his regalia and medals. While the dictator beamed at Mo the photographer inwardly fumed, for the picture on the shirt was one he had taken. He had not given his permission for it to be used, neither had he received any royalties! Wisely, he decided to let it go unmentioned. The next two weeks took on the mantle of burlesque as Idi went through his repertoire of the unexpected and the outrageous, undeterred by the fact that Botswana and Zambia boycotted the summit, along with Tanzania, who called on fellow OAU members to condemn their host as a "murderer, oppressor, black Fascist and self-confessed admirer of Fascism."

On the eve of the summit, Idi was carried into a reception shoulder-high on a litter by a group of expatriate Britons, as a symbol of the role reversal in Africa: whites were now carrying blacks around. Later, in another publicity stunt, these same businessmen knelt before Idi to swear an oath of allegiance, a humiliating act which provoked outrage in Britain. Mo photographed the group gathered round the Ugandan leader reading from a prepared document. When these embarrassing pictures made headline news around the world, Mo was accused of faking the evidence. Independent examination swiftly vindicated the photographer.

On the second day of the conference, Mo was in the press room when he happened to glance at the telex machine rattling out information. He read a flash which revealed that General Gowon, the Nigerian President currently attending the summit, had been overthrown. Mo tore off the telex, crumpled it up and threw it away then went back to the conference room and began photographing the general.

He recalled: "I filmed him from every angle and while I was doing so his foreign minister went over to him and whispered in his ear. He got up and left and I followed him out and asked for a statement. He said 'about what?' and walked off. But I had the stills and film exclusive. Next day, after a brief press conference when Gowon formally announced he had been deposed, he made a discreet and dignified exit." Later that day, the

summit had a somewhat depleted air about it as other heads of state,

perhaps fearing a similar fate, returned early to their respective homes.

Unruffled by this turn of events, Idi carried on the show by celebrating his marriage to his fifth wife Sarah, a 19-year-old go-go dancer working for a band organised by members of his Revolutionary Suicide Mechanised Unit and his co-driver in his OAU car rally. The original ceremony had been private but, with a little prompting from cameramen pointing out the missed photo opportunity, Idi re-staged his nuptials in lavish style, lashing out £2 million on a sumptuous banquet. His bride wore full wedding dress, the guests included a host of heads of state and a gun-toting Yasser Arafat was best man. Idi cut the cake with a ceremonial sword.

The finale of the summit was a symbolic "Battle for Capetown" military exercise in which Idi's air force was supposed to strafe and bomb an uninhabited island on Lake Victoria – intended to represent the Cape – before his troops stormed the bastion to capture and destroy the hated South African flag. Predictably, it ended in farce when the bombers' aim was so poor they completely missed the island and came worryingly close to scoring a direct hit on the VIPs and guests assembled nearby. Farce turned to humiliation for Idi when the firmly-planted South African flag defied all attempts by his invading troops to uproot it. If some of the guests found it amusing, Idi did not. Incandescent with rage, he dismissed the head of his air force, Brigadier Smurts Guweddeko, the same evening. Guweddeko's body was found a few weeks later.

The summit over, Mo returned to Kenya, where he pursued a series of assignments and prepared a portfolio of pictures for a book and film for a documentary on the el-Molo, a crocodile-hunting tribe, living on the shores of Lake Turkana. But it was hard to keep Uganda off the front pages. With such chaotic leadership, the country was sliding inexorably into disarray and it was inevitable it would make headlines again, though few could have envisaged the spectacular way in which it occurred.

On June 27, 1976, Palestinian terrorists hijacked a commercial airliner and took it to the Ugandan airport of Entebbe. The Airbus had taken off from Tel Aviv on its way to Paris via Athens with 246 passengers and 12 crew. One traveller was 75-year-old Dora Bloch who was en route to her son's wedding in New York. At this time, Mo was in Mauritius covering the OAU conference at which Idi was due to hand over the reigns of office as head of the OAU to his successor Sir Seewoosagur Ramgoolam. As described in the previous chapter, Mo declined the offer of a lift in Idi's private jet and did not go to Entebbe, missing the Israeli raid on the airport and, more importantly, avoiding Idi's wrath at being so publicly humiliated.

By early 1977, it was becoming increasingly obvious to the outside world that the man once seen as the salvation of his plundered country, was yet

another capricious tyrant intent on hanging on to power at any cost. Torture and wilful massacre were commonplace. The smallest signs of dissent were crushed ruthlessly. Early in the year, thousands of Langi and Acholi people fled the country in the wake of purges which saw the tribespeople ousted from jobs, jailed or murdered. Idi's alienation from the international community was also growing by the day. Still fuming over his loss of face in the Entebbe raid, he launched tirades against his neighbouring countries in an arbitrary way which suggested serious mental instability. The East African Community collapsed and, in February, came the news that Ugandan archbishop Janani Luwum had been murdered just days after a confrontation with Idi. Soon after, the despot jokingly awarded himself the "CBE" to become the Conqueror rather than Companion of the British Empire. Then, in September, word leaked out about the fate of Dora Bloch who had gone missing during the Israeli raid on Entebbe.

A refugee from the dictator's clutches revealed that he had been one of a burying detail which dug graves for a policeman guarding the elderly lady. Both had been shot. Four days later, acting on a tip off, Mo traced Idi's former cook who revealed to the world that the Ugandan leader kept human organs and heads in his fridge. As more and more atrocities were disclosed, the world watched and waited for the inevitable. Nemesis was fast approaching.

It is hard to imagine that anyone could rival Idi's increasingly deranged and violent behaviour. Yet the following year, 1978, saw the Central African Republic offer up its own colourful character who, with his unique brand of shameful extravagance, briefly took the spotlight off the Ugandan dictator. Former French Army sergeant Jean-Bedel Bokassa was not content with simply being president of his impoverished, semi-desert country; he decided to crown himself emperor. Despite being leader of one of the world's poorest 25 countries, he determined upon a spectacularly lavish ceremony based on the imperial coronation of his hero, Napoleon, in 1804.

The inventory for this bizarre spectacle, which cost a quarter of his country's annual national revenue, was mind-boggling: 17 costumes worn at Napoleon's coronation; a 32lb robe for Bokassa containing 785,000 pearls and a million crystal beads, costing £75,000; a £32,000 gold and sequinned gown for his wife, Empress Catherine, and a diamond-topped crown, sceptre and diadem for the empress, costing £2.5 million.

Two hundred and forty tons of champagne, wines, caviar and flowers plus doves, a seven-tier cake, 60 Mercedes limousines, 30 Peugeot 504s and 150 BMW motorcycles, were all flown in at a cost of £1 million. All male guests were required to wear morning suits. The penalty for breaking

the dress code was to have an ear cut off. It was a story Mo could not miss, but it presented problems because the French, as former colonial masters, had used their influence and got there first. Mo said: "Being in Africa and not doing the biggest story around was just not on. I was determined to go, but when I offered the story to Visnews they said it was an impossible job because a French television company had exclusive rights and a French picture agency had exclusive stills rights. I decided to go anyway and AP took up the assignment. I didn't anticipate any problem with the morning suit because so many English people get married in them. But when I went round to my friends, no one could help."

After a fruitless search of Nairobi, Mo eventually borrowed a morning suit from the props department of the Donovan Maule Theatre Company and flew out via Douala in Cameroon to the Central African Republic's capital, Bangui. He was still worried about the dangers and protocol in this remote state, so he stopped off in Douala and went to the British Embassy. There, he was given a sombre warning.

Mo said: "We saw the British No 2, who spent the next half an hour telling us we shouldn't go there and the British Government would have absolutely nothing to do with us if we got into any trouble. He was a typical British diplomat who was informing us, in effect, that we were a nuisance and would be better off going home and should stop causing them problems. Naturally, that made me all the more determined to go."

Mo changed on the plane, as did the other three journalists travelling with him, much to the amusement of fellow travellers. He was in full gear when they landed in 35C(95F) heat.

Mo said: "When we came off the plane we looked absolute fools in morning suits and with cameras dangling round our necks. The immigration officials were falling about laughing so we had no problem getting into the country. Then we went to the Ministry of Information to get accreditation, but were told it was impossible as the French had all the rights.

"It was a tough situation. By now I was absolutely roasting but I couldn't get accommodation because all the hotels were full, so I spent the night in a church.

"Next morning, I went to the palace and just walked in. I think I got away with it because I was so well dressed. I hung around where the coronation was going to be and the French pressmen soon realised I was not just another guest taking shots for the family album, but a professional. They tried to throw me out and grabbed me by the shoulders. But at that moment trumpets sounded a fanfare and the coronation ceremony began, so they rushed to their own equipment and left me alone.

"During the scuffle I had been pushed against one of the French camera tripods which fell over. It was then that the emperor arrived and I started taking pictures. The French guys were desperate to get their camera working so they stopped hustling me. But that was one camera that didn't take any pictures of the coronation! Meanwhile, I got some excellent shots.

"After the coronation, Bokassa drove in his horse-drawn carriage to the church, more than a mile away. The route had been covered with a red carpet. But nobody had taken into consideration that all the following cars in the entourage would then drive along behind. By the end of the day, the carpet was in shreds and tatters. Later, at the church, we were kept well away from the emperor. I got fed up with that and towards the end, moved down to the front. The security men were very jumpy and grabbed me to throw me out. But Bokassa spoke to one of them, and after that I was left alone. I think he really enjoyed being photographed. I was only inches from him and got the best pictures.

"There were hundreds of security men about but I ignored them and, as the procession left the church, I walked backwards right in front of the emperor, using a 20mm wide-angle lens. He loved it.

"Later, after Bokassa had fled his country and gone into exile in France, I heard that human flesh had been served up at the banquet which I attended. I don't know what it was I ate but it tasted fine. At least it wasn't pork." After the ceremony was over, to the fury of the French agencies, Mo caught the next flight to Paris and then connected to London, where his pictures were sent across the world. Mo said: "My pictures were used by AP and by many magazines. It annoyed the hell out of the French. I reckon that was the most bizarre story I ever covered."

Bokassa was deposed two years later and charged with a catalogue of gruesome crimes. Among them he was convicted of murdering members of his army, poisoning his grandchild and participating in the killing of 50 schoolchildren who had refused to wear uniforms to school. He was investigated on suspicion of cannibalism but insufficient evidence was found to prove the charge. At his trial in 1987 his cook came forward to testify that the emperor had kept corpses in a deep freeze and on one occasion had been asked to serve one to Bokassa.

From Central Africa, attention turned to Zaire, where Shaba Province – formerly Katanga – was waging a secessionist war of independence. The area was mineral-rich and provided much of the country's natural wealth. The people of Shaba, situated in the extreme south-east, wanted to form their own nation. For 10 days, Mo travelled that vast country, recording the devastating results of the internecine war, before returning to Nairobi. Soon afterwards he was unanimously elected chairman of the East African

Foreign Correspondents' Association, a position he was to hold for the next five years.

It was not long before Uganda beckoned again. With his usual unpredictability, Idi invaded Tanzania. Whatever his motives – and one might have been to deflect attention from the parlous state of affairs within his own boundaries – it was the beginning of the end for one of the continent's most ruthless men. Julius Nyerere, who considered Idi a Fascist, responded by sending his troops into Uganda, in what became a six-month-long struggle that finally brought down the despot.

Tanzania had at first only intended to respond to Idi's aggression with a tit-for-tat incursion. But it soon became clear that here was a chance to rid East Africa of the tyrant once and for all. With superior numbers (swollen by rebel Ugandans) and superior arms, Tanzania swept across the country. Then the vital towns of Masaka and Mbarara fell to the invading forces and, though Libya gave Idi some help by sending 2,000 troops, it recognised the inevitable and stopped short of wholehearted support. By April, Nyerere's troops were on the outskirts of Kampala.

Mo and his Camerapix team regularly flew in and out of the country, bringing the pictures to TV screens across the world but, when the fight reached Entebbe and Kampala, no one could get in. Mo felt certain the two cities had been taken but, with communication lines out, the situation remained unclear. To steal a march on the other journalists by then gathering in Nairobi, Mo took the calculated risk of chartering a plane and flying in with the BBC's Africa correspondent Brian Barron and Eric Thirer, BBC camera-soundman in Nairobi.

But finding someone willing enough and, perhaps, foolhardy enough to fly into a war-torn country was not so easy. Mo began by trying all his usual contacts. Each one refused saying the risk was too great. Mo said: "I tried all the charter companies but they didn't want to know. We persevered and eventually, on April 13, I met Dick Knight, a veteran pilot who runs one of Kenya's largest air charter companies at the Dambusters Club at Nairobi's Wilson Airport. He said he was interested. From experience, I told Dick that the difficult part would be getting down. If he could get us on the ground, I felt we would have a good chance.

"He asked me what I thought they might do and I said the worst case situation was that they might shoot us down before we landed. We knew there had been major battles around the airport between the Tanzanians and Libyans supporting Idi Amin. Dick said he wasn't worried about the Tanzanians killing us as they couldn't shoot straight, so it would be OK! He was more worried about what would happen after we landed, but I told him if we got that far he could just leave us there and take off again.

"When we had sorted out the flight I went back to my office to finalise my equipment and to phone a contact in Dar es Salaam for help. He told us we were mad to even attempt to go in and they would shoot us out of the sky."

They had no way of knowing what sort of reception they would get and Mo later recalled the tension on the flight: "We flew in absolute silence. It was a big risk, but we had to take it. We had to gamble on the attacking forces having taken over. If we went in and the losing side were still fighting, it would have meant almost certain death. We didn't even know if they would shoot us out of the sky or not when we landed." Barron never forgot the deathly hush and stifling atmosphere of anxiety. He said: "I'm not sure exactly who was on board now but I remember how scared we were. You could have cut the atmosphere with a knife."

Thirer, too, recalled: "We just didn't know what to expect though we had a pretty good idea of what would happen if we had made the wrong decisions. But it was a great story because it was a time of such transition."

They had every reason to be worried. Only weeks previously, Ugandan forces had killed four Western journalists covering the war. Mo said: "In a situation like this we knew that if we encountered the wrong side these guys would just chop us up. There was no way they were going to leave us alone. The last thing you want is to be filmed while you are losing a war."

While the trip was fraught with danger, it was not a reckless move. Yes, it was risky, but he had calculated all the odds and knew he was probably going to be OK. In the event, they touched down at Entebbe to find a gala reception committee waiting. Mo said: "It was amazing. This was not a war situation we had flown into. There were tribal dancers and a line-up of Tanzanian dignitaries – a welcoming party." But it was not for them.

Mo said: "I was first out of the plane and you could see the shock on their faces when they saw who we were. There was a former prime minister of Tanzania, a former minister of defence and the commander of the Tanzanian army. I thought 'Oh shit! We've done it now'."

Mo piled on all the charm he could muster while the welcoming party went into a huddle to discuss their fate. Minutes later, while the authorities were still discussing what to do with them, another plane flew in carrying the real VIPs, including Yusuf Lule who was to be sworn in later that day as the new Ugandan president. There was no time for Mo and his men to be dealt with, so they followed the party and filmed the presidential ceremony on the steps of Kampala's Parliament Buildings.

Afterwards, the three newsmen toured the city. It was a gruesome business: bodies littered the streets, shops had been looted and everything was in a state of chaos. Mo and Barron then took advantage of the

opportunity to investigate on-the-spot rumours about the evil nature of Idi's regime. In so doing, they became the first outsiders to uncover the brutality which had kept the increasingly deranged Idi in power. They discovered that the premises of the State Research Bureau had become a torture chamber from which no one, save the inquisitors, ever left. Mo also found suitcases full of files containing written evidence of the activities of the state of terror.

In the ensuing days, Mo travelled widely in Uganda filming the aftermath of Idi's downfall, but one person was missing from this story – the great dictator himself. Whilst urging on his troops, accusing them of cowardice and claiming to be in charge of 90 per cent of the country, Idi was in fact making preparations to flee. He co-ordinated his escape from his favourite red TR-7 sports car, moving rapidly around the country, eventually quitting his luxurious villa beside the shores of Lake Victoria and moving to the eastern industrial town of Jinja. As he put the finishing touches to his escape plan, the country was virtually in control of the Tanzanian liberators. Nonetheless, the Ugandan people were, from time to time, treated with broadcasts from their leader who used a mobile transmitter to berate the invaders. In one English language transmission he told the country: "I would like to denounce the announcement that my government has been overthown. This is not true." Hours later, Idi took a helicopter to freedom. He remains at liberty.

He left behind a grim legacy. About 2,000 loyal troops had rallied to his side in Jinja and, after he departed, they ransacked the town and surrounding countryside in search of anything from food to medicine to women. Senior figures associated with the absent dictator hurriedly gathered their ill-gotten wealth and headed for the Kenyan border. Prominent among them was Colonel Nassir Abdalla, governor of Kampala. He led a posse of refugees who moved into Kenya in a convoy of 20 Mercedes and 40 trucks full of plunder. Most of the refugees – about 80 per cent – were Nubians, a tribe from northern Uganda who had remained loyal to Idi. They began the rigours of exile in Alfa Romeos and Peugeots. The less fortunate arrived carrying their worldly goods on wheelbarrows and hand-pulled carts.

During this time Mo and his team came across a Tanzanian soldier near the border who had 'acquired' a shiny new bus. Nearby was a conspicuously empty showroom. Mo said: "The conclusions were obvious but these were strange times and we didn't push the matter, especially as we wanted a lift to Jinja. The driver said he had no petrol, so I made a deal and offered to take the bus back across the border to Kenya and fill it up with petrol if he would give us a ride to Jinja. He agreed, but insisted he

came along in case we 'stole' his bus. He had to leave his gun at the border post, but otherwise the arrangement worked. At Jinja, we filmed Tanzanian troops taking over the airfield and then went to investigate State House where Idi had been staying. There was an elegant carving of a large wooden eagle which I admired, so our driver decided to 'acquire' it. We put it in the back of the bus and back at the Kenya border town of Busia our obliging soldier handed it to me as a gift." The eagle was duly hoisted aboard their plane as they set a course for Nairobi.

It was a flight Mo never forgot and which almost ended in disaster when the pilot diverted to Nakuru to refuel and overshot the runway. He recalled: "As we came down I could see us flying past the control tower and thought 'We're never going to make it.' The main Mombasa-Kampala road lies at the end of the runway and I could see these two huge trucks driving right into our view.

"We touched down but then the pilot realised he couldn't stop in time and tried to take off again, which was worse because there were power lines across our path. I really thought this was the end. Finally we slammed into a stone dyke, the plane spun and folded up. I opened the door and threw myself out followed by the others. The pilot was last. He ripped off his epaulettes and threw them to the ground saying 'That's it. I'll lose my job.' I said 'Bloody right you'll get the sack. I'll make damned sure of it.'" Today, standing sentinel over the dining room of Mo's home in Nairobi is the large wooden eagle. It has a slightly textured look, poignant testimony to the one flight it made which had a singularly unhappy landing.

During this chaotic time, one story had been playing on Brian Barron's mind –the whereabouts of Idi. Barron could not dismiss the spectre of the Ugandan rogue and the slick way he had evaded capture after his downfall and approached Mo about finding him. The two men discussed the possibility of tracking him down.

Mo quickly accepted the challenge, for he also felt irked by Idi's disappearing act and viewed the success of the tyrant's escape as an affront to his professionalism. No one was allowed to compromise that, and he determined to track the dictator down. Mo made discreet enquiries. He delved into his invaluable contacts book, made phone calls, followed up clues, hints, tips and rumours, until he began to get feedback and locked on to the elusive ex-dictator's trail. It was known that after the Big Man left Jinja, he went to Libya, staying as a guest of the Libyan leader, Colonel Muammar Gaddafi, in a large house outside Tripoli. But such a low-key existence did not suit his flamboyant personality and he moved on.

Since then there had been no positive sightings, but strong indications suggested Idi had finally gone to ground in Saudi Arabia. Further probing

confirmed that he was living with his family in the city of Jeddah, but that was as far as the information went. It was enough for Mo. He felt that if he could get into Jeddah, he could track him down Idi.

Barron explained: "I came up with the idea and Mo seized on it. We had a fair idea that Idi was either in Libya or Saudi and I felt a Muslim journalist was essential on this story. I approached Mo and he was very keen. There was no written agreement. We shook hands on it and kept in touch all the time. He did all the work tracking Idi down and, after an exhaustive series of checks, found him in Saudi." It was clear this would be an expensive venture, so Mo turned to Visnews for backing. Newsroom executives showed enthusiasm but management was hesitant. Visnews eventually came onboard although expressing doubts over BBC involvement. Even at that stage, the signs of an uneasy alliance were evident. Mo had some misgivings; he had worked with the BBC in the past, only to see credit for his exclusives claimed by the corporation. In the end, the story's potential overwhelmed all doubts, written terms were agreed and the project got under way.

Mo, Barron and Thirer flew from Nairobi to Jeddah on May 28, 1980. They entered the country separately and incognito, for Saudi Arabia had banned foreign film crews and was not noted for its tolerance towards transgressors.

Mo had added professional surveying equipment to his cameras, which he now broke into pieces and shuffled around his luggage, while Barron carried through a vital 20 rolls of Eastman colour negative. To Barron's despair and frustration, however, suspicious customs officers took the film from him after he landed, though they gave him a receipt in exchange. This was a major blow to the expedition; without film there was no story. It was the kind of situation in which Mo revelled. When all the odds were stacked against him he would respond rapidly to the challenge with a combination of raw instinct and seasoned experience.

Quickly, he got to work. He contacted a Visnews production division colleague in Riyadh, who gave him the name of a Jeddah photographer. Somewhat worryingly, the photographer worked for the ministry of information and it turned out he could not help anyway.

Mo remembered: "I was getting desperate but decided I had better search for Idi in case I got lucky with the film in the meantime. So I hired a car and got chatting to the driver who was a Pakistani. By a stroke of good fortune, he knew of Idi and confirmed that he was in Saudi and often went to pray at the Holy Mosque in Mecca, the biggest mosque in the world. I got him to drop me there and went in. It was Friday, the mosque was full – it holds half a million people – and I was looking for one man. 165

"This was a classic needle in a haystack situation, but just when I was beginning to despair I got lucky. I saw one of Idi's bodyguards. He recognised me and we chatted. It turned out I had only just missed the Big Man, so I asked the bodyguard if I could pay my respects to him. He told me to give him my phone number and he would pass it to Idi."

Back at the hotel, a call came from one of the dictator's sons who said he would take Mo to see his father. Meanwhile, Mo's Visnews colleague had phoned with the news that the ministry photographer had reported Mo's presence to his superiors and had been summoned to the minister to explain what was going on.

Now Mo felt obliged to reveal his mission. The Visnews man, who was in Saudi trying to clinch a million-dollar government contract, was outraged. If Mo's true intentions were revealed, the contract would be in jeopardy. He gave Mo an ultimatum: quit the country by nightfall or face arrest. Mo was running out of time and still had no film. On the off-chance, he called at Kodak's Jeddah branch. They didn't stock Eastman colour negative but, by yet another stroke of Mo's luck, the manager told him a customer had ordered 20 rolls then left the country before they had been delivered. Mo bought the film for less than he would have paid in London, a minor triumph but one he enjoyed immensely.

The minutes were ticking away fast. Idi's son called and took Mo to meet his father. It was a nervous time for Mo. Idi's mercurial mood swings were legendary and Mo had no guarantees that the Big Man would not throw him out. There was a brief moment when Mo thought his gamble had not paid off and he was faced with the thought of returning home empty-handed. But suddenly, as he looked up, there was the Ugandan dictator smiling a welcome. Mo knew he had cracked it.

There was a traditional reunion, an embrace and then tea, but NO interview. Idi explained he was a guest of the Saudi king and therefore reluctant to compromise his hospitality. Outwardly calm, Mo talked to Idi for hours, gently wearing him down, praising him, telling him how his countrymen felt let down that he had not spoken to them since leaving. Finally, in the early hours, the Ugandan agreed to a 'one minute' interview on camera. Mo's forceful eloquence had paid off again. Barron said: "He was always like that – he could persuade all kinds of people to do things they didn't want to do."

Mo dashed back to his hotel, collared Barron and Thirer, hurried back to Idi's home and started the interview. Of course, once the dictator warmed to his theme he kept talking for more than an hour, giving the team a world exclusive. Now all they had to do was get it out of Saudi.

They went straight to the airport, where Mo hid the film in his suitcase

and checked in for London while Barron went to collect the film held by customs. Thirer took a separate flight. Next morning at Heathrow, Barron requested the interview footage. Mo hung on to it, pointing out that it was Visnews property. He drove straight to the Visnews lab, where the film was processed immediately.

Later that day, the BBC issued a press release detailing how, in a joint operation with Visnews, Barron had tracked down and met Idi Amin. It was described as an exclusive interview and did not mention Mo. He was furious, but the last straw came when that evening's papers carried the story of Barron's 'scoop.'

Visnews protested, but Mo did more. He went to a BBC press conference organised to maximise Barron's 'exclusive' and threatened to disrupt it by revealing the true sequence of events unless he received due credit. That night, before the footage was shown, the BBC ran pictures of Mo and Barron introducing the film.

Barron recalled: "It was a bloody good news story and we all did well. I remember when we turned up at Idi's house, the Saudi bodyguards freaked out. But Idi told them to calm down because he was a guest of the king, and after that it was OK. What is important is that Mo and I did not fall out over this story. We, as operatives, remained good friends. Like everyone else with Mo, I had blazing rows with him. The problem in this case was that the BBC shamelessly hyped my role in it all. Let me make it quite clear; he made it possible and he did all the hard work."

Barron worked with Mo on and off for the five-and-a-half years he was in East Africa. He had met him in 1975 when he was BBC's Far East correspondent. A year later, he moved to Nairobi and until 1981 was the corporation's Africa correspondent and regularly teamed up with the cameraman. They went into Uganda several times and Barron was on the plane that flew first into that country following Idi's overthrow. Despite many clashes, he admired Mo. He said: "He was a superbly gifted photographer and a towering figure in Africa who carved out his own visual niche. I felt entirely positive about the guy; he was a straight-on-the-chin sort of person and you knew where you stood with him. He was also absolutely fearless."

In July, 1982, for the last time in his life, Mo visited Idi again in response to a request by Britain's *Sunday Express* newspaper to complete a "Where Are They Now?" series. Inquiries revealed that the ousted dictator had moved house in Jeddah and, arriving at the airport, Mo again faced the prospect of a possible fruitless search. Yet again, he was saved by his incredible luck. As he stood outside the airport a hotel bus pulled up beside him, and the driver said: "Remember me?" It was the same Pakistani who

had helped him on his previous trip. He knew Idi's new address and took Mo straight there.

The cameraman said: "There were guards on the door but they recognised me and let me in. I went into the house and saw Idi's children watching television. I asked if I could see their father and soon after he came downstairs and greeted me like a long-lost friend. I stayed talking with him the whole day.

"He gave me a long interview which I recorded on his tape-recorder but he wouldn't let me take any pictures. As I left, he asked me to return the next day. When I went back, I took a map of Uganda I had brought with me, and now he became very interested. At that time Obote had attacked the country, and Idi wanted to know all about Tanzanian troop movements.

"I hadn't got a clue but I thought 'What the hell!' So I said 'Oh, there's a battalion there, a brigade here and a few companies over there.' I just pointed anywhere. I thought, if he's planning to attack Uganda on my information, he's got a real surprise coming. But now he let me take some pictures."

Mo returned to London, handed over his interview and rolls of film to the *Sunday Express* and caught a Kenya Airways jumbo back to Nairobi on the night of July 31, a date long to be remembered in Kenya's history as the time that the country's air force attempted to take over the country in a coup.

Those were busy times for Mo, perhaps the busiest of his career. His coverage of the Ethiopian famine and its consequences took up months of 1984, and in 1985 he travelled internationally to accept acknowledgement of his part in highlighting the tragedy. In November, he was in the US to receive prestigious awards and spent some days enjoying the fruits of universal acclaim. But work was never far from Mo's mind and, two months later, he was hard at it planning a further trip to Uganda.

Since the fall of Idi, hapless Uganda had undergone a series of political upheavals which left it enfeebled and prey yet again to unscrupulous power seekers eager to milk the time-honoured culture of graft, greed and nepotism. After the euphoria engendered by the Tanzanian liberators of 1979, too soon it became clear that old tribal differences could not be eradicated as swiftly as some might have hoped and the ethnic cleansing which had gone on then for some two decades continued. In an attempt to fill the glaring power vacuum, Yusuf Lule was appointed president. His tenancy lasted a scant two months before he was followed by Godfrey Binaisa who, in turn, survived only 11 months before being toppled by a military coup. The military announced that elections would be held at the

end of September, 1980, giving the chance for that seasoned opportunist and gambler Obote to return to the political fray. Astonishingly, despite his past excesses, he won the election by a hefty – if questionable – margin, backed by an army under Major General Tito Okello. Poor Uganda! In weeks the country was riven by chaos and bloodletting as Obote avenged himself on those who had supported Idi, and Okello's uncontrolled troops were given licence to loot and slaughter.

Desperate to save the country he loved, Yoweri Museveni, who as the head of the Uganda National Liberation Army, had fought in support of the Tanzanian invaders, launched a long and bloody bush war which led to Obote's second downfall after he consistently refused to negotiate with the guerrillas. Okello was sworn in as president in July 1985, but, though he signed a peace agreement with the rebels, it was apparent that nothing could stop the march of Museveni's new order under the banner of the National Resistance Army. As the old year bowed out and the new year dawned, the NRA held increasingly large swathes of the country. With his impeccable contacts and raw instinct, Mo sensed that Kampala was about to fall and, in January 1986, he made his move.

Getting into the country was no easy matter, for the border between Kenya and Uganda was closed. Mo chose a suitably obscure route across Lake Victoria, into Tanzania and then into Uganda. It was a journey which would have been prohibited to most people because Tanzania had also barred entry. Mo went back to the contacts book, made a call to President Nyerere's press officer and secured permission to touch down in Mwanza and Bukoba.

Guided by his maxim that 'in war there are plenty of vehicles but no fuel,' he took the precaution of carrying 200 litres of petrol. After a flight over Lake Victoria to Bukoba, Mo struck lucky when the driver of a pick-up truck took him and his crew – including Wooldridge, Michael Rank of Reuters, Willetts and Mo's cousin Mohamed Shaffi – from the airport into the town. More through luck than judgment, the party met a senior civil servant for the area who offered them transport but had no fuel. Mo's pre-planning paid off; they filled the vehicle with his supplies and drove to the Uganda border. There, they met one of Museveni's army chiefs, known only as Commander Fred, who instructed his driver to take them to Kampala.

Next morning, they arrived in time to film the triumphant entry of Museveni into the city. Other news crews had driven to the Kenya/Uganda border, where they could only view events from the wrong side of the wire. Mo's exclusive film was sent by satellite to the Eurovision network and, via Visnews, to 500 million homes around the world. His entire and

somewhat circuitous journey had taken less than 40 hours.

The return from Uganda was another example of Mo creating his own luck. He had the temerity to ask Museveni if Entebbe airport was clear and if any planes were available. Even Mo was slightly surprised when the new president-elect assigned a senior officer to the party with orders to do everything possible to get them back to Nairobi that day.

They drove to Entebbe past the last scenes of sporadic fighting between loyal troops and Museveni's NRA and arrived at the airport as the Resistance Army took it over. Minutes later, a plane carrying vital medicine for the UN approached and was being refused landing permission when Mo's 'minder' countermanded the order, allowed the plane to touch down, and told the pilot to take the cameraman and his triumphant crew back to Nairobi.

Above left: Wallowing warthogs improve their complexions with a mud bath.
Left: From Mo's Turkana portfolio: el-Molo youths bring ashore two Nile perch almost as big as themselves.
Above: Balletic dolphin leaps from the azure waters of the Indian Ocean.
Previous page: Watchful Grevy zebras on the plains beneath the snow-flecked peak of Mount Kenya.
Overleaf: A twilit tortoise silhouetted against a breath-taking African sunset, made a stunning study for Mo's wildlife collection. Inset: Lappet-faced vultures provided Mo with an unusual composition.

Above: Oryx in unicorn pose shuns a young elephant at a drying water hole in Namibia. Inset: Distinctive markings and graceful horns identify an elusive bongo.

Overleaf: From an unusual vantage point in a handy acacia tree a cheetah spots its prey, against a background of Africa's highest peak, Mount Kilimanjaro. Inset: Ever-watchful cheetah family on the look out for lunch.

177

Above left: Massive flock of flamingos make a pink snowstorm as they take flight.
Left: Eponymous Bird Island in Seychelles is the breeding ground for thousands of migrating species.
Above: Shimmering landscape of flamingos in a spectacular aerial shot.
Overleaf: On safari with his family in Tanzania, Mo came across this extraordinary scene - an African python suffocating a fully-grown Thompson's gazelle, by crushing its chest. They watched for hours as the snake, by unhinging its jaws, completely swallowed the animal.

Left: Open wide! A cheetah and a baboon show why they are at the cutting edge of East Africa's wildlife.
Above: Lithe leopard demonstrates its agility.
Overleaf: Double take! A pair of reticulated giraffe in elegant harmony.

185

THREE'S COMPANY

'There was nobody I would rather have

been with in a dangerous situation'

GRAHAM HANCOCK, AUTHOR

ANYONE FOLLOWING Mo's career will know how closely his life was interwoven with those of his two friends and colleagues, Brian Tetley and Duncan Willetts. Together they formed a triumvirate which produced a phenomenal volume of high-quality work, putting Mo's company Camerapix at the forefront of African and international media companies. In the early years, Mo concentrated almost entirely on news, expanding from stills to cine as his experience grew. He met Tetley in Nairobi in 1969 and Willetts eight years later. After they joined forces, Camerapix gradually expanded to include publishing and, largely through Willetts, to studio and broader-based commercial work (though Mo drew Willetts into the news forum whenever he could).

In many ways, Tetley and Mo were chalk and cheese, but they worked well together, each tacitly acknowledging the formidable talent of the other and just as frequently lambasting each other as 'a complete bastard.' Tetley had an awesome appetite for his favourite warm Tusker beer. But this was more than matched by a genius for the written word – graphic and rich in imagery for his extensive work in Mo's many publications, and sharp, accurate and precise in his coverage of news events.

Tetley was born in Birmingham and went to school in Solihull before beginning his career as a copywriter at an advertising agency in 1951. He

soon moved to mainstream journalism and during his lifetime was an editor on no less than 13 occasions, was an editorial director three times and consultant to many august publications. He was a hard news reporter, feature writer and investigative reporter with many newspapers, winning awards on several occasions. A veteran of Fleet Street, Tetley caught the Africa 'bug' early in his career and moved to Kenya in the 1960s, becoming a citizen of Kenya 20 years later. Indeed he often told people that he was "born in England, but made in Kenya." Like so many creative people, he was a maverick, whose chaotic private life led him into a riot of marriages, romances, bar-room scrapes and the occasional night in the cells.

Where Mo was a paragon of punctuality and sobriety, Tetley – once described by the *Baluchistan Times* as a "reputed personality" – was notoriously unreliable, sending the photographer into apoplexy when he went walkabout at a crucial time. I can testify to his idiosyncrasies, for I worked in the same small office with him for two years.

There were frequent temper tantrums, typewriters thrown, cups smashed, phones ripped out – all too often done in hangover extremis or through an alcoholic haze. There was no middle course with Tetley. He was a peaks-and-troughs man whose life graph ran like an AC/DC current on overload. The highs were exhilarating, for he had a wonderful sense of humour, and could convey it as well by the written word as he could by holding an audience spellbound with one of his vast range of entertaining anecdotes. The lows, when the black dog was on him, were dark times. He might disappear for days, and then a stream of women would lay siege to the office, demanding his head, his money or both. Stories of Tetley's antics are legendary. John McHaffie recalls one occasion when he was changing for a cricket match and took off his shirt to reveal a livid rash all over his torso. He said: "I was really worried. I knew what kind of a lifestyle Brian led and thought he might be seriously ill." Tetley nonchalantly shrugged off the enquiries explaining that he had been staying in a house with no running water and had bathed that morning at a standpipe using coarse industrial strength washing powder.

On another occasion, Tetley was wending his way home through the less salubrious back streets of the capital when a mugger leapt out from the bushes demanding money. Ever persuasive, Tetley convinced his would-be attacker that he was penniless, and instead took him home for a beer and a sandwich. The man stayed for four days. Willetts was less than amused when Tetley single-handedly put back the launch of Kenya Breweries' new Premium lager beer. Willetts had been given the only case of the brew, complete in its new livery, for promotional photography. During his lunch break, Tetley wandered into his studio, saw the open case as an invitation

and drank the lot. Willetts was enraged when he returned and would have assaulted the errant writer, but Tetley had sloped off into the welcoming anonymity of Nairobi's urban jungle, to remain discreetly absent for several days.

When Mo planned his expedition around Lake Turkana in 1980, Tetley was seconded as author. It promised to be a hazardous safari and the writer, who occasionally displayed an engaging timidity, did not want to go. But the parlous state of his finances dictated otherwise. The evening before they were due to leave, Tetley took solace in women and drink, a fatal combination which resulted in a bad beating causing him bruising, a black eye, cuts, abrasions and a set of broken false teeth (the same teeth ended up in a gutter on London Bridge years later, but that is another story).

He was taken to Nairobi Hospital, where Mo found him the next day. The cameraman suspected this was all a ruse to avoid the journey so he returned to the hospital at midnight, dragged Tetley from his sick bed, bundled him into a Land Cruiser with the rest of the safari team and headed for the open road. But the heavily-laden vehicle rolled, spewing safari equipment and people all over the road. No one was badly hurt but the hapless Tetley was shaken up and collected yet more cuts and bruises. While the vehicle was being repaired, Tetley hitched a lift back to town and readmitted himself to Nairobi Hospital where he quietly returned to the same ward and same bed as before. Medical staff were completely mystified as to how their patient had acquired more injuries overnight. Not surprisingly, they refused to accept Tetley's unlikely explanation.

During his Kenyan career Tetley contributed to virtually every local publication, turning out features, news stories and columns with a brilliance and brio hard to rival. When not at his desk he was often to be seen at the Sans Chique bar behind *The Nation*, quaffing warm Tusker and holding court. Two years before his death, Tetley returned to Engand where cancer of the colon was diagnosed. A subsequent operation proved successful and, for a time, he worked for the soft-porn newspaper, *The Sport*, writing the leaders in the morning and editing the sex letters in the afternoon. But Mo and Kenya beckoned and he returned to Africa. It says much for his popularity and respect that, when he died, more than 600 people of every age and colour attended his funeral. Friends placed two symbolic bottles of Tusker in his coffin with him.

Willetts first met Mo in 1976 in Juba, the capital of southern Sudan, when he was filming a piece on the integration of the two armies after the conflict between the Muslim north and the Christian south. The two got on well and Willetts, who was coming to the end of a contract in Sudan, asked about work in Kenya. Mo told him: "If you get a work permit it will

be OK. You can come and work with me." A year later, the photographer walked in to Mo's Nairobi office waving a permit, saying: "Now, about that job..." True to his word, Mo took him on to run the burgeoning Camerapix studio – an aspect of photography Mo had never really enjoyed – and the relationship grew to one of deep mutual respect and close friendship though, as with many of Mo's colleagues, it was not without its difficulties.

As Willetts settled in, he broadened his work base to encompass news, wildlife and travel. When he combined with Mo and Tetley to produce one of their many publications, they were a formidable force unrivalled in their field. In a portfolio of some 40 titles produced by Camerapix, Tetley either wrote or edited the text of nearly every one, and Mo and Willetts took virtually all the pictures.

Producing the book *Journey through Pakistan* became a particularly important project for Mo. He went to Pakistan in 1980 to film a documentary about the Aga Khan's architectural awards in Lahore, having flown in on the Ismaili leader's personal jet. As Mo's parents were now settled in the country – and since his last visit had ended in arrest and deportation – he decided it was time to establish friendly relations with the new military regime of President Zia ul Haq.

Accordingly, he took with him two large photomurals of Mecca and Medina to present to the head of state. Mo managed to grab a minute of the president's time, which extended into a long conversation over countless cups of tea. Finally, the president asked him: "Would you do something for my country? I would like you to produce a book about Pakistan."

Charged with this duty, Mo enlisted the talents of Willetts and writer Graham Hancock, later to become a best-selling author. Together, the three spent several months travelling Pakistan, photographing the people, plains, wildlife, deserts, and mountains, including K2, the world's second highest mountain. With Zia's impressive backing, all doors were opened to them and facilities and support willingly provided.

Hancock remembers his association with Mo as a seminal point in his career. He said: "I first met Mo in 1979. I was editing a magazine called *The Traveller* and Mo had sent in a piece on Lake Turkana, which I used. We got on well and he invited me to come and work with him in Nairobi, which I did in 1981. But the arrangement didn't work and, to be honest, I think Mo screwed me, so we dropped the partnership deal but still worked together on several projects and remained friends for the rest of his life.

"Pakistan was a revelation for me. I worked with Duncan and Mo and we became very close. I spent four weeks travelling with Mo through northern Pakistan and got to know him really well. Up to this time I had

travelled a lot but had never written a book. Mo taught me so much about making and producing books and working successfully in the field. He was up before dawn and worked all through the day."

One day, in a remote part of the country, they stopped to photograph a woman washing in a stream. What began as an innocent exercise almost ended in tragedy when the woman's husband arrived. He clearly viewed the situation as an extreme violation of his domain. Hancock explained: "Mo was taking pictures when this Pathan tribesman turned up wearing a large sheepskin coat with his arms folded beneath it. Mo turned to me and said quietly 'This man has a gun hidden beneath his coat and he is going to kill us. Don't make any sudden movements. I will try to talk him out of it.' When I looked into the man's eyes, I knew Mo was right. And that's what he did. He talked and talked and gradually the tension lifted, until the man opened his coat to reveal a loaded and cocked revolver. In the end, he became the best of friends with the man but I have no doubt he would have shot us. Instead, he put the gun back on safety and the crisis was diffused. It was a perfect demonstration of what an operator Mo was in the field. There's nobody I would rather have been with in a dangerous situation. He always knew what to do and how to do it."

The result was a book of visual beauty and compelling text which was critically acclaimed and earned Mo the personal thanks of Zia ul Haq. Shortly after the book's publication in 1982, Mo received a communication from the cabinet secretary in Islamabad notifying him that the president had decided to confer on him the award of Tamgha-i-Imtiaz, Pakistan's second highest civilian honour, ranking with a British knighthood.

Mo did not find out about the award immediately for he had dashed off to Beirut, where he was back at the frontline again after the 1982 Israeli invasion of Lebanon. This was a three-week assignment, principally to give his Visnews colleagues in the war-torn Lebanese capital a much needed break. Mo came under fire regularly and survived a bomb blast that removed the top floor of his hotel.

In the whimsical way that news trends occur, Visnews became less focused on events in Africa and turned its attentions elsewhere in a troubled world. This meant leaner times for its Africa bureau chief whose company depended substantially on a flow of work from the agency. Mo's financial arrangements with Visnews were complicated. David Kogan, a managing editor there for nine years, described the set-up as a 'curious commercial situation' but because of the nature of the beast (in this case Mo) it was a set-up that worked.

Kogan said: "You have to remember that Mo was our most successful operator. He was a mogul in his own domain and it was better to reach an

191

accommodation with him than to cause a problem." Nonetheless, Mo's workload for Visnews at this time diminished, so he turned his attention to his burgeoning publishing career. To put the finishing touch to his Turkana book, *Cradle of Mankind,* he needed aerial shots, an expensive but necessary exercise. Fortuitously, British explorer Colonel John Blashford Snell was running an Operation Drake Outward Bound venture to Sibiloi National Park at the time and part of his transport arrangements included the use of an old single-engine Beaver aircraft. As Mo was reporting on Blashford Snell's project, which involved taking youngsters from all over the world to out of the way places, he was able to requisition the 33-year-old plane and employ it to take aerial shots for the book.

The hapless Tetley, who was terrified of flying, was recruited for writing purposes and, together with the two pilots, he and Mo took off on what should have been a fairly routine journey. But as the plane slowly crossed Lake Turkana with Mo hanging out taking pictures, the engine coughed, spluttered and fell silent.

Later Tetley recalled: "We drifted on in ominous silence with only the sound of the slipstream. I was terrified. I've always hated flying and this situation scared the hell out of me, especially as I could see the pilots anxiously twiddling with every switch and button on the instrument panel. Mo just hung out of the window and went on filming as if nothing had happened."

Eventually, by the highly technical method of 'wing-wiggling,' the two pilots managed to persuade fuel into the errant engine and restart it, only for it to die again as they came in to land. The spluttering bone-shaker startled a herd of zebra as it came low over the land and Mo nonchalantly captured the moment on film, using the panicking animals as a two-page spread in his book.

Other books were already in the pipeline. *Run Rhino Run* by Esmond and Chryssee Bradley Martin and *Ivory Crisis* by Ian Parker were well on the way at the same time as Mo was planning yet another title, *Journey through Kenya.* The latter's publication was scheduled to coincide with the OAU heads of state summit in Nairobi in June, 1981. Willetts and Tetley were duly despatched post haste to collate material. That safari ended on New Year's Eve, 1980 – the night terrorists bombed Nairobi's oldest and most prestigious hotel, the Norfolk.

Hancock remembers it well, for he was dining with Mo in Nairobi when the explosion went off. He said: "We were about three miles away and, even that far, the force knocked crockery off the wall. Mo phoned round and found out that it was the Norfolk, so we grabbed our jackets and dashed into the office, where Mo picked up his equipment then headed for the

hotel. It was a terrible scene of devastation, with bodies and debris everywhere. We stayed all night as Mo took pictures of it all, then went straight to the airport to get the film on the first plane out. Again, I saw Mo at his best. He had no official papers to get into the airport but he said to me 'Just follow me and look like you have every right to be here.' So I did and we strode past all the guards and security, past customs and passport control and right up to a British Airways jumbo that was about to leave. No one stopped us.

"But his audacity didn't end there. He marched on to the plane and sweet-talked a passenger into taking his film to London. He did it all by bravado. He was courageous and organised and told me his philosophy was 'Never be a victim, always be on top.' It certainly worked for him and taught me a lot about life and how to operate in difficult circumstances. I know he was a hard man – that was necessary in his job – but he also had a big heart and many people were unaware of that. After I left Nairobi, I was in touch with him every couple of months. He was a great man and I shall miss him."

The Norfolk bombing did have one lighter aspect and that involved Tetley. He had spent New Year's Eve at the infamous and exotic Starlight Club not half a mile from the Norfolk. By the time the explosion occurred, Tetley was under a table and beyond the cares of the world. He woke next day to discover the mayhem and immediately got to work. While Hancock had filed a story to the *Daily Express,* which the paper used as its splash on January 1, 1981, Tetley sent copy to *The Sun.* By inventive genius and to steal a march on his rivals, he claimed the perpetrator of the bombing was a global terrorist known as 'The Maltese Falcon.' This was complete fiction but it had the effect of making phones buzz all round Nairobi as furious news editors in Fleet Street harassed their correspondents, demanding to know who the 'Maltese Falcon' was and why they had heard nothing about it! Tetley remained tight-lipped about his 'source' and chalked the story up as another triumph. He much preferred on the hoof journalism to the more mundane world of book writing and editing.

By then, the publishing side of Camerapix was developing from an interesting sideline into a major part of the business and Mo launched an exhibition in London of pictures to accompany the publication of *Cradle of Mankind.* It was staged at the Commonwealth Institute and officially opened by Princess Alexandra. During its three-month display, more than 100,000 visitors viewed the pictures.

Later, with the publication of *Journey through Kenya,* Mo presented a leather-bound copy to the Queen during her visit to the country in 1983. At the Nairobi ceremony, flanked by his two colleagues, he

uncharacteristically forgot to mention the title and had to be reminded of it by Tetley.

Back at work, Mo headed for Pakistan, where he was collating material for a book on that country's fighting forces. It was not an easy time, as Pakistan was then involved in a border war with India. But that didn't bother Mo. Indeed it seemed to many that such potential conflict only enhanced the attraction of the assignment for the cameraman. By calling on his extensive Pakistani contacts gleaned over many years Mo was able to gain access to sensitive military areas and enjoyed the full cooperation of the army, navy and airforce.

The action in the disputed region was played out against the stunning backdrop of the mountainous territory around the Pamir Knot, where four of the greatest mountain ranges in the world meet. To capture such dramatic scenery on film, and the action taking place within it, Mo flew in a specially equipped helicopter, doors off, at high altitudes, hanging out over snow-clad peaks and plunging precipices. Tetley, who was with Mo on the trip, steadfastly refused to go higher than the nursery slopes, citing his fear of heights. Mo, just for good measure, later flew on supersonic bombing runs in F-16 jets of the Pakistan Airforce to complete his pictorial assignment. The book was published in 1988.

Willetts fondly recalled his association with Mo. "We always got on well but, like everyone who knew him, there were rows. Many of them ended up with us yelling at each other across the office, but that was how it was. We blew hot and cold and it was soon over.

"Brian drove us both to distraction. He could be completely unreliable, but he was also one of the best writers I have ever known and totally loyal. He never had much money but he was a widow's mite man. If he only had one penny on him he would give it to you, or even to a complete stranger.

"His lifestyle made Mo despair but he recognised the genius behind the flawed exterior and would sack him one day only to take him on again the next. Both were happier in action because neither could stand inactivity.

"I remember, just a few days before they died, we were all in the office together. It was late in the evening and everyone else had gone home, but we had another book to complete and were inevitably working late. Brian went out and got some chips and we sat together in the dark room eating, talking and laughing. Mo said 'We've seen them come and go, but we're still together after all these years!' It was a good feeling. I miss them both very much. Brian was a great character and Mo was a good human being, more so than most people will ever realise. He was positive yet down-to-earth. A great loss."

Following his efforts on behalf of Ethiopian famine victims, Mo organised and produced a documentary titled African Calvary, *persuading many world leaders to contribute. Here, the then British prime minister, Margaret Thatcher, meets Mo at No. 10 Downing Street. In the background is broadcaster Michael Barratt.*

*Above: Talking to Mary Robinson, the then president of Ireland, in Dublin
at an exhibition of the work of four colleagues killed in Somalia in 1993.
Mo also helped produce a book,* Images of Conflict, *as part of the tribute.
Pictured centre is Amy Eldon, sister of Dan Eldon, one of the photographers who
died in Mogadishu.*

Overleaf: The once fertile highlands of Ethiopia, laid waste by a decade of drought, which brought about a terrible famine causing nearly a million deaths. Inset: Skeletal victims at Makele relief camp.

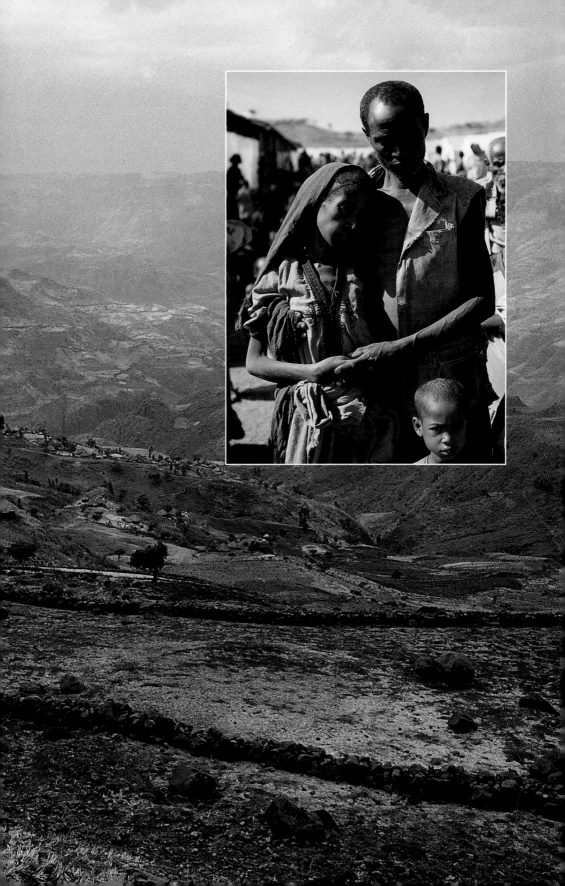

Mo, Dolly and Salim in Nairobi with, centre, Harry Belafonte and, left, Marlon Jackson, during their tour of the famine-hit areas of East Africa following the recording of the best-selling single, We Are The World.

Above: A rare moment of relaxation for Mo and Bob Geldof, two of the principal motivators of the world's greatest act of giving, in which millions of pounds were raised for famine victims.

202

Overleaf: Many of America's top singing stars came together to record We Are The World, *USA for Africa's contribution to famine victims. Written by Lionel Ritchie and Michael Jackson, it shot to No. 1 in the US within days of its release.* 203

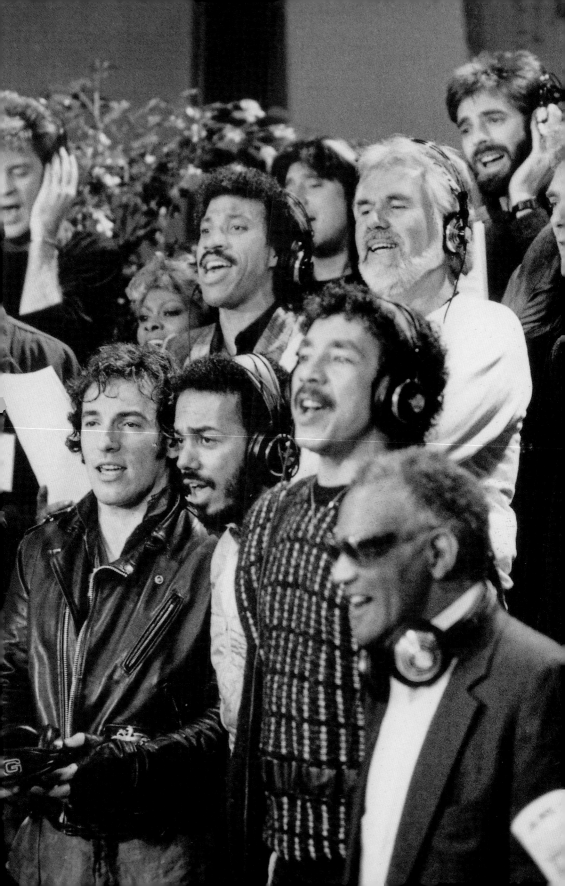

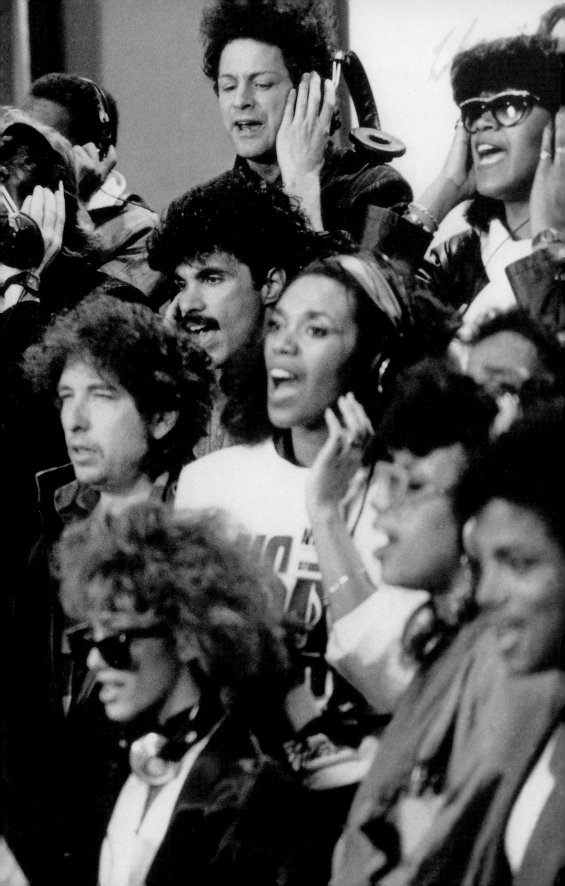

BBC reporter Mike Wooldridge, seen here with wife Ruth and Mo, was one of the first journalists to comprehend the full scale of the drought-related disaster about to hit the Horn of Africa in the 1980s.

Above: We are the World *shot straight to No. 1 and became one of the biggest selling singles of all time. This platinum disc, presented to Mo, still hangs on the wall of his Nairobi office.*

Overleaf: Mo refused to let the tragedy of starving Ethiopians escape from western eyes and frequently went back to the highlands to update his story. Here he revisits Korem, where in 1985 conditions, though grim, had markedly improved.

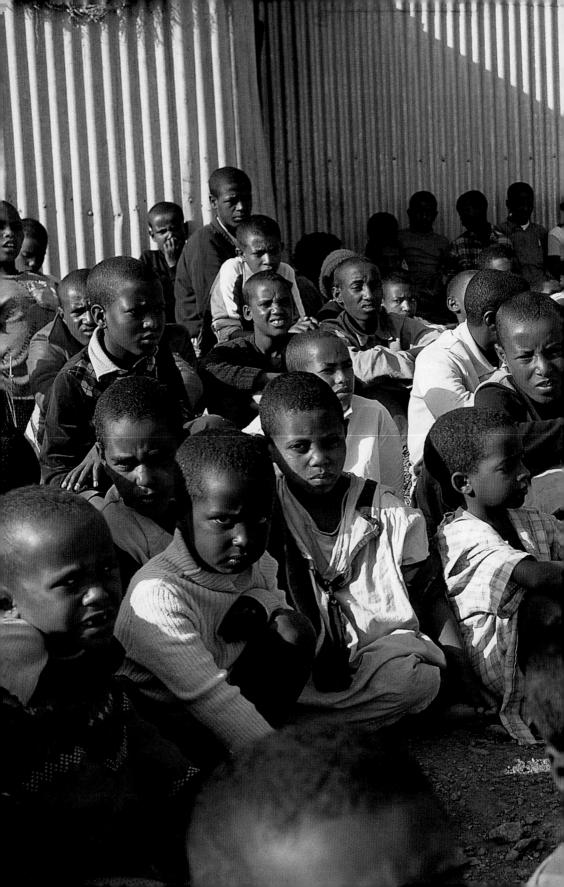

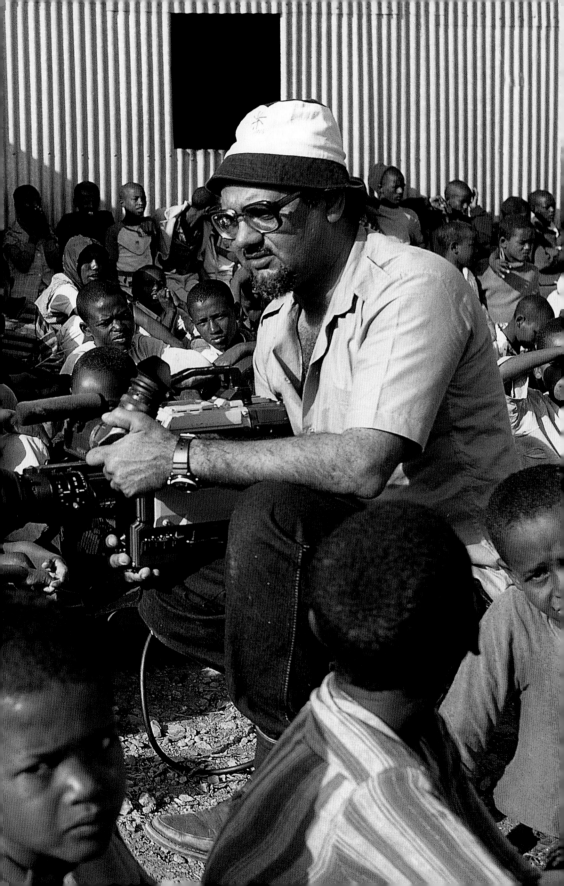

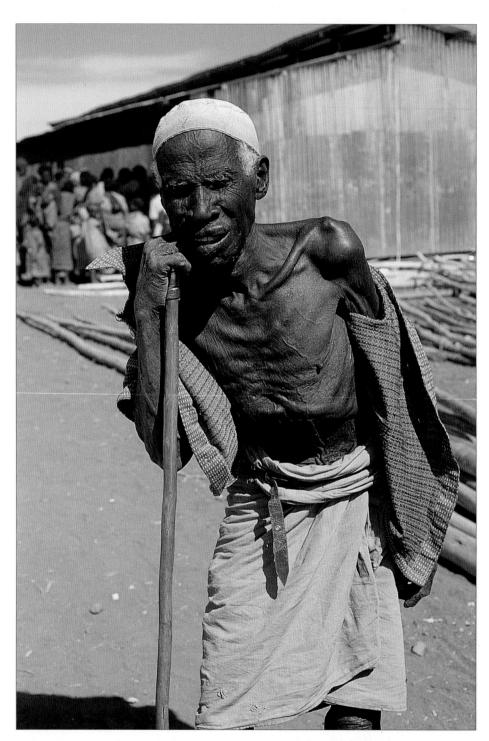

It was the quiet dignity of the victims which struck Mo so forcefully.

CLOSEST THING TO HELL ON EARTH

'The power of Mo's gift compelled me and my colleagues to respond to the needs of the people of Africa'

<div align="right">HARRY BELAFONTE</div>

T HE EVENTS which brought about the Ethiopian famine of 1984 add up to a litany of despair seldom recorded in the annals of global disasters. The cruellest acts of nature and man fused into circumstances of such horrifying magnitude that, even with the passage of years, it is still hard to contemplate the consequences.

Mo's pivotal role in focusing world attention on the plight of starving millions must be seen as a landmark in the turbulent history of the continent. It was not just a matter of being in the right place at the right time. After all, Mo fought for months for permission to visit the relief camps. Had he not been so determined, had he not stubbornly refused to be thwarted by a bungling bureaucracy mindful of its own lacklustre role in the nightmare, the harsh facts might never have been exposed. Put simply: if Mo had not acted when he did in the way he did, millions more men, women and children would have starved to death.

Shortly after Easter (spent filming the East African Safari Rally with his son Salim, Willetts and Tetley) Mo joined a press party for a two-week tour of Somalia, Ethiopia and Djibouti to look at refugee repatriation schemes. The trip was organised by the UN High Commissioner for Refugees and was intended to show what was being done to help victims of the drought-stricken Horn of Africa. It was the first indication of the

immense human tragedy to come. The Horn had been in the grip of drought for nearly a decade and little had been done to alleviate the effects. The ensuing sequence of events was an inexorable slide to disaster. At first cattle suffered; as the animals grew thinner, farmers had to sell them cheaply before they died as worthless bags of bones. Then the crops withered and died in the relentless heat and arid conditions. Once fertile ground became sterile wasteland.

Soon, reserves of food began to run out and, with no money to buy more, people began to starve. Relief camps were set up and a tide of skeletal humans trekked slowly into these isolated oases of hope. And hope was about all that could be dispensed. Agencies, overwhelmed by the scale of the problem, had very little food to offer. It was too little too late. No one had considered the enormity of what was happening. Outside the region, few seemed to care.

During his tour of the area, government Relief and Rehabilitation Commissioner Dawit Wolde Georgis took advantage of a press conference to warn of the risk of death by starvation of six to seven million people. He gave an interview to BBC reporter Mike Wooldridge which Mo filmed.

A major disaster was unfolding before the eyes of a seemingly ignorant and uncaring world and Mo knew he could not stand by. He discussed it with Wooldridge and they agreed they should try to reach the most seriously affected relief camps of Korem and Makele in Ethiopia's province of Tigre. This would be no easy task, for Ethiopia's Marxist regime, under Colonel Mengistu Haile Mariam, was at that time involved in a fierce battle with guerrillas fighting for freedom for the highland region and Eritrea.

These were restricted areas for foreigners and the government was understandably sensitive about allowing journalists to visit them, particularly as one film crew – on the pretext of covering the famine – had concentrated instead on the war zone. It was against this background that Mo began a six-month campaign to get permission to visit Korem and Makele.

His first gambit on returning from the press trip, was to write an exclusive front page story in *The Nation* newspaper in Kenya, highlighting the impending peril. The paper ran it under the banner headline '*Millions face death in Ethiopia.*' Mo reported: "Between five and seven million people could die in the next two months if the world does not act. The worst drought in Ethiopia's history has now spread into its once-fertile highlands with more than a fifth of its 31 million people victims. During the last 12 days, by DC-3, helicopter and four-wheel drive vehicle, I have travelled thousands of kilometres across the Horn of Africa to witness one of Africa's greatest tragedies in the making. Yet despite appeals at the highest level,

the world has turned a blind eye to the starving nomads and refugees in Ethiopia, Djibouti, Somalia and Sudan." The story was also sent to Western newspapers.

By coincidence, an hour-long documentary called *Seeds of Despair*, scheduled for screening by Britain's Central TV in mid-July, 1984, was in the making in the area near Korem. At the same time, Britain's Disasters and Emergency Committee, comprising major fund-raising charities, decided to launch an 11-nation appeal for starving Africa. At first, the Independent Broadcasting Authority cast doubts on whether the crisis was of sufficient severity to justify a national TV appeal, but the film soon convinced them.

The BBC also agreed to run an appeal the same day, calling in their Africa correspondent Michael Buerk, who was then operating out of South Africa, to supply the material. They asked Mo, Visnews' Africa bureau chief, to provide the pictures.

But Mo was already on safari with Brooke Shields, filming for an episode of the US TV series *Lifestyles of the Rich and Famous*, so the job was passed to Mohinder Dhillon. He quickly delivered first class footage, including shots of Buerk with famine victims. These two jointly televised appeals and a brief news item produced an amazing response from viewers. Donations flowed in and soon totalled £10million. On July 20, Buerk made his first contact with Mo with the brief message: "A note to say thank you for all your help in the miracles that led to a very successful story. Without your contacts it would not have been possible."

Mo then went to India for the second *Lifestyles* shoot. When filming was over, he travelled to Germany for the Frankfurt Book Fair where he had several new publications to promote. He then headed home via Visnews in London where he learned he was wanted back in Ethiopia. He arrived on October 12, and next day received a message from Buerk urging him to follow up the Ethiopian story. Mohinder Dhillon's film had, at last, begun to stir international interest.

Mo had been working for months on the problem of obtaining entry and travel permits to Ethiopia for himself, Wooldridge and a sound man, and now he discovered the BBC were desperate to get Buerk in the picture as well. News editors had been so surprised by the response to the earlier story they were keen for a crew to go back as soon as possible. They wanted more comprehensive coverage of the situation in the relief camps.

There followed a prolonged telex dialogue between Buerk and Mo in which it soon became clear that the crucial factor was Mo's ability to obtain the relevant permits. Having spent so long persuading the Ethiopian authorities to allow three of them in, he was doubtful they would accept

one more journalist. More worryingly, such additional pressure on the already disinclined authorities might be the last straw and persuade them to cancel all the permits.

It should be remembered that, at that time, Mengistu's regime was involved in several internecine struggles within its boundaries. These were costly exercises for a fragile economy and as a result there had been little state help for the starving. Conscious that any story on the true situation in the camps would reflect badly on the government, officials were not well disposed to inquiring Western journalists. In addition, they were anxious not to have their internal strife aired to the world. Against this background, Mo had already achieved considerable progress in getting as far as he had.

He reminded Buerk: "Although I am known as a 'friend of Ethiopia', I still need travel permits like anyone else." Nonetheless, Buerk persisted and Mo reluctantly agreed to try to get the additional documents.

Now, as never before, he needed to rely on that renowned contacts book and call in favours. Mo said: "Getting permits was very, very difficult. I had already spent months trying to get permission to go north. I had been negotiating with Tafari Wossen, information chief for the Government's Relief and Rehabilitation Commission, and when I called him again at his house he was not at all happy. It had taken him a long time to get the permits for the three of us. To add another name was almost impossible.

"I had known Tafari for more than 20 years and put a lot of pressure on him, explaining our visit was for the benefit of millions of his countrymen. Eventually, he said he'd try to help us but made no promises. Then I contacted Visnews and explained there was a delay caused by getting the additional paperwork. They were getting anxious because they felt the story was cooling in Western minds. If it wasn't filmed soon it could be too late for everyone concerned. I called Tafari again and again until he finally agreed to make it possible for Mike to come with us."

On the morning of Wednesday, October 17, 1984, Mo met Buerk at his Nairobi office, together with Wooldridge. Later that day, they flew to Addis with soundman Zack Njuguna. From the moment they arrived they had to tackle an assault course of obdurate bureaucracy, the first obstacle being the discovery that permission to go north had been withdrawn by the Relief and Rehabilitation Commission.

Mo said: "Tafari explained that they had decided they didn't want us to go to Makele or Korem. Instead, they wanted to take us to other places and show us their resettlement schemes. They accused us of only being interested in showing the horrors and not what the government was doing

to solve the problem. This, of course, was partly true but I argued that it was not the case and that we had to show the problems before we could show the solutions.

"I said that the problem was on such a large scale that, whatever the existing solutions, they were only a drop in the ocean; we had to go north to where the situation was most critical. Tafari remained unconvinced, so in the end we had an argument and I stormed out of his office and went to check in at the Addis Hilton. From there, I made more phone calls which left me without a shadow of a doubt that Makele and Korem were the places we had to get to. I went back to Tafari's office but he was out for the day. Then I marched into the commissioner's office. He was in a meeting so I went to see the deputy commissioner who was in. He appeared not to know what I was talking about and was surprised we'd been given the permits in the first place, let alone had them withdrawn. But I kept on at him and in the end he promised to have them reinstated and gave us permission to go to Makele and Korem. So I sat in his office while he made the relevant phone calls and was finally told to come back that afternoon to pick up the permits."

It had gone almost too well for Mo's liking. The cameraman began to suspect a hidden agenda. He was right; the deputy commissioner knew that, even with the permits, the road route was too difficult and dangerous to travel and would take several days – time the journalists did not have. The only alternative was to go in by air. But they discovered there was only one company running charter planes and it flatly refused to go north. The permits held by the newsmen were beginning to look like so many worthless scraps of paper, until Mo resolved the problem.

Often daunted but seldom defeated, he went to visit the Addis office of World Vision, a Christian relief organisation, and discovered they too wanted to get to the relief camps but had also encountered a wall of bureaucratic resistance. However, they did have one vital advantage over Mo's party – they had an aircraft. They had been trying to get permission to take relief supplies to the camps for three months without success. Mo saw his solution.

He said: "We made a deal. If I could get the permit, we could go in their plane. I went back to the deputy commissioner who was furious I'd found access to an aircraft. But he was put in a position where he had to give permission and we finally got the vital documents."

On the morning of Friday, October 19, the newsmen loaded World Vision's Twin Otter and filed a flight plan north that took in the ancient city of Lalibela. But once they had taken off, they decided to give the town a miss. It was just as well, for they later learned that at about the time they

would have been landing there it was occupied by Eritrean rebels. Had they landed, the story of the famine might have been very different, for they would almost certainly have been incarcerated for weeks. In the event, they flew straight on and two hours later, at noon, were touching down at Makele and preparing for a day's filming.

Any sense of achievement they might have had at finally reaching the camps was quickly dispelled by the sight that greeted them. Hardened though he was by 25 years in the frontline, nothing could have prepared Mo for what he and his colleagues now beheld. The scene was a vast plain amid the mountainous highlands laid bare by a decade of drought. To this desiccated spot tens of thousands of men, women and children had trekked from the surrounding countryside which was now a barren dustbowl. Some had been on the road for days. All were hungry, most were literally starving, many were dying. An average of 100 deaths was being recorded every day. A large majority of them were children. At Korem and another relief centre, Alamata, 700 kilometres north of Addis, it was the same story.

The statistics created their own macabre record book: in a country of 33 million people, 7.7 million were affected by the drought, 5.5 million were starving and 2.2 million were obliged to leave their homes to seek help. In Alamata camp, two doctors, three nurses and three nutritionists were tending 100,000 people. Another 90,000 victims waited patiently outside the camp for aid. The doctors had enough food for 3,000. The chance of more supplies was as remote as the camp itself because the rebels had cut off the area, and any convoys that did attempt the journey were likely to fall foul of the impoverished and hungry guerrillas.

At Korem, another 100,000 sufferers had gathered with 80,000 more on the outside. Thousands more were heading to the camps each day. Every 24 hours another 300 arrived, all at starvation level. In a desperate attempt to prolong their lives, nurses at Korem fed 500 children each day on a high-energy diet of powdered milk and biscuits.

There was not much to talk about. The journalists went about their respective tasks in subdued mood. Mo filmed it all, never flinching from the worst tragedies. People were literally dying in front of his camera. Already he realised they were witnessing a disaster of catastrophic proportions and he knew it was their duty to document it and bring it to the attention of the world.

Wooldridge will never forget stepping off the plane into that biblical wasteland. He said: "Makele was absolutely appalling – the sheer depth of the tragedy was mind-numbing. Everywhere we walked, people were dying. In one shelter a nun told us that someone was dying every few minutes and it wasn't just the old and young. Normally fit people were keeling

over. "I watched Mo filming and Mike doing his report to camera. There was none of the usual banter. Normally Mo relieved a tough situation with humour, but not there. I could see he was devastated. But he just kept filming.

"I remember walking around trying to do radio commentary and I doubted whether I could actually convey the truth, if there were actually words which could portray what I was seeing. You didn't need adjectives. I had been with Mo on the earlier tour of the Horn of Africa and I thought I had become used to horrifying images, but this was something else entirely.

"It was so quiet, I think, because the people did not have the energy to make any noise. The only sound you heard was the wailing and crying of the grief-stricken. If they had to move, it was with a quiet dignity – that was all they had left. One man came up to me and offered me his son because he could do nothing more for him. I was heartbroken."

Buerk still finds it hard to recall those tragic scenes: "It was the closest thing to hell on earth – like walking into a scene from the Bible. I had never seen anything like it before nor have I since. There were all these people, thousands of them sitting around waiting either to get food or to die. The doctors and nurses were making life or death decisions all the time. It was an agony for them all.

"I felt completely helpless; all they wanted was food and there was nothing we could do about that, so we did the only thing we could and filmed it. Mo knelt down and let his camera pan around these quiet people without disturbing them, then we'd move on. The scale of it was almost impossible to comprehend."

With rare candour, Mo admitted: "Ethiopia changed me. Until then I had been able to go into any situation, no matter how awful, and switch off. I could remain at a distance from the subject, not get involved. My job is to act as an unbiased observer, to report what I see without making judgments.

"But this was different. You can't remain untouched when there are people dying as far as the eye can see, especially when so many of them are children. Some of those scenes which I filmed completely choked me up, though I tried not to show it. What got me was that these people hadn't done anything wrong; they were just victims, people who had no food. I don't think I have ever felt so helpless.

"Once I saw an incident where there was food for only 100 people and somebody had to choose who should receive it. There was no logical basis on which they could make that decision because all the people were in the same condition. It was tragically arbitrary. Every morning a nurse had to

pick out the 150 babies to feed because that was all the food there was. By extending life to those 150, she was condemning others to die. It was as simple and as heartbreaking as that. I always thought of how that nurse must have felt. What a decision to have to make!"

Speaking to medical staff at Korem, the journalists recorded their reactions and were told that the most important aspect of their visit was to tell the outside world what was happening. They needed no second asking. Mo, Buerk and Wooldridge spent three days in Korem, Makele and Alamata documenting the tragedy. When they could film no more, Mo went back to World Vision and persuaded them to fly him and the crew to Addis on October 21. From there they flew back to Nairobi the next day, in time to go through the cassettes in Mo's editing suite.

Mo remembered: "It really hit me when we edited the film. As we were looking at the pictures, taking them back and forth and cutting them, it came home so hard I cried. So did everyone else who was in that room."

In the early hours of October 23, Buerk packed the edited tapes and flew back to London. That same day, the first brief news bulletin was televised at lunch time. In Nairobi, Mo worked ceaselessly to produce words and pictures about the famine as fast as possible. The following day, newspapers across the world were running the story, together with his haunting pictures.

And yet TV nearly passed the famine by as a news item. There had been so many stories on hungry people that cynical news editors were worried about viewers suffering from compassion fatigue. "Not more starving Africans," was the reaction of one network producer, and it was a feeling that was not without support. Indeed, Eurovision and NBC initially turned down Mo's film material until they saw it linked with Buerk's spare, but compelling commentary. It would have taken very little – a late-breaking story, some other major catastrophe closer to home – to relegate the Ethiopian famine to an also-ran.

When the BBC piece was screened, NBC's London office got straight on to their counterparts in New York to stress its importance and its dramatic impact. Tom Brokaw, NBC's veteran anchorman, described the day his news team viewed the footage: "Stories of mass hunger and death are not that uncommon, but with everything else that is going on these days often these stories don't have much impact. They're just words from far off places. Not any more. It was a moment I shall never forget. The entire newsroom came to a complete stop – and that's something very hard to do in any newsroom in the world.

"Not a breath was taken. When the film finished there was this utter silence; I think people were washed in their own thoughts, deeply moved

by what they had seen. People remember me turning and saying 'If we don't put that on, we shouldn't be in this business.' What we didn't anticipate was the impact it would have in the US. It moved a nation as few other single reports ever have."

Paul Greenberg, then executive producer of NBC's *Nightly News*, also recalled the silence when the footage was shown. "All the side talk, the gossip and talk of the then presidential election campaign just stopped. Tears came to your eyes and you felt you'd just been hit in the stomach."

Similar scenes were taking place in newsrooms the world over. Much as they tried, hardened news men and women could not turn away from these haunting images. Irish pop musician Bob Geldof was at home watching TV with his wife Paula Yates when Mo's film was shown. Its effect upon him was so profound it moved him to launch Band Aid in which rock stars came together giving their services free and raising millions of pounds for the starving. In a foreword to Tetley's book on Mo in 1988, Geldof wrote: "I was confronted by something so horrendous I was wrenched violently from the complacency of another rather dispiriting day and pinioned – unable to turn away from the misery of another world inhabited by people only recognisable as humans by their magnificent dignity.

"I do not know why Mo Amin's pictures did this to me. God knows, if you watch an average night's news you are confronted with enough scenes of horror seriously to question man's sanity. But the tube also has the ability to shrink events and make them bearable in the context of your living room. Ultimately, one becomes immune, if not anaesthetised.

"But the pitiless, unrelenting gaze of this camera was different. Somehow this was not objective journalism but confrontation. There was a dare here – 'I dare you to turn away, I dare you to do nothing.' Mo Amin had succeeded above all else in showing you his own disgust and shame and anger and making it yours also. It's certainly true that if it were not for that now historic broadcast, millions would be dead. There would have been no Band, Live or Sport Aid, no mass outpouring of humanity's compassion. No questioning of statutes, laws and values both inside and outside Africa. No reappraisal of development, of the nature of international aid, no debate on the mire Africa had become.

"In this brief, shocking but glorious moment Amin had transcended the role of journalist/cameraman and perhaps unwittingly become the visual interpreter of man's stinking conscience. He had always been among that breed considered extraordinary. He is without question an extraordinary man. I thank God that I was home that autumn evening. I thank God that I was watching that channel and I thank God that Mo

Amin sickened and shamed me." In his autobiography *Is That It?* Geldof spoke of that momentous evening with graphic clarity: "From the first second, it was clear that this was horror on a monumental scale. The pictures were of people so shrunken by starvation that they looked like beings from another planet. The camera wandered amidst them like a mesmerised observer, occasionally dwelling on one person so that he looked at me, sitting in my comfortable living room. Their eyes looked into mine. Paula (a TV presenter from whom Geldof is now divorced) burst into tears, then rushed upstairs to check on our baby.

"The images played and replayed in my mind. What could I do? All I could do was make records that no one bought. (At that time Geldof fronted a band called The Boomtown Rats). But I would give all the profits from the next Rats record to Oxfam. What good would it do? It would be a pitiful amount, but it would be more than I could raise simply by dipping into my shrunken bank account. Yet that was still not enough."

Geldof was galvanised into action. The following day he marched into the office of Phonogram and suggested the Band Aid record which stirred the conscience of Europe. He garnered the elite of British pop to produce the seasonal best seller *Do They Know It's Christmas?* Artists included Paul McCartney, Midge Ure, Phil Collins, Paul Young, Simon Le Bon, Bono, Paul Weller, George Michael, Francis Rossi, Sting, Nick Rhodes, David Bowie and Boy George.

In turn, America responded by setting up USA for Africa. Spearheaded by Harry Belafonte and Ken Kragen, the organisation brought off an incredible logistical coup by bringing together many of the top US music stars in Los Angeles, on January 27-28, 1985, to record *We Are The World*. The song was written by Michael Jackson and Lionel Richie, who were joined by Bruce Springsteen, Diana Ross, Paul Simon, Kenny Rogers, Ray Charles, Tina Turner, Stevie Wonder, Dionne Warwick and many others. It sold in its millions and raised more than $50 million for victims of the Ethiopian famine and other drought-hit countries in Africa. It was all brought to a conclusion with a colossal 16-hour Live Aid marathon concert screened worldwide which went on record as the greatest single charity event ever.

These international efforts began a ripple effect of giving which spread across the world. Unprompted, money poured in from families, individuals, children, organised groups, commercial concerns and governments. Not everyone gave cash. Farmers donated grain; a small British air charter company flew their plane to Addis to help with transport; dockers in Southampton, UK, refused overtime payments and worked through days off to load 100,000 tonnes of wheat bound for Ethiopia; many

pharmaceutical companies donated urgently needed medical supplies. It was as if the world's financial floodgates had been flung wide open as everyone responded to the impact of Mo's images. Giving on such a monumental scale had never occurred before, nor has it since.

It has been estimated that 450 million people watched Mo's film; three presidents admitted they cried; one billion people watched the biggest pop concert in the world; Band Aid alone raised more than £100 million.

US President Ronald Reagan saw Mo's film. Visibly moved, he immediately pledged $45 million. Australian Prime Minister Bob Hawke watched the footage, wept, and launched a nationwide famine appeal. A week after the broadcast, the Save The Children Fund office in London recorded donations of more than £14 million. As well as state donations, ordinary American citizens freely gave another $70 million and similar stories of unprecedented generosity flooded in from all over the world. Three million people could have perished in the famine. But in the event, through intervention, one million died. That a million should die of want in a world where there is a surplus of food is a tragedy that shames mankind. That two million were saved when consciences were at last roused went some way to redeem humanity's awful tendency to close its eyes to the suffering of others.

AFTERMATH

IN THE wake of the immense response came the plaudits, with Mo and Buerk receiving a host of awards. The BBC promoted the footage around Buerk's commentary. Just as with Mo's previous world exclusive on Idi Amin, the corporation was happy to play down the cameraman's central role, preferring to sing the praises of their own man. As before, Mo was furious at this treatment and let it be known, so that in the end he was given due credit. It is worth noting that Buerk always recognised Mo's contribution and was frequently at pains to ensure he received appropriate acknowledgement.

A Visnews internal report at the time bemoaned the way in which Mo had been so lightly treated, but concluded: "The obvious consolation is that the massive relief effort is now under way, tens of thousands of famished people are now receiving food and this can be directly attributed to Mohamed Amin's Visnews pictures."

But Mo spent little time basking in the acclaim. Notwithstanding the scale of public reaction, he applied a pragmatic newsman's sense of proportion to events. He was keenly aware of how quickly a story could go

off the boil if it was not kept in the forefront of daily bulletins and on the front pages of newspapers. Accordingly, six days after the first sensational broadcast, he set off for Ethiopia again with a soundman and Buerk.

He explained: "I felt it was my duty to do what I could to keep working on the story. The immediate impact was so strong, I didn't want to lose it, so I did dozens of other news pieces and then decided to do a documentary."

It was during his second visit to the famine-stricken Ethiopian highlands that Mo formulated his plan to record a film on the plight of all African areas suffering major problems. It didn't worry him that there might be stumbling blocks and prohibitive financial constraints. He simply knew it must be done and did it.

He said: "I was aware that this terrible hunger problem was much bigger than Ethiopia alone. I felt very strongly that a documentary about the wider issue was needed to keep the issue alive and in the minds of viewers around the globe.

"It was the television pictures in the first place that moved the world and moved the governments, and that brought about the global interest which, in turn, brought about the flow of aid. I felt it was our responsibility to keep the story in people's minds – something I had never done before. Normally, as far as I'm concerned, I'm just a newsman moving from one story to the next. But this was different; I felt that there was an element of responsibility due from us and that we should do everything we could to keep the story alive."

To underpin the story, Mo went to major players on the world stage. First he called on Mother Teresa of Calcutta who had referred to the Ethiopian famine as an 'Open Calvary.' Mo adopted the phrase, calling his documentary *African Calvary*. As he filmed Mother Teresa, she placed an arm on his shoulder and told him: "My son, God has sent you for this hour." There was a similar response from the Vatican when Mo filmed the Pope, and Britain's Prime Minister Margaret Thatcher recorded her concerns when Mo called on her at 10, Downing Street.

Mo said: "I was worried that by the time the film was made, people would already be forgetting the famine, but we had to press on. I was convinced it was the best way I could contribute to alleviating the suffering. We approached a number of people to help because we were not in a position to make an expensive film with our own resources. The response we had from every organisation was incredible.

"Their generosity helped to keep us going. We felt that, being from Africa, we perhaps had a reason to do something like that. But Europeans, particularly in London, every time we asked them to do some work for us, whether it was editing, dubbing, sound or music rights, everyone of them,

without exception, did it for nothing. It was absolutely amazing. I had never encountered such generosity of spirit in my life.

"We had decided from the start that all the money made from *African Calvary* would go to charity. We could have personally made a lot of money from the film, but right from the start a decision was made that not even expenses would be claimed. Everything went to charity.

"In fact all the money went to the Water Decade Realisation Fund, a trust in England headed by Sir Edward Heath. Through the fund, the money went to water projects in Africa, particularly in famine areas. Having gone to so many drought-affected countries, I was only too well aware how absolutely crucial water was to such areas. You can have food, but if you have no water, food is only going to be a short-term solution."

For the man who started this unstoppable ball rolling there was hardly time to pause, let alone reflect on what his actions had precipitated. *African Calvary* was now underway, and there was much to do. In this project, Mo had turned to Mohinder Dhillon for help. After their reunion, they formed Mo Productions to produce the documentary and Mohinder spent time in Ethiopia filming.

He recalled: "When it came to the need for a second trip, Mo was up to his eyes in work so he tried to persuade me to go again. But I told him 'What kind of business arrangement is this? Get out there and get filming!' Which of course he did."

The same measure of generosity which mobilised help for victims of the famine was forthcoming in the making of *African Calvary*. Mo donated all his time and effort free, but such a vast project needed far more input in terms of resources than even he could manage. By good fortune, Peter Searle, the British director of World Vision, decided to call on Mo in his Nairobi office at this time. Within the hour they were shaking hands on the outline deal which ultimately saw *African Calvary* produced. Searle, who has since died, spoke warmly to Tetley about his experience of working on the project with Mo.

He said: "Mo had produced the initial footage that exposed the drought to the world, but he knew the picture was bigger than Ethiopia and there was much more to tell. I was with the world's largest private voluntary agency and he was conscious we were working in many countries that had not received the publicity which Ethiopia then had. So there and then I committed my own office to make this film without authorisation."

Unicef became involved and Diverse Productions in London gave editing and post-production facilities, while their staff donated their time. "The generosity and dedication of all concerned was incredible," Mo said shortly afterwards. "Everywhere I went, people were willing to help and

gave whatever they could." Visnews, the BBC and 20th Century Productions provided further help which saw 7,500 video cassettes of the documentary being sent free to libraries, schools, churches and hospitals.

Searle said: "I watched Mo take risks with his safety, reputation and contacts, but none appeared to have suffered. All considerations of personal comfort and health were secondary to what he was filming." On April 2, 1985, BBC2 screened *African Calvary* to critical acclaim.

Now more praise began to flow in for his coverage of the famine. Many plaudits were joint recognition of his work with Buerk and, for the next few months, Mo globe-trotted across three continents to accept some of the awards. The British Academy for Film and Television Arts (Bafta) gave its award for Best Actuality Coverage of 1984 jointly to Mo and Buerk, the Royal Television Society 1984 award for International News again went to the two men and Europe's prestigious Monte Carlo television festival awarded the pair their Golden Nymph trophy for International News.

The day after *African Calvary* was premiered, Mo was in America to receive more accolades. In New York he accepted Long Island University's prestigious George Polk Award for Best Foreign Television Reporting; later he received the Overseas Press Club of America award.

His next appointment was in Washington, where he went to the White House to be honoured by Vice President George Bush who told Mo that by his actions he had stirred the US Congress to empower a unique Bill to donate an additional one billion dollars of aid to Africa. Hundreds of VIP guests from government, defence, business and private organisations gathered to hear Bush describe Mo as the "man who mobilised the conscience of mankind."

Bush said that such government action would not have happened "if the world had not first seen the misery for itself as a result of Mohamed Amin's persistence and courage in risking his life time and again to produce the televised coverage. Many are alive today because of his photography."

The pen with which the vice president signed the Bill was given to Mo after the ceremony and remained a treasured memento of an historic occasion. It is still kept in the Nairobi office of Camerapix.

Once *African Calvary* was finished, so was Mo Productions. The old friends/rivals could never quite make it as a team, though Mohinder still recalls Mo with affection. He said: "We went too far back to be at war. But we were both too single-minded for any partnership to last for long."

After Mo's death, Mohinder received a letter from an old Kenya colleague, Ivor Davis, who had worked with him many years previously. Davis said: "I have a distinct recollection of a letter a very young Mohamed Amin wrote to us from Dar es Salaam which began 'Dear Mr Davis, I hear

that you and Mr Dhillon are now into cine filming for television and I would very much like to do the same.' I flew to Dar with a few rolls of film having told Amin to hire a Bolex or a Bell and Howell camera. We went round a home for handicapped children run by white nuns and I (a non-cameraman!) actually briefed Amin on how to shoot a clip. I don't think either of us visualised the kind of pupil we were dealing with!"

Davis also met and worked with Tetley on and off for a number of years. They first encountered each other in 1956, when Ivor was a feature writer with the *Birmingham Gazette* and Tetley was the copy boy. Davis, now working in Zimbabwe, was one of many journalistic colleagues of both men to write published tributes to them.

With typical restlessness, Mo was soon back in Nairobi from where he continued to focus his energies on further promoting the cause of famine relief. He flew thousands of miles across the US, to Europe and around Africa, espousing the cause. One two-week safari saw him with Harry Belafonte, Marlon Jackson and Ken Kragen – the top management of USA for Africa – and a host of other stars, as they toured East and Central Africa seeing how best to dispense the accumulated funds. That was followed by a 12-hour live fund-raising telethon staged in Nairobi and linked to the US. Earlier, it had nearly foundered in a sea of petty bureaucracy until Mo, with his impeccable Kenyan contacts, was called on to 'fix things.'

Then it was off to Rome to receive the A H Boerma award from the Food and Agricultural Organisation of the UN, before heading again to the US for more accolades. On November 19, he received the Distinguished Achievement Award of the University of Southern California, followed by the Kenny Rogers World Hunger Media Award at the New York headquarters of the UN on November 26.

The USC presentation was particularly significant for Mo, being the first time in the award's 26-year history that a photojournalist – and a non-American – had been so honoured. In his response to their glowing praise, Mo was uncompromising. He told his audience: "For me, this is a sad occasion. The reports which won this award were of a million deaths which need never have happened.

"There are two questions in my mind: how long are we to allow the political divisions of the world to obstruct the supply of basic food and medicine to the needy? And does TV act responsibly regarding Third World problems or simply exploit them for their emotional impact?

"Governments and international organisations knew of the situation in Ethiopia long before my reports, yet did little or nothing. Despite UN warnings in 1980 and again in 1983, no government heeded the cries for

help to any significant extent. Was it the politics of Ethiopia which were behind the West's failure to respond?

"Ethiopia received nothing matching its needs. Whatever the reason for this, combined with drought and other factors it produced the most appalling tragedy we know of only too well. That surely is a scandal for which no right-minded government anywhere can duck the responsibility. There can be little doubt that had the matter been left in the hands of the world's governments an even more ghastly disaster would have developed and might yet be going on.

"This Ethiopian tragedy has proven beyond doubt that TV organisations underestimate the amount of public interest there is in the Third World. Why do I say this? Because when my first report from Makele was offered to Europe's broadcasters they turned it down. I understand the situation was pretty much the same in the US. But when viewers saw it, they proved beyond all question they were not as small-minded as some of the people who run the media. The power of TV news could not be demonstrated more clearly."

Mo pointed out that responsibility must go hand in hand with power. He said that the media failed in its responsibility if it did not report the often horrendous problems of development facing the peoples of the Third World. He said: "We must report them courageously, without favour to East or West. If we do that, we can trust that the people would want to see that their governments will take their responsibilities of the Third World seriously. If we do that, I believe the day will quickly come when no child, man or woman, anywhere, need ever again go hungry to bed or starved to the grave."

After his tour of East and Central Africa, Harry Belafonte came to know Mo well. He was one of hundreds who sent personal messages to the cameraman's family following his death. Belafonte spoke eloquently at a tribute to Mo held on April 22, 1997 in New York. Later, on the first anniversary of Mo's death, Belafonte said: "Beyond all else, Mohamed Amin was an artist. It was this fact that touched the conscience of all who saw his work. It was his art that powerfully translated his remarkable instinct for interpreting the needs of the oppressed and in doing so helped others understand their moral responsibility for the elimination of that oppression. The ability to see humanity within the whole framework set him apart.

"The power of his gift compelled me and my colleagues in the entertainment communities of the world to use our resources in response to the needs of the people of Africa. Mohamed Amin was no ordinary man. Would ordinary men were made of such courage in the struggle for

truth. . . then uncompromised love for one another would be tangible."

Ken Kragen was equally warm in his tribute to Mo: "The finest thing you can say about any human being is that his life made a difference in the world. Mo's clearly did. His work was the catalyst that launched many African relief efforts around the world, including Band Aid, *We Are The World*, Live Aid and others. His professionalism and dedication were an inspiration to us all."

Lionel Richie, one of the originators of the famine relief effort in the US, was recording a new album in Nashville when he took time out to reflect on Mo. He said: "To be able to use my God-given talent as a writer and performer for the good and well-being of others is one of my greatest pleasures. *We Are The World* was such an opportunity for me. It began with four people, myself, Michael Jackson, Quincy Jones and Stevie Wonder. But after the word went out that we were doing such an immense project, we were joined by 45 of the greatest artists in the world to ensure our success.

"The feeling was beyond my wildest imagination. It was unbelievable in its magnitude. So many people, so many countries, so many cultures all coming together. A common cause and a common belief to save lives. It became an anthem, a movement, a feeling of empowerment and the results were incredible. *We Are The World* was a project that I shall never forget and I'm sure the planet will never forget. We are the ones who will make a brighter day if we all just start giving."

Kenny Rogers said: "We all dream of doing one thing in our lifetime that might change the world. Most of us never do. But Mo Amin, through his wonderful talent as a photographer and his compassion for people, captured the essence of what 'hunger' is all about, and the world responded.

"He, his gift and his contribution will always be considered the turning point in solving world hunger. I am thrilled to have met him and to have been a small part of his challenge."

Later, in December 1986, Mo flew to London for another award ceremony, this time to receive the Order of Christian Unity's Valiant for Truth award. It was yet another significant recognition of his work for the hungry and homeless. The award had special relevance because, at that time, Mo was working on a 27-minute documentary *Give Me Shelter*, part of his contribution to 1987's Year of Shelter for the Homeless. Among other nominees were Sir John Junor, Bernard Levin, Lord Denning, Mary Kenny, Bishop Desmond Tutu, Peregrine Worsthorne, Doctor Wendy Savage, and Winnie Mandela. Mo was selected from a short-list of three – the other two were Charles Douglas-Home, then editor of *The Times;* and a contemporary of Mo's, the late UPITN cameraman George De'ath.

The award is made annually to "pay tribute to the individual or group working for the press, television, radio or literature who has best used modern means of communication courageously to convey the truth in the public interest." Making the presentation, General Eva Burrows, the then head of the International Salvation Army, praised Mo's courage and honesty and said: "I would add a third quality, which is the key to the powerful visual presentation which so stirred the world – the quality of compassion."

Mo replied that it gave him special pleasure to receive the award, bearing in mind he was Muslim and this was a Christian organisation. "In a world where religious difference is so often the pretext for violence, I find this heart-warming," he said.

Five years later, Mo returned to Ethiopia to witness the last rites of Mengistu's repressive regime. The end had been coming for months, but now the rebels were at the gates of Addis and the game was all but over. News crews from around the world converged on the Ethiopian capital to record the final days.

ለኢንዱስትሪ ሚኒስቴር
MINISTRY OF INDUSTRY

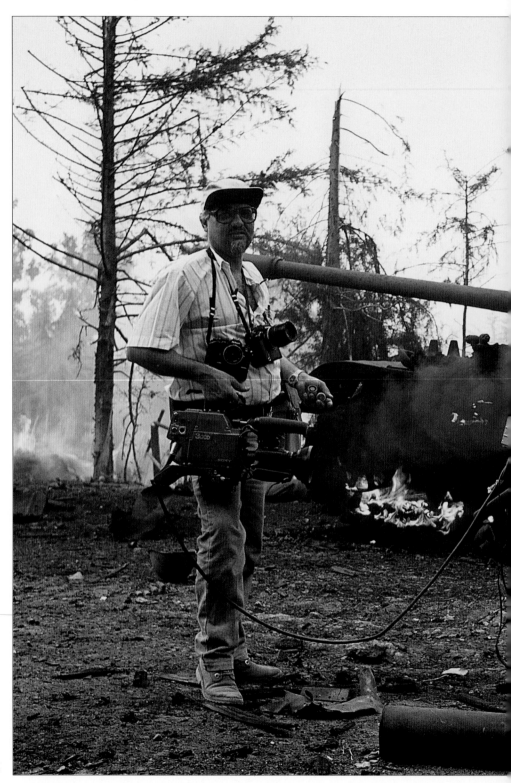

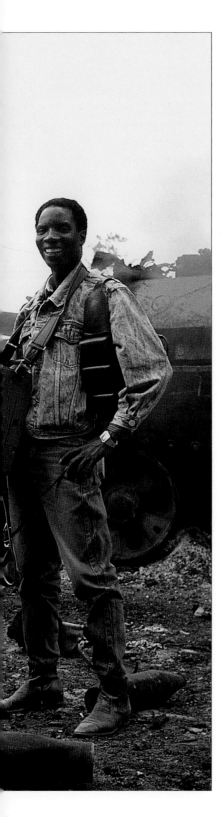

Left: Frontline friends Mo and soundman John Mathai on an Ethiopian battlefield just a day before the explosion which killed Mathai and cost Mo his left arm.

Above: Mo and Mike Buerk with conquering rebels in Addis Ababa.

Previous page: The largest ammunition dump in Africa erupts in spectacular fashion, sending up a mushroom cloud of smoke and an incandescent display of exploding missiles, rockets and ammunition.

With his severely damaged left arm heavily bandaged, Mo lies in an Addis hospital fighting for life. BBC reporter Colin Blane who, with Mike Buerk, rescued him from the blast, tends his critically injured colleague.

Just three months after his left arm was amputated, Mo was back at work with a bionic version and a specially adapted camera. Colleagues were astounded at his amazing recovery.

235

Aided by US orthotics expert, John Billock, Mo gets to grips with his bionic arm. His quest for a prosthesis formed the subject of a BBC television documentary.

CHAPTER 9

WITHIN A WHISKER
OF DEATH

'Some people suggested we should have

left him and rescued his camera gear!'

COLIN BLANE, BBC REPORTER

O N THE terrible morning which so nearly cost him his life and lost him his left arm, Mo should not have been in Ethiopia at all. The rebels who had been fighting a war against Mengistu's repressive regime had successfully taken Addis Ababa and it was all over bar the shouting. Along with the rest of the press, Mo was looking to get out and move on to fresh conflicts. Journalists were packing up and making arrangements to leave. Mo had already been on the phone to his Nairobi headquarters and was ready to go. But as he rested in his eighth floor room at the Addis Hilton in the early hours of June 4, 1991, a spectacular fireworks display erupted in the city. The spontaneous outburst was caused by an exploding ammunition dump which, unknown to observers, was full of high explosives, rockets, missiles, bombs and bullets.

From his viewpoint, Mo watched the sky erupt in sparks and flames and knew something serious was going on. As dawn broke, he made up his mind to track down the source of the detonations. Not all the journalists were so keen. There was something ominous in the continuous nature of the explosions. Mo's London office manager, Debbie Gaiger, who was in Addis to co-ordinate the Camerapix operation, cautioned against his decision but knew it was useless to try to dissuade the determined photographer. And if Mo was off on a story, others, trusting to his news

237

sense, decided to go with him. Besides, it was the only semblance of a story around. None of those who set out from the Hilton that morning could have had any idea of what was to come. All were seasoned journalists, but all were to say later that they had never before or since encountered anything so cataclysmic.

Recalling his own experience, Mo said: "Death missed me by a whisker, yet I remember everything with clarity. The little details, like signing a chit at the hospital for my wristwatch and never seeing it again. It still annoys the hell out of me that some bastard is walking the streets of Addis wearing MY wristwatch!

"And MY cameras! I'd shot some good footage that morning and had already booked a satellite feed to send my pictures to London later that day. Moments after the dump erupted, I shouted at the guys I was with to grab my cameras. They didn't, and you may think I'm a bastard but I'll never forgive them; and I'll never forget that they saved my life when I would not have blamed them for getting out of that hellhole as fast as possible."

Earlier that week, Mo had broken all his careful safety rules by riding on the back of the leading rebel tank up the main road through Addis to fallen Mengistu's Menelik Palace. It was a high risk mission as there were still troops loyal to the regime fighting a last ditch battle in the city. Mo said: "My desire to get the best shots completely overruled my safety code. On this occasion, the gods were with me. The clips were shown across the world that night and I'm proud that my coverage of the rebels' triumphal entry into Addis was acclaimed the best."

It was the final throes of a dying order and soon afterwards the rebels effectively took over. Everyone was packing up and looking for new wars. Mo was waiting for the airport to reopen so that he could fly out.

He said: "Mengistu, like most killers, had fled as soon as the end was near and the final attack on Menelik Palace was the only bright spark in the closing chapter of the war. The entire press corps was installed at the Hilton, and there was no better place to be based. It enjoyed not only remarkable facilities, considering it was at the hub of a civil war, but also superb views of the palace in the immediate foreground and a broader canvas of Addis as a whole. Indeed, some of my colleagues had chosen the wiser and safer option of gallery seats at the show – watching from the balconies of their rooms."

Reporting the event for *The Times* of London was their award-winning Africa correspondent Sam Kiley. At this point, Sam was still relatively new to the arena of conflict, but his recollections make a graphic record of the event: "The disadvantage of eighth floor accommodation at the Hilton

and its ringside battle views was that I had to sleep in the bath for safety from stray bullets and shell splinters which whacked into the concrete of the building; and from the reckless shooting which competed with Addis's legendary howling dogs to keep one awake.

"A French reporter next door lost his whole window to a splinter which, smoking hot, had landed on his bed while fortuitously he was brushing his teeth.

"When it came, the explosion sent a heavy, crumping shock wave through the hotel. I opened my eyes to look at my watch. 5.25am. 'Oh no, not a coup at this time in the morning,' I thought while peering at the quiet palace 400 yards away and hoping that perhaps I could watch whatever battle was going to ensue from the comfort of my bed. Ethiopia had been a dramatic initiation to war reportage. I'd only covered the shambolic 1990 coup attempt in Trinidad and Tobago before, and, along with *The Independent's* Richard Dowden, a veteran war correspondent, I had wandered into a sniper's nest in the Menelik Palace exactly a week before as the rebels were still fighting for it, and been caught in a counter-attack by Mengistu's palace guards about an hour later.

"I was weary of war and the brave, machismo front adopted by most of us was wearing thin – at least in my case. Fear was creeping in. I expected blood to come pouring out of a hideous exit wound in my stomach every time somebody slammed a door or dropped a dish.

"So with the sound of the explosion and lesser reports echoing I staggered out of bed and into a colleague's room with a view of the most fantastic fireworks display due south on the road leading to Debre Zeit. An exploding ammunition dump where real fireworks were stored was sending sparklers high into the sky. It was also throwing up ballistic missiles which screamed erratically over the city, sometimes exploding in the air, but more often smashing into the ground. Curfew was due to end in an hour, when I knew some of us would not be able to resist rushing to get as close as we dared to the core of the inferno.

"'Can't we just pretend it isn't happening and go back to sleep?' I begged. No one listened. Some were setting up TV cameras, others were giving live descriptions of the display to obscure radio stations. I joined those preparing to go to the dump. We kept close tabs on Mohamed Amin, Visnews cameraman, and his team, which included BBC reporter Michael Buerk. Mo was a shrewd operator who would not piss on a competitor if he was on fire. And he knew Ethiopia inside out. He already had a car, so Dowden wandered off and charmed a West African businessman into lending us his battered Renault Fuego, on the understanding we would drop him off at his home on our way. The explosions continued unabated

and threatened to engulf the city if just one shell entered the vast fuel storage tanks about 200 metres from the dump's epicentre.

"Jammed into the car with Richard driving and two other journalists, we dropped off the West African and headed for our destination, past fleeing peasants carrying what possessions they could. Some were just running for their lives as missiles and shells howled overhead. Richard was determined to get as close as possible.

"I was trapped in the back of the car and oddly, what upset me was the thought that if we received a direct hit I should have risked being blown up in such an ugly automobile. We drove close. Now we were just a few hundred yards from those fuel tanks. As casually as possible, I said 'Turn around Richard, we're getting too close to those tanks.'

"Deaf to my advice and to yells for sanity from the other journalists, Dowden drove on. He continued until we were only yards from hundreds of thousands of gallons of high octane fuel currently being subjected to bombardment by armour-piercing shells. It only needed one bullet to send us all to oblivion.

"Reinforced by abject terror, I barked at mad Dowden – who was muttering about 'pressing on' – and told him to 'turn the fucking car around!' It worked. Suddenly he swung us about and, finally realising the danger, jammed his foot on the accelerator. We hurtled off up a side street.

"As we willed the old car onwards, the seat beneath me raised itself as if snatched up by a giant and dumped the back wheels down again before the sound of hell itself came from behind. The blast was so powerful it had burst forward faster than the speed of sound and plucked up the car by its rear axle. We raced to get away from the inevitable debris we knew would soon be raining down. Pieces of concrete the size of dining-room tables were already crashing into houses hundreds of yards ahead of us. (Some of these slabs – the roof of a reinforced underground high explosive bunker – were thrown more than a mile as if they were nothing more than pebbles from a beach).

"Unknown to us at the time, Mo and his team had headed directly to the dump. Mo, Buerk, John Mathai, Colin Blane and another cameraman, Nick Hughes, had left their vehicles and started filming when the Big Bang occurred.

"Nick, although closest to the bunker (he had actually crept inside the ammunition dump compound to film) was lucky and hid beneath a piece of corrugated iron when the shrapnel and debris began to fly. He emerged bleeding from a burst ear drum, but was otherwise unhurt. John, Visnews' Kenyan editor who was helping out as Mo's sound man, was picked up by the rush of air which came ahead of the flying debris and hurled against a

wall. He was killed instantly. Buerk and Blane survived with cuts and bruises having been thrown some 50 yards by the blast.

"But Mo had been badly injured. His left arm was hanging by a thread and his blood was pumping on to the dirty pavement. .

"We were ignorant of this disaster as we drove down the Debre Zeit road, convinced that nothing could follow such a blast. Towards us, blaring its horn, came a black 1960s Mercedes. As it flashed by, I saw at the wheel an ashen-faced Colin Blane. There were a jumble of others whom I couldn't make out. The back window had been shattered and there was blood on the frame around the glass diamonds of the screen.

"We carried on until we reached the Agricultural Marketing Board building, a 1960's structure typical of the ugly developments that curse the cities of modern Africa. It had been split down the middle by the blast, leaving a four-inch crack. Then, as more rockets burst from the flaming munitions dump and roared overhead, we retreated.

"Back at the Hilton, we found the Mercedes. Its back seat was covered in blood. I found one of Mo's Nikons also smothered in blood and took it into the hotel. Someone said 'John's dead and Mo's dying. What's your blood type?'

"We found out that Mo had inadvertently been taken to the worst and most ill-equipped hospital in town. His colleague Debbie told me that SAS troopers had seen Mo first at the hospital and then handed him over to the surgeons who were struggling to save his life, and his arm. We set about organising Mo's evacuation, which meant getting permission to open the airport, finding an ambulance and making sure it would be able to pass all the road blocks around the city. Every minute lost brought Mo closer to death and we all knew he faced the almost impossible task of surviving a four-hour flight to Nairobi in a light aircraft – if the plane ever arrived in Addis. My colleagues, who had good relationships with the rebels, set off to organise the logistics while I stayed at the Hilton to co-ordinate efforts to get Mo out.

"The next hours were a blur as I tried to get a phone line to the outside world. Mo had come round asking about his cameras, so we wandered about looking for them. I asked the rebels if they had seen them – and they lost their tempers. 'We're not thieves!' yelled one of their commanders. But they came through with permission to drive through road blocks and open the airport.

"Every international caller I got hold of was told to scramble a hospital plane from Nairobi and arrange for a microsurgeon to be on standby. Finally the message got through and two planes were scrambled. Mo had stabilised but was still at death's door. He did not know about John – a

secret kept from him until he was out of danger and back in Nairobi some days later. In convoy, we rushed to the airport. Everyone was tense but trying to sound positive. There seemed to be an understanding that we should pull together and will Mo's survival.

"One plane took Mo's team, John's body as well as evacuating a pregnant Kenyan woman. The other, equipped with a nurse, took Mo. As he was lifted in, I had a strong feeling that he would survive. The old bastard was being his usual tactless self, bawling out the people lifting him up the tiny ladder into the belly of the aircraft. 'Get a fucking move on. Not upside down . . . Fucking hell.' Mo's language was not that of defeat. I smiled and turned to the other plane. John's body was being gently lifted in by his cameraman friend Nick Hughes. Nick, sombre but very controlled, lifted the man with whom I had shared the back of a tank a week before so lovingly it seemed he was trying not to bruise John, who just seemed to be sleeping lightly. I turned away, my eyes brimming with tears. An SAS trooper, a Londoner, looked me straight in the face. 'We're in the same business in many ways,' he said. 'You will probably go through this again. And it doesn't get any easier.' As he turned away his eyes reddened, perhaps at the memory of a fallen comrade."

Mo remembered the spontaneous reactions of the other journalists in Addis with emotion. He told me: "There were dozens in the press corps at the time of the incident and for what they did I owe a debt of gratitude – and I don't hand out thanks too often or too profusely. But I saw the selfless gestures of hard-bitten colleagues queuing to give blood without a second thought, in less than sanitary conditions, and I am genuinely proud to have known and worked with them.

"Michael Buerk is an old friend and colleague (though he won't thank me for the 'old' bit) with whom I have worked in many a tight spot. He's a first-class professional, a good front-of-camera man and a bloody good reporter."

Buerk was known for his ability to keep his cool in tough situations. It is a measure of the enormity of the Addis explosion that even he was seriously shaken. This is his version of events: "I had been working with Mo for old times' sake and because the other film crew weren't quite so switched on. Also they had lost their transport. I was woken around three or four in the morning by incredible flashes of light. I got our BBC crew to film from the Hilton Hotel balcony.

"Mo of course had transport, two vehicles, one of which was a black Mercedes. We decided to investigate and I set off with Mo and Colin Blane. Nick Hughes went his own way. We were all looking for the best vantage point. Nick was extremely fortunate because he went to film at the other

side of the dump where he saw two fire engines at the scene. It's actually his footage you see in the news clips of the explosion. He was filming over a parapet and couldn't get a steady shot so he ducked down to set up a tripod, and that's when it happened. You see those fire engines being blown to bits – as he would have been had his head still been above that parapet.

"We had parked the car and went to look over a wall at the ammunition dump. This wall went down into a small valley where there was a squatter camp. The well of the valley was used as a latrine. It was filthy with a trickle of human detritus. We filmed from there but decided to go round the wall for a better view. All the time there was the pop-pop-pop of ammunition exploding and shells going off. No one is certain but it was reckoned to be the largest ammo dump in the whole of Africa.

"To see if he could get a clearer shot, Mo moved further out into the middle. John Mathai was about six yards ahead, and Colin and I were still shielded by the wall. All of a sudden the bloody thing went up. I mean it was incredible. An amazing sight – I've been back to look at it since. There was no huge bang as I can recall. Just a short of 'whoosh!' We were all thrown back a long way – many yards. It was a strange thing, this experience of being thrown back in the air; an extraordinary sensation. Then I hit the ground. I came round not totally conscious of what had happened for some moments. But then I saw Colin trying to get to Mo who was lying sprawled some distance away.

"The air was full of dust, like a grey cloud, and there was an enormous amount of shrapnel flying about pinging everywhere. It really was bloody frightening! Amazingly, Colin and I were OK. A few bumps, bruises and scrapes, but considering everything we were all right. Now the sequence is a little hazy. I know one of us, or maybe both, went to get the car. We knew Mo was in a bad way. John was just recumbent. There was not a mark on him yet he looked lifeless. I couldn't see his face but there was something ominous about the way he was lying.

"Colin was making his way to Mo and rather shamed me because when I came round I thought 'Fuck me! Let's get out of here.' But Colin was incredibly brave and got over to Mo, so I felt I had to lend a hand. Mo's left arm was all tangled up with his stills camera and that, ironically, may have helped save his life initially because the binding straps acted as a tourniquet. Colin had pulled him some way to safety when I got there.

"What was curious was that Mo's wrist and hand were perfectly OK and he still had his watch on. His arm down to about his elbow was also fine. But everything after that was shredded. So much so that when we picked him up I really thought his hand was going to fall off. The arm was just sinew – horrible. We managed to get him to shelter then fetched the

car. "It was at this point that Nick Hughes arrived and went to get John. That was the bravest action of that day. Shrapnel was still flying everywhere but Nick went out and pulled John back. We could see no sign of obvious wounds. It was just the shock of the blast. Very sad.

"Incredibly, Mo was conscious throughout. I reckoned he would lose his hand and his arm and there was a probability he might bleed to death because he was losing a hell of a lot of blood. But he's a solid character and I felt he would pull through. We got him to a hospital and I went back to the Hilton to raise the alarm. His colleagues were wonderful. The Channel 4 team were helpful, but it was the Reuters boys who made the difference. Their communications set-up was so much better than everyone else's. They were in touch with their Nairobi office and played a major role in organising Mo's evacuation.

"We all gave blood – some of us joked darkly ' This is nothing new!' It was one of those occasions when the entire press corps rallied round, despite the situation and the conditions.

"It was an incident which had a major effect on anyone in Addis that day. One journalist who stayed inside the Hilton said that at the moment of the blast the sky went an incandescent silver. Many of the press corps were in the Hilton's ground floor coffee shop, which was fronted by a massive glass window, when it happened. They all dived for cover, and seconds later the huge sheet of glass blew apart shattering everywhere. When the initial chaos died down, everything went quiet and all those in the hotel knew just how bad it must have been for those of us at the dump."

Mo's own recollections of the explosion and ensuing events are remarkable for their clarity.

He said: "When the explosions started, I set off to investigate with Buerk, Colin Blane of the BBC, and my soundman John Mathai. When we got to the dump, there were missiles and shells going off everywhere. Mike Buerk wanted to get closer, so we moved up behind this wall. We took care, looked for cover and checked our escape options. Beyond it was an open sewer and the dump was the other side. John and I moved out to get a better view when the whole thing went up with an almighty bang. It was the mother of all explosions. The mushroom cloud was like the one at Hiroshima. Tanks and armoured vehicles were being thrown hundreds of feet into the air.

"When the crunch came it was just coincidence it happened to be John and me and not Colin or Mike. The sheer enormity of the explosion was something none of us could have contemplated in our worst nightmares.

"Nobody is really sure how it began. There were several theories. Some said it was sabotage by fleeing troops loyal to Mengistu. Others said it was

simply squatters who started a cooking fire that got out of control. No one will ever know the truth. What is certain is that between 800 and 900 people died in Addis either as a direct result of the explosion or from the resulting devastation. It might have been more than 1,000 but no one was counting bodies at that time and there was little comfort for the injured as hospitals had nothing left with which to treat them, as I soon found out.

"The next thing I remember was coming round and looking at the remains of my arm. On reflection I'm surprised at how calm I was. I knew exactly what was going on, exactly what had happened. My right arm was pretty badly shot up and I'd taken a hit in the shoulder, but I could see how bad the left was.

"Very slowly, I moved my right hand across to test the feeling in the fingers of my left hand. There was none. It was then that I knew the full extent of the damage. I didn't need surgeons to tell me amputation was inevitable. Colin and Mike tried to come and get me but there was too much debris and shrapnel flying about so they waited for three or four minutes. I was lying on my back with live bullets flying around, some of them hitting me. I reckon my cameras and camera bag saved me because my chest was badly bruised. Colin came first, then Mike, and they both tried to lift me. But they couldn't get me out of this ditch where I was lying. I was covered in blood and human shit from the ditch.

"I told them to get John first because he's lighter than me and I thought he had ducked the blast and was just in shock. They took John and then came back with at least two other guys. But they had a problem getting me out because my arms were so badly shot up and there was nowhere to grip me.

"In the end they dragged me out of the ditch as I argued with Colin and told him to get my cameras. He was more concerned about me but I insisted on seeing him take the cameras because there was a tape in one of them. Eventually he agreed and they took me back to the car – the black Mercedes which I had rented and promised faithfully to return in good condition. Unfortunately, it was a complete write-off. The doors were missing and the roof had gone up, but the engine was working. So they threw me in the back of the car and drove off. But they didn't take my cameras, the bastards.

"Much later, I got one camera back. One of the videocams was stolen and a couple of months later the rebels found it, realised it was mine and handed it back. It was totally wrecked but I got the tape which contained some of the explosion scenes.

"I've taken a few knocks in my career but these were the worst injuries I'd ever had. Yet deep down I thought there was a good chance I would

live, so I thought I might as well have my things with me, especially my cameras. Colin bitched like hell for days. He said 'We should have left you and taken the bloody cameras, because no one would have stolen you!'

"I don't remember being in pain. My arm was a mess and I recall looking down at myself and seeing bits of me literally dropping off. I suppose I must have been numb with shock. They took me to a hospital, put me on a stretcher and I lay in a corridor on a trolley for what seemed like hours. A couple of doctors came along, bound my arm to a piece of wood to try to stop the bleeding and set up a drip, but there was no medicine in the place so I just lay there. The guys of the press corps all gave blood, but there was nothing else that could be done until the two planes came in from Nairobi.

"By that time I had been taken to the airport, from where I was flown out by Amref, the African Flying Doctor Service. In that sense, at least, my proverbial luck was in. Other less critically wounded died simply because they did not have the resources summoned to help me.

"In fact, the rebels were very good. I had spent some weeks with them in the bush six months earlier and got to know their leaders – the value of contacts – and they offered to lend me a plane. But they were very nervous about it because the pilot was from the old regime and they didn't hold out much chance of him or the plane ever returning from Nairobi.

"I have been criticised for taking John into danger and been accused of being indirectly responsible for his death. This is not true. I did not push him into anything. John had asked to come on the trip. He was a good sound engineer and a good editor, but when he came with us he wanted to go out on assignment rather than be locked in a room all the time, which was why he was doing the sound recording. I always make it clear to my colleagues that I never ask anyone to go into situations which I would not go into myself. John made the choice. On this day, we knew exactly what we were doing, we were not pushing our luck. But nobody was aware that we were walking towards the dump. Had we been there 30 seconds later, we would have been right on top when it finally went up and would all have been blown to bits. The explosions had been going on for hours and we reasoned that it was relatively safe to be there. No one could have anticipated what happened.

"One of the reasons no one else got so close is because we were virtually the only journalists who managed to hire a car. I had rented it on a company American Express card and no one ever told me afterwards what the charge was for one written-off vehicle – and I never asked.

"In Nairobi, neurosurgeons confirmed what I already knew – my arm was finished. There were no veins and no blood supply. All that remained

to be done was to saw off the shattered end. What really bothered me was my right arm. Seven bullets had passed through it and there was more than an evens chance I might lose that as well. If that happened then my career as a cameraman was over. This I dreaded more than anything else. If I couldn't take pictures, my life would be pointless.

"As I signed the piece of paper authorising doctors to cut off my arm I said to myself 'This is not the end, this is the starting point.' I determined that I would leave hospital the moment I could clean my teeth on my own." One week later, he walked from the ward and headed home – via the office.

Mo may have had no doubts, but he frightened the hell out of everyone else. His brother Iqbal recalls: "I heard about the incident as I returned to England after a business trip. It was on the news that there had been an explosion in Ethiopia, and several journalists were injured. I just knew it would be him. When I got home, the phone went and it was his family in Nairobi telling me the bad news. I showered, emptied my suitcase, refilled it with fresh clothes and caught the night plane to Kenya.

"I went to see Mo in hospital the next day. He looked in bad shape but he was already joking. I pulled his beard and called him junior – he hates that nickname – and told him to stop giving us all such a bloody fright. He told me to piss off, and that's when I knew he would make it."

When Mo announced his plans to return to work, there were many experts who counselled against such a move. This merely strengthened his resolve. He said: "The conviction of doctors and specialists in Africa and Europe that I would never work again annoyed me. They said 'Your career is over.' That was a red rag to a bull. Nobody was going to tell me what to do. I had to prove them wrong."

London manager, Debbie Gaiger, had played a vital role in keeping Mo alive after the explosion. She had been at the Addis Hilton when the dump went up. Her version of what took place gives another perspective on events.

She said: "I shouldn't have been in Ethiopia at all, but in situations like that Mo liked to have his staff around to help out. In fact, he tried to con me into going. At the time, I didn't know the situation there was so bad and Mo wanted me to go along to sort out some business. We were producing Ethiopian Airlines' in-flight magazine and he said there were problems which needed attention. I was reluctant to go, but he was insistent and in the end I went. I began to get a bad feeling about the trip when I got on the plane for Addis and found I was the only passenger!

"When I got to Ethiopia I found out why. I was in the Hilton coffee shop when the dump went up. One of the reporters nearby shouted for us

all to get down under cover. I pulled a table over me and seconds later the massive glass window blew in with an incredible sound. Glass shattered everywhere. We knew that anyone nearer to the blast must have caught it badly and we just waited and prayed for them to come back. Eventually, Mike Buerk arrived. He was covered in blood and badly shaken. He told me that John was dead and Mo had been badly injured and Colin had taken him to the Addis hospital.

"We went there in the Mercedes Mo had rented. By now the roof had caved in and there were no windows. There were shards of glass all over the place and on the back seat was blood and a pulpy mess where they had put Mo. When I saw him at the hospital he looked at me and told me he was going to die. As we spoke, a doctor was bandaging his left arm and pulling great lumps of shrapnel from his right arm. I managed to phone doctors at the Swedish and Black Lion hospitals to come and help, then I telephoned the British Embassy.

"They were terribly unsympathetic because they had earlier advised us to take shelter in their Embassy and not go to the Hilton. They adopted a 'we told you so' attitude. The Ethiopian doctor said he would have to amputate Mo's arm at the shoulder and it would have to be done soon. The official from the British Embassy who had arrived was also insisting on amputation. I said there was no way I was going to let this happen. I didn't know much about amputation but I knew that if they took Mo's arm off at the shoulder there was virtually no hope of attaching any functional prosthetic. They had no drugs, and the place was filthy, with cockroaches running around the floor. Also I didn't want him to have transfusions in Addis because of the risk of Aids through infected blood. The Embassy official told me it was all my responsibility. In the middle of all this, a nurse came in asking for me. She told me there was a telephone call in the basement. Amazingly, it was David Kogan from Visnews. How he'd got through I'll never know, but he was very reassuring and told me not to worry and everything would be OK."

Everything almost wasn't OK for Kogan. He'd been woken at his London home in the early hours and told of the tragedy. Soon afterwards, he gave television news interviews, then drew $30,000 cash and headed for Heathrow en route to Nairobi. But customs, suspicious over such a large sum of money, took him aside and questioned him. They thought Kogan was on a drug run, and he was having difficulty convincing them otherwise when, on a television in the corner of their office, he saw himself being interviewed on the news. He was able to convince them of his true identity and they let him through.

Debbie said: "In the meantime, Colin had organised the press corps

into giving blood while I went with Reuters' Aiden Hartley to plead with the new prime minister to open the airport and clear the buses off the runway. He was happy to do this because, a few weeks earlier, Mo had been with him and other rebels in the bush.

"When I got back to the hospital, the Kenyan ambassador was sitting with Mo, who was drifting in and out of consciousness. The Red Cross offered to drive him to the airport in their ambulance. Tafari Wossen, who had done so much for Mo during the famine, also called in to offer help. Eventually, two Amref planes flew in, and we were able to leave.

"What was very touching was to see all the journalists lined up on the runway like a guard of honour as we took off. Four hours later, we landed at Wilson Airport, Nairobi, where an ambulance was waiting, and Mo was taken straight to hospital.

"I still hoped microsurgery might save his arm, but the doctor at Nairobi hospital showed me the X-rays and it became clear the arm would have to be amputated. Mo signed the form, and soon after they operated. When I went in the next day, it was the first time I had seen him without his arm. I was shattered, but I could tell Mo was recovering because he asked me what had happened to the arm. I said I didn't know but I imagined it had been thrown away and asked him why. He said 'Well, the hand was still intact, I could have used it for a paperweight!'"

With time for reflection, one thing persistently nagged at the back of Mo's mind – what had happened to his cameras in the blast? He wrote to Colin Blane – the BBC's Africa correspondent from 1989 to 1993. On June 28, 1991, Blane sent him the following letter: "You are quite correct when you say that you did ask me to pick up your television camera, sound recorder, battery pack, camera bag and three stills cameras. At the time, however, I felt it was a straight choice between rounding up your gear and getting you out of the gully and off to hospital.

"I know how much the equipment meant to you and I suppose it's understandable that you should make a fuss about it. But some people in my office have suggested that we should have left you and taken the camera gear. It didn't occur to me at the time, but that way at least the gear would have been safe and the looters wouldn't have bothered with you!

"You are entitled to ask why we didn't go back for the gear after putting you in the back of the car. Take another look at the television pictures. I think Michael Buerk said it was like a war in one hit and I know if I close my eyes I can still hear rockets whizzing past and debris falling from the sky. I think the condition of the car is a reasonable guide to what happened. When you hired it, it was a respectable Mercedes. After the explosion, it looked as if a tree had fallen on it. You may remember the broken glass

you had to lie on as we drove away. That was all that was left of the windows.

"One other thought. After you were hurt, we were the only ones crazy enough to hang around. I was almost knocked down by people and vehicles fleeing the scene when I tried to get another car. Frankly, I wasn't going back into the gully for 20 TV cameras.

"Once we left, of course, there wasn't much chance of ever seeing your gear again. You didn't know this at the time (neither did I) but while we were pulling you out of the car at the hospital the local vultures were sizing up an unexpected opportunity. No sooner were you eased out of one car door than light-fingered Ethiopian looters were slipping in the other. That's when my tape recorder and at least one of your stills cameras was spirited away to the Addis flea market.

"As for your watch, all I can say is that you had it on your arm when you went to the operating theatre. I made five more visits to the hospital after you left and the trusty Heuer chronometer had done a vanishing act in the best Mengistu tradition.

"In case you were wondering, I did go back to the scene of the accident the following day and even then it was still a dreadful place. We picked our way through unexploded Chinese hand grenades and pieces of shrapnel. We saw the burnt-out fire engine which had also been caught in the blast; we saw the stacks of AK-47s turned white by the heat; we saw the gully where you and John were hit – but we couldn't find your camera. Strangely enough, I'd like to see the footage you shot, but I don't need it to remember exactly what happened."

When Mo was strong enough, he booked a ticket to the UK, where he was reasonably confident he could be fitted with a false arm. He was less bothered about how it looked than how it worked. It had to be able to operate a video camera well enough for him to work again. It was equally clear that a new camera would have to be a part of the plans.

Visnews' engineering manager, Graeme Thompson, took up the challenge enthusiastically. He said later: "No one had done this before, for the simple reason that there aren't any one-handed cameramen. Professional broadcasting equipment is designed for right-handed people who use their left arm to control the functions of focus and colour balance."

Graeme approached the problem by trying to operate the camera himself using one arm. Then he approached Pyser-SGI of Edenbridge, Kent, UK, distributors of the Fujinon range of lenses and accessories. Their engineering manager, Paul Goodwin, met Mo, discussed the problem and did an incredible job modifying a Fujinon A14 x 8.5 ENG lens to include a rotary control next to the VTR button so the right-hand thumb could operate the focus. He also altered the camera and lens wiring to allow

colour balance to be adjusted by the right hand using two buttons on the lens. A special shoulder brace, which helped Mo steady the camera, was made by Optex Limited.

Mo recalled: "The result was a complete success and at least I knew I could return to work. In fact the new camera was so good that several other cameramen envied me and asked how they could get one. I told them 'You'll have to get your arm blown off!'

"Finding a new arm was harder. I was under the impression I would find the latest and most up-to-date prosthesis in England, but I was wrong. While doctors and specialists were extremely helpful, their offerings were fairly primitive. About the best they could offer was a hook – but I'm not a bloody fisherman. All I needed to complete the picture was a parrot, an eye-patch and a wooden leg!

"I told them I had heard of developments in electronic prostheses in America that might be the answer, but they cautioned me against raising hopes. Their feeling was that many products in the US were merely cosmetic gimmicks and a waste of time. However, I felt I had to give the States a try, so I flew to visit several research centres there which specialised in the development of controlled artificial limbs.

"Two experts thought I should have more surgery to remove the remainder of my elbow. This would have the benefit of allowing them to fit an electronic elbow to give me more flexibility. I was still not convinced. I didn't like the idea of having yet more bits chopped off me. Then I met John Billock, clinical director at a centre in Warren, Ohio. This was the turning point.

"He felt I did not need to lose the elbow and set about building me a fully bionic arm. There followed two weeks of tests and fittings. To be honest, by now I was thoroughly fed up with the whole business. It was more than two months since I had begun my quest and there were times when I felt like giving up."

The bravery of one small child gave Mo the courage and determination to continue. Billock brought in five-year-old Stephanie Bogdan, a girl who was born without an arm. Without any fuss she slipped on her artificial arm and quietly went through a series of manoeuvres to demonstrate her dexterity. Her quiet composure in the face of such adversity moved the cameraman almost to tears.

He said: " I knew then I could sort out my own problem. At least I had had the use of my natural arm for much of my life. You may have seen the documentary the BBC made of my search for a new arm. Stephanie is shown going through her paces and I think she stole the show.

"I returned to Warren for final fittings and eventually went home with

a new left arm. Its use is limited but it's fine for camera work. Maintenance is costly and the equipment doesn't last long so I'll probably have to get a new one every three or four years. With luck they'll update the technology and a lighter, more flexible version will be available."

What the technology did was to give Mo, via £40,000 of Nasa technology, a prosthesis that was extremely powerful. Basically, it allowed Mo's shoulder muscles to manoeuvre a mechanical elbow and wrist. Muscle impulses picked up electronically in the biceps and triceps of his upper arm activated the opening and closing of the hand. The arm was powered by two six-volt batteries which could even be charged from his camera or car battery if power ran out when he was in the field. He could – and did – demonstrate its abilities by crushing cans and breaking bottles, to the amazement of onlookers. He could also revolve his hand through 360 degrees, a trick he seldom lost an opportunity mischievously to exploit.

Camerapix colleague Steve Gill said: "The arm and hand were very lifelike and unless you were studying it, you were unlikely to spot the difference. One day we went to a bank where Mo had to pay in a cheque. As he queued, he carefully put the cheque into the fingers of his left hand, and when it came to his turn he thrust the cheque at the clerk and at the same time rotated the hand in a complete circle. The girl behind the counter screamed and dropped a pile of papers on the floor. She was terrified. Mo wept with laughter. What was less funny was being driven by Mo when, just for the hell of it, he would only use his artificial hand."

When he travelled, Mo would sometimes take his spare bionic arm, always an item of interest as he passed through the security check at airports. When questioned about his unusual luggage he gave his stock reply: "Don't worry about it, I'm in the arms business!"

Not all aspects of this false limb were so amusing. It was uncomfortably heavy and anyone who knew Mo in later years would have noticed a pronounced slope to the left. To counter the problem, and to avoid possible back trouble later in life, Billock built up his shoe. When he initially examined Mo, he was astonished to find there was a 4.5cm discrepancy between the length of his damaged right leg and his normal left leg, the reason why Mo walked with his familiar rolling gait.

Billock grew to respect and admire Mo. He said: "My family and I came to know him through his personal tragedy. He came into our lives and our hearts. Doubters had told him he would never again be able to operate a camera professionally. Fortunately, they didn't know the man behind the name. His own need, and especially his insistent desire always to exceed one's expectations, led me and my staff to further develop new technology which would improve his functional abilities and which since then has

benefited many others. On my first encounter with Mo, I told him it would take six weeks to produce this specialised prosthesis – a schedule based on my years of clinical and technical experience. By his persistence, Mo had it all over and done with in half that time because he wanted to cover a meeting of the Commonwealth Nations in Zimbabwe. He had the unique ability to challenge you to go beyond the limits of your own abilities. He was a man who knew and had no limits or boundaries. To him, anything was possible.

"Mo was a great ambassador for his country and the whole of the African continent. During one of his stays with us he spoke to my daughter's fourth grade class, at her request, about Africa. For well over an hour and a half, my wife and I watched in amazement as he kept 130 children mesmerised, sitting on a gymnasium floor around him, with his stories of Africa, the wildlife, the climate, the geography, and most importantly, its people. Each of those children wrote him a thank-you note. He replied to every single one of them. His love for children truly shone through that sometimes tough exterior, and I believe this love may have been the catalyst behind his efforts to awaken the world to the Ethiopian famine.

"My family and my staff are better people today for having known Mo. He was one of those rare individuals who somehow change your life forever. We are all eternally grateful for having the opportunity of knowing one of God's special people and share in the sorrow of having lost him."

In 1998, the American Academy of Orthotists and Prosthetists launched an annual award for outstanding disabled persons and decided to name it the Mohamed "Mo" Amin Humanitarian Award. In its year of inception, the award was made to Mo and received on his behalf by his son Salim in Miami on April 2.

Three months after the Addis explosion, Mo returned to full-time work. In October, he covered Queen Elizabeth's visit to Africa and the Commonwealth Conference in Harare. As British Prime Minister John Major left his limousine and walked past the Press corps he spotted Mo and came over. Mo remembered: "He asked me about the new arm and congratulated me on my return to the circuit. I knew then that I had made it back. I couldn't resist a private smile. Here I was, head of Visnews' Africa bureau, chief executive of my own company, publisher of more than 40 books, film and documentary producer and winner of some of the most prestigious awards in the business. I had achieved a lot since the day when I bought my first Box Brownie camera for 40 Tanzanian shillings at the age of 11."

John Major remembers that meeting. He said: "I was walking into the conference when I glanced at the assembled press and, to my astonishment,

I saw Mo there. I was amazed because it was only a few weeks since he was so badly injured. Reading the news reports of the incident I don't think anyone expected him to live, let alone return to work. I went over to speak to him and welcomed him back. He was as irrepressible as ever. You could be sure if you were on official business in Africa, Mo would be out there in front getting the pictures. We all miss him. His contribution to his profession and to the people of Africa is incalculable. He was unique, a man of outstanding courage and compassion."

What was not generally known was that, following the accident, Mo was in constant pain. He seldom showed it, though his irascibility sometimes ran very high. The pain was caused by a metal plate inserted into the top of his arm to hold the fragmented bone together. After the accident, the bone of his left arm above the elbow was shattered in shards no more than a few inches long. It would never have healed as a cohesive unit so surgeons had no option but to insert the plate and attach the sections of bone to this. It was not a satisfactory answer but the best option in the circumstances. For the rest of his life, Mo frequently returned to hospital for treatment to try to alleviate the suffering. In the many interviews for newspapers, magazines and TV he gave after the accident, he never once mentioned this fact.

Looking back on his closest brush with death and his subsequent struggle to overcome disability and reclaim his career, Mo told me: "Whatever the future holds, one thing is certain – that day, that hour, that split second changed my life irrevocably. From a practical point of view, nothing has ever been the same. Things you normally take for granted like tying shoe laces, driving, dressing, using a knife and fork, and any function involving the bathroom – tasks you perform daily without a second thought – now take up extra valuable time. Some things I just can't do.

"I don't like it, but I've learned to live with it and now I'm back at work and into a routine it's a lot easier. Not perfect, but easier. One thing it hasn't done is stop me. I've just had to change my methods. Part of my success is that I never trust completely to luck, even though I'm accused of having more than my fair share of it. I make sure I have the right equipment, back-up and, perhaps most importantly, the contacts. I'm still as diligent, perhaps even more so now, and I will usually double check everything again. Maybe I'm a little more cautious, though it's early days yet as to whether it pays off."

CHAPTER 10

THE OLD TESTAMENT
WITH ROCKET LAUNCHERS

'He was not beaten to a story in Africa

in 30 years'

MIKE PAYNE, REUTERS

SIX WEEKS after the Addis explosion there was a knock on the door of Visnews managing editor David Kogan's London office, and in walked Mo. Kogan was stunned, the more so because Kogan himself had been involved in the Addis incident and knew precisely how close the cameraman had come to death. But there Mo was, larger than life and as waspish as ever.

Kogan said: "Half jokingly, he began to berate me about expenses for the Ethiopia trip and demanded compensation for his camera which, if not completely smashed, had certainly not been recovered. I was amazed. This was a truly remarkable recovery. Only Mo could have done it. He was a genuinely incredible guy."

Kogan was well-placed to judge, having been Mo's line manager for nine years, a job few might envy. And he did not just have Mo to deal with. There were two other prima donnas. He said: "When I joined Visnews in July, 1988, I was warned about these three moguls who had been with the company more or less since its beginning. They were powerful figures within their own areas and you had to pay them due respect. There was Jean Magny in Paris, Prem Prakash in Delhi and Mo in Nairobi. They had set up their own operations in their own territories and you had to be careful how you treated them. They had a curious relationship with

255

Visnews because they were bureau chiefs who also ran their own companies. It was a very confused commercial set-up, but it worked. Of course, London had to deal with them and at that time the office was filled with people who had come out of local newspapers who had never worked for an international news organisation. They were frequently phoned up and terrorised by Mo, Jean and Prem.

"You learned that you did not argue with Mo about covering East Africa, you did not question Jean if he said he would not cover something in Paris, and Prem dominated his own area. It was actually a rather amateurish organisation when I joined, but the method of dealing with these guys did work.

"I knew I would have to meet Mo sooner or later, and people had told me he would come in demanding vast amounts of money for his contract and there would be complicated contractual negotiations – all that sort of stuff. So when we first met I told him 'Look, I have come here to sort things out. Either you work with me or we're going to fall out. It's not like the old days. We're not prepared to put up with you guys telling us to piss off.'

"So we did our contractual bit which was very complex – an odd melange between us and Camerapix and an individual deal with Mo as Visnews bureau chief. But I played it straight and so did Mo and we learned to respect each other. We got on pretty well after that.

"Our arrangement was something which Reuters, when they came in, did not understand. This was actually at the bottom of many of Mo's problems with Reuters. They didn't understand this Visnews Heath Robinson way of holding these relationships together and keeping these giants in place. But if you bear in mind that Visnews' only awards were won by Mo and Prem in their individual countries, you can see why it was necessary to keep them happy by allowing them creative freedom at the same time as having tacit control over their operations.

"Over the next two years we achieved a working relationship, with me in London and Mo in Nairobi. It remained that way until the Addis explosion occurred. That fundamentally changed our relationship."

Mo's world certainly began to change. He did go back to the frontline, but less frequently, preferring instead to concentrate on his publishing empire. A lot of the book production was done in London where many magazines and travel titles were produced. Towards the end of his life, Mo retrenched his publishing interests in Nairobi where his cousin's wife, Rukhsana Haq, took over as editorial director of that section of the Camerapix business, continuing to produce new titles. Mo was a great fan of the British Royal Family and during the course of his career met most

of them. The Queen and several of her relatives have personally signed copies of some of Mo's books which he presented at appropriate events. So it was with particular pride that in January 1992, Mo, clad in morning suit and top hat, went to Buckingham Palace where the Queen made him a Member of the Order of the British Empire. Congratulations poured in from around the world. One of his favourites was a telex from Mike Buerk with which he was so taken he later displayed it at his Nairobi office. It read: "Delighted to hear secret news. Couldn't have happened to a better person. Except me, of course. Unaccountably left out of knighthood lists yet again. Most people would have given an arm and a leg for one. Which means that you got yours half price!"

The *Sunday Times* reported a little known aside to Mo's award. To the cameraman's embarrassment, he found he was due to receive the MBE from the Queen on the very date he was down to cover a crucial assignment. He rang Buckingham Palace to point out the clash of dates. But an aide made it clear that this was not an invitation but a royal command. "Oh dear," said Mo. "I have to be at the reburial of the Emperor Haile Selassie." "In which case," said the aide. "I am sure Her Majesty will excuse you on compassionate grounds."

The MBE was an award of which Mo was especially proud and he was in fine form at the celebrations held later in an Italian restaurant in Pimlico. Surrounded by colleagues and friends, he kept everyone amused with anecdotes about his meeting with royalty. But he was upstaged by Buerk, who proposed a toast to his old friend and sparring partner. Buerk told the audience: "Once upon a time, Mohamed used to do reports about other people – wars, famines, that sort of thing. Now he's become so eminent he need only broadcast about himself. A small industry has grown up making films and radio programmes about Mo. Indeed, I'm making one myself. The International Red Cross still can't work out why the BBC has to send seven people to Somalia, and why they spend most of the time filming each other!

"The latest outing was on *Desert Island Discs* with Sue Lawley. All those things I never knew about Mo. Fourteen languages he speaks. FOURTEEN! But have you ever met anybody who understood any of them? It's bad enough trying to work out what he's saying in English – but have you ever seen him trying to talk to an Arab? Mo reckons being able to say 'Can I have blank receipt, please?' amounts to total fluency.

"Mo uses this fluency in languages at airport customs, speaking at high speed and with either enormous charm or the utmost ferocity, in a language the officer doesn't understand. Only once have I seen this fail, at an African airport where Mo turned to me and said 'This place is the arsehole of the

world.' The customs officer leaned over and said 'You're just passing through then, sir?'

"And Mo's lifelong love of music! I must say he kept this very much a secret passion. I was convinced that music to Mo was the rustle of high denomination notes. That and the screams of Visnews accountants. To hear Mo talking to Sue Lawley you would think that there sits a patron of the Mogadishu Philharmonic. All those nights in Ougadougou or Kampala or Makele talking about women or fiddling expenses, or those bastards on the foreign desk – and all he really wanted to be talking about was Puccini!

"Even Mo's apparently encyclopaedic knowledge of music is not perfect, however. He did have a little help in compiling a list of records that meant so much to him he would like to take them to his desert island. And shortly before the recording of *Desert Island Discs,* he went off to learn the crib sheet by heart. After 15 minutes, he came hurtling down the stairs, yelling 'You've screwed me up' His puzzled colleague asked 'What's the matter, Mo?' 'You said this piece was by Mozart.' 'But it is, Mo.' 'Well who's this bastard Adagio, then?' "

Buerk was telling the truth about Mo's lack of musical appreciation. The photographer made no secret of his disinterest in the arts and turned to close friends for advice. His final choice of eight records was: 1, Mozart's Clarinet Concerto; 2, *Wind Beneath My Wings,* by Bette Midler; 3, *My Way,* by Frank Sinatra; 4, *Malaika,* by Myriam Makeba; 5, *Smile,* by Nat King Cole; 6, *Do They Know It's Christmas?* by Band Aid; 7, *Aaja Ab to Aaja,* by Anarkali; 8, *Land of Confusion,* by Genesis.

For his luxury, Mo asked for his left arm, a request willingly granted by Sue Lawley, who also allowed him a satellite dish and TV set. He chose the *Life of President John F. Kennedy* – one of his heroes – as the book he would like to take with him.

Various publishing and news ventures kept Mo travelling and, though his enthusiasm for the hotter news spots of the world waned, his drive and energy were still as strong as ever. Long-term projects which had hitherto been left on the back-burner now began to take shape. He spent time working in the beautiful Seychelles islands, 1,000 miles off the East African coast, producing books and films. Robin Kewell, of the British documentary film company R.K.A. Productions, worked closely with him on a film about the island of Aldabra. It was a time he recalls with fondness. "Working with him was great. Working for him was another matter. Some people slagged him off, but I never found him to be difficult. As long as he didn't own you it was OK. We clicked and we got on well. I was always amazed at how he got things done – it was just by force of personality. When he died I felt robbed; I wanted a few more years of his laughter and wit."

Mo passionately believed in encouraging and developing the role of Africans within the continent's media sources. He was wary of the Western view of Africa and regarded the way in which the outside world portrayed it as condescending or, more seriously, as having colonial undertones. In Mo's eyes, this was tantamount to racism.

He rarely missed an opportunity to condemn this "condescension" and to press the cause of Africa. In January, 1995, 10 years after the Ethiopian famine, he spoke at a Los Angeles ceremony to mark the closing of USA for Africa which, over the past decade, had raised millions of dollars.

He said: "As a newsman, the danger in covering Africa is not only a physical danger but one born out of ignorance, bias, lack of interest and false priorities by the powers that be in the media – particularly in Europe and here in the US.

"When US and Western troops left Somalia last year, almost all newspapers and international television news organisations pulled out. The explanation was that readers and viewers back home would have no need to know what was happening in this war-wracked country. The impression created was that people in different countries only want to know of events where their own people are involved.

"Yet there are many events worth reporting on that continent. The UN is there, spending millions of dollars of taxpayers' money. What is being accomplished, or not accomplished, surely people around the world want to know."

Mo went on to point out that events in Africa and other Third World countries were only covered internationally when they could not be ignored. By then, he said, they were no longer events but tragedies. He added: "The second point is that good news – or what you might refer to as human interest – is ignored. As a result, there is little understanding of the causes and effects.

"Decisions on what goes into the press or on TV are made by editors sitting in cities like New York, Washington and London. These so-called experts do not even know the distance from one place to the other that needs to be covered. Most of them have never set foot in Africa."

Four months later, in May, Mo illustrated the cynicism of some Western editors in a speech to journalists of the US news station, CNN. He said: "A senior editor once asked me to cover the general election in Nigeria, adding that I should only spend the money if there were riots and dead bodies in the streets of Lagos. I asked him if this was the way he would treat a general election in Europe or the US. He answered that the two situations were 'different.' I asked how. He said 'You know.' To which I replied 'Well, I don't know.'

"In the event, I never went to Nigeria to cover the elections. Being an African, I couldn't bring myself to treat an African in this mischievous manner. This is often the reason why Third World leaders find it difficult to trust Western correspondents. It is the journalist's tendency to find fault rather than to report those countries objectively. It's as if human life would cease to be interesting if tragedies were minimised.

"A few Western correspondents know this is not so, that there are many positive stories to be told about Africa, dealing with development achievements, commercial success, rich harvests and happy human interest stories. But their editors back home have so often told them that such stories from Africa cannot interest US or European viewers. Thus few correspondents want to waste time by sending stories which they know will not be passed by their editors."

In the same way, Mo felt that African journalists were not given the same opportunities as their counterparts in Europe and America, and that international agencies operating within the continent were happy to maintain a status quo in which white journalists and managers continued to fill many of the senior roles. To balance this, he set up organisations to promote the cause of African journalists and was vocal in their support. He wanted to see Africans reporting on Africa, highlighting the good points as well as the bad, emphasising the diverse beauty, art and culture within the continent that was not always recognised. He wanted news and current affairs aired on a regular basis in a positive way.

Eventually he put a name to the idea – *Africa Journal* – a weekly half-hour television programme produced primarily for Africa. The *Journal* gradually became an obsession with Mo and led to a bitter dispute with his partner in the project, Reuters. But the final bust-up was some years ahead.

Meanwhile, fate was to lure him back to the frontline one last time. A new theatre of war had opened up in Somalia and Mo knew he had to be on the spot.

After Somali dictator Mohamed Siad Barre was overthrown in January, 1991, the country descended into anarchy where the rule of the gun was the only authority and rival faction chiefs fought a bloody battle for supremacy. Caught in the middle were the innocent civilians who, as the fighting went on, saw their loved ones killed, their homes wrecked and their lives destroyed. In 1993, the UN did its best to broker a peace formula and restore some kind of order to the chaos by sending in troops from Pakistan. Later, and more controversially, the Americans stepped into the situation sending in soldiers who were met with open hostility. It was a particularly bloody war, often fought in narrow streets and non-selective

in its victims. In all, some 20,000 people died in what was described as 'the Old Testament with rocket launchers.' Despite the obvious dangers, Camerapix kept a regular team flying in and out of Mogadishu, the Somali capital. Mo had been and so had his son, Salim, now a budding cameraman and very much a part of the company.

Like his father, Salim was involved in photography from his earliest years and by the age of five was treating it as a serious pastime. When he was 10, a shot he had taken of the East African Safari Rally became his first published picture, appearing on the front page of the *Sunday Nation* complete with a byline to make a boy swell with pride. It was becoming clear that career direction would be a matter more of inevitability than choice.

At 18, Salim left Nairobi for Canada to pursue a media course at Vancouver's Langara College School of Journalism. There, he helped produce a weekly newspaper, writing articles and taking pictures, all good experience for the years to come.

He returned to Nairobi when he was 22 and four months later, with the dust of travel barely settled, he was in the frontline. With a touch of irony, Salim recalled: "From the very first, dad said 'Don't be a journalist – get a real career. This is a shitty life. You have no social life, you're never around.'

"But I always wanted to be a journalist, right from the word go. For me, there was never anything else. It was all I had ever seen or known. I don't think mum was very happy about it, especially when I came home and said I wanted to go where the action was. But amazingly she seemed to think it would be OK if I went with dad! At least he always insisted we never travel in the same plane. He knew the risks and that was one way of minimising them."

Salim – who also filmed fighting in southern Sudan and Rwanda – travelled to Somalia to record the arrival, Fifth Cavalry-style, of the US peace-keeping corps. Thereafter, he and other Camerapix staff took it in turns to do a stint amid the action before returning to Nairobi. By chance, on one of these changeovers, his place was taken by his father's cousin, Mohamed Shaffi. In missing what followed, Salim inherited the legendary luck of his father for Shaffi found himself at the centre of an incident of such barbarity it stunned the world. He also came within a shutter's blink of death on the lawless streets of Mogadishu. Four of his colleagues were not so lucky.

Shaffi, 46, had always looked up to his charismatic cousin, watched him grow up and saw his career burgeon. He was there at Nairobi airport when Mo was deported from Tanzania to Kenya after being tortured in

Zanzibar. "I remember reading in the papers that he was coming to Nairobi with his girlfriend," he said. "It was taken very badly by the family. They didn't think much of that at all. Things were different then. Mo got a flat in town with Dolly. We knew, but nobody said anything about it.

"After a while, Mo started working abroad and he would send me a postcard from every country he went to. I've still got 50 or 60 of them from all over the world. I always looked up to him. He was nine years older than me and appeared to have a glamorous, exciting life. Everyone was impressed. I felt I had something to prove to him and my family, so when my father gave me a choice – the family construction business or photography – I was never in any doubt."

And there was no doubt in Shaffi's mind as to where he wanted to work and with whom. Mo was not so convinced. He was uneasy working with family and those relatives who did join his company all testify to how prickly he could be. But for Shaffi, the chance to work with Mo was all he wanted.

He said: "Mo was my hero and I asked him to take me on and train me to use a movie camera. I'd done some stills work with him but I wanted to use a videocam. Six months later, I had done little else other than file negatives (a soul destroying job when you consider Mo had the largest slide library in Africa consisting of more than three million transparencies).

"Every time I asked about movie work he'd dodge the issue. Eventually I had a showdown with him and he told me to forget any ideas of video work. He told me I'd never make it and I should leave. Basically, he'd had six months out of me for virtually nothing. After talking with my family, I decided to stick with it just a little longer.

"One day, Mo took delivery of some new video equipment and I asked him if I could have a go. He was disparaging, but told me to go out and get some city shots. I'd been on many jobs with him and had watched his technique carefully so I knew exactly what to do. I followed his methods and came back with some good footage. Mo was surprised, so he gave me another go and this time the results were even better. Then he went to the UK and gave me some library filming to do while he was away.

"I had to go out into the bush and, while filming, I became aware of how badly Kenya had been affected by drought, so I called Mike Wooldridge and we did some film with words to camera. Two days later, the footage was running on BBC TV news bulletins. Mo saw it while he was in London and was furious. He thought someone was working on his patch, phoned Nairobi and demanded to know what was going on. When he found out it was me, he was really pleased. After that, I gradually became Mo's number one cameraman and got sent on jobs around the world. It was like that

with Mo. You always felt you were proving something, that you had to live up to his standards. If you didn't he could be very scathing, really humiliating."

Then came the Mogadishu run on which Shaffi stood in for Salim. In an incredible sequence of events, Shaffi stared death in the face on seven occasions and survived by a whisker each time. Tragically, photographers Dan Eldon, 22, and Hos Maina, both working for Reuters, and Hansi Krauss of Associated Press and Camerapix sound engineer Anthony Macharia, 21, were not so lucky. They were all beaten and stoned to death by an angry mob.

The incident, in July, 1993, followed a US air attack on Mogadishu. The intended target was the headquarters of warlord General Aideed, but a civilian house took a direct hit and many men, women and children died.

The injuries Shaffi received when he was beaten almost to death left him with permanent mental scars. Mo sent him to London for treatment where his physical injuries healed within months, but the nightmares remain. It would have been understandable if such experiences had put him off news camerawork for life. But Shaffi returned to work with Mo for several years more.

He recalled: "In the office, he continued to drive me just as hard even though I suffered the after effects of Mogadishu for a long time. But out of the office he could be very kind, especially with children. I know he loved me and my family, and I loved him. When he died, I went with Salim and Nick Kotch from Reuters in Nairobi to help bring his body back from the Comoros. I was completely devastated by his death."

Tough or not, Mo was deeply affected by the deaths of his four colleagues in Somalia. When a permanent record of their achievements was quickly organised and a book produced portraying their art, he spoke movingly of each individual at a memorial service in Fleet Street's St Bride's Church.

He kept on expanding his publishing empire, broadening his field of interest to new countries in and out of Africa. In tandem, he nurtured his favourite project, *Africa Journal*. Soon, it became his passion and finally it led to the biggest bust-up of his professional life.

Mo had worked as Africa bureau chief for Visnews for many years. When the agency was taken over by Reuters, he continued his role, though internal restructuring meant changes which did not meet with his approval. The close corporate methodology and tougher accountability did not gel well with Mo's maverick style, and he never fully came to terms with his new bosses. Nonetheless, he persuaded Reuters to partner him in his *Africa Journal* project. Mo never liked parting with money and was reluctant to

commit Camerapix to the large financial burden of the new venture. He believed that the way ahead lay with Reuters' financial, news and technical resources and set about charming them into the fold. He eventually succeeded but it was never a happy marriage and, a year after the launch, separation if not total divorce, was in the air.

The agreement between the partners was complicated. *Africa Journal* was produced at Mo's studios in the grounds of his house in the affluent Nairobi suburb of Lavington. He had spent thousands of pounds installing new equipment and turning his drive into a full-scale car park. He hired staff – some against the advice of colleagues – and, in the first instance, took an overseeing role. But while Mo hired, Reuters bankrolled and accordingly insisted on more control than Mo would grant. He clashed with them and the new team. He felt that local staff were playing second fiddle to expatriates and disagreed with some of the working practices. Even so, the programme was launched and *Africa Journal* proved a success and received due acclaim. But Mo was still not happy and, without consulting Reuters, sacked people. In return, Reuters reinstated one, and then leaned heavily on Mo to take a back seat. Outraged, Mo hit Reuters with a locust swarm of faxes, memos and letters. Reuters responded and the situation degenerated into open warfare. Reuters suggested that Mo leave the running of the studio to the new team while he went on the road to sell the programme.

It was another slap in the face for the cameraman. On August 5, 1995, he wrote to his line manager Mike Payne: "I fought for this project for several years while a number of (Reuters) people in London and elsewhere did everything in their power to throw obstacles to prevent *Africa Journal* becoming a reality. Why do the individuals concerned today have a different view after only eight or nine months? Is it because it is a success that they had not expected? I am told 'Mo, we never wanted *Africa Journal*, but now it is a success we will take it on.' Well, Reuters can just fuck off!"

Sickened by the whole affair, Mo applied for a redundancy package. It looked like the ideal compromise but, inevitably, neither side could agree on terms and, just for good measure, Mo weighed in with a colossal bill for expenses incurred in setting up the project. It was instantly disputed. Legal letters were angrily exchanged as the affair reached a nadir. Reuters made several offers, Mo rejected them. He felt badly let down, or as he put it, "screwed," and it was his intention to fight as hard as he could. He seldom lost battles and he certainly didn't intend to lose this one. Anyone who had crossed him in the course of this business could expect trouble. Mo was a formidable opponent. He spoke to his former Visnews colleague, David Kogan, about the dispute and Kogan's advice was "Forget it, drop it,

rise above it and move on." Mo could not do that. It was too personal and he wanted blood.

Payne said: "*Africa Journal* was a tremendous initiative on Mo's part. To get the project up and running he went through all sorts of contortions. You have to remember that at this time there were no African programmes about, and for, Africa. After it all started going wrong Mo constantly sought my advice, but at the time I was in Moscow. He should have had a proper written agreement with Reuters. As I remember, it was just a verbal arrangment. Unless things are in black and white there'll always be problems. I saw myself as a peace-keeper, but there were months of bitter blood to sort out. Part of the problem was that TV for Reuters was a fairly new idea. Television is very much a maverick – and so was Mo.

"He had really worked hard setting *Africa Journal* up and selling it, but after Reuters got involved I think he knew in his heart it was never going to work. He felt as if his baby had been snatched away. It's such a shame. It was a great concept, but Mo wasn't really a TV news producer. He was much better in the field. Things were just starting to improve when he died. Ironically, the *Journal* now looks like being a success. There are a lot of ideas in the pipeline, including a deal to put the *Journal* into schools in South Africa. It's a shame Mo isn't here to see the project through.

"He was one of my closest friends – a unique and brilliant individual. I can honestly say there was not a story in Africa in 30 years in which the opposition beat us hands down."

Reuters editor-in-chief Mark Wood recalls the issue as a long and thorny one. He said: "There was a lot of friction between the people involved with *Africa Journal,* and Mo was not an easy man to deal with. There were different views of what the programme was supposed to be. Mo wanted to run all aspects of it in his way, but what he saw as a 'European' view of the programme we viewed as simply a 'commercial' one. We had to be cost-conscious but there did not appear to be much common ground. However, I believed we were moving to a resolution of the problems when, sadly, Mo died. He was a great loss to us all; a colourful character who is sorely missed at Reuters."

His business manager at that time was Steve Gill. He said: "The *Africa Journal* affair obsessed Mo. He could not be persuaded to walk away from it. I didn't think there could be a satisfactory conclusion as Mo saw it and told him so, but he wouldn't listen. Mo had often been the little guy taking on the big guys and winning and he didn't see why it shouldn't happen like that again. From a business point of view this was a mistake."

Gill was well placed to judge. He had known the cameraman for 20 years, having first met him when Gill was an accounts manager at a London

bank and had been sent out front to deal with this "difficult customer." He said: "We had a stand-up row. Basically, he told me where to go and I told him to do the same. After that, we got on well. I found that he would try to intimidate you, but if he couldn't do that and you stood up to him, you were OK."

The two men became friends and later, when Gill was in charge of the bank's African affairs, he saw Mo regularly. Eventually, Gill left London and moved to Kenya, where he set up his own financial management consultancy in Nairobi. Mo persuaded him to join Camerapix just after the *Africa Journal* project began.

Gill said: "Mo was not a good businessman in the true sense of the word. What he did best was selling himself. He had done very well but he would have done better if he had run his business properly. He didn't know the profit margin on many of his projects. But then I don't think money was his driving force. I suspect he might have been haunted by thoughts of poverty in his early life and was determined to make sure he would be OK financially. But when he achieved that level of financial security, and it was not a problem any more, he became driven by other agendas.

"He rarely thought things through, acting on impulse. He would get an idea, make a snap judgment, then go ahead regardless. When he was working on books, he would make his mind up to do one on a specific country and push on without thinking it through. There would be no guarantees that the book would sell, and no up-front orders. But that didn't matter to Mo. He would find a way of rationalising it and carry on.

"If the book went into reprint, which it usually did, he would at least cover his costs. Once the book was up and running, he would get someone else to work on it and move on to something else. He worked at such a pace it was virtually impossible for anyone else to keep up with him. He'd become frustrated and impatient when others couldn't match his output and would shout at the staff, tyrannise them, abuse them and call them all the names under the sun. Yet I've seldom seen such loyalty in a company as in those people who worked for Mo. Many had been with him for years."

For Salim it was no different. In the office he was simply a member of staff. Once, when Salim wanted to take his mother on a trip to Tanzania, he had to send a memo to his father addressed formally "To M. Amin."

In the last years of his life, Mo became increasingly preoccupied with *Africa Journal* and Reuters. But those who knew him well now saw subtle changes at work. For the first time in his life, the cameraman found the brake pedal, albeit imperceptibly, for at the time of his death he was personally involved in 26 different projects with Camerapix. No one saw

this more clearly than his elder brother Iqbal, a successful businessman who built up an internationally renowned company manufacturing high technology audio equipment from its base in Cambridge, UK, before selling it in 1998. Iqbal shared his brother's obsessive attachment to hard work and now, having achieved many of his goals, was looking for a change of direction. Sensing Mo's shift of mood, he convinced him to take time out in Mombasa for a look at their future lives. He said: "Mo would always listen to me and I managed to persuade him to come with me. I had a plan which involved both of us taking a back seat in our respective businesses and spending more time together enjoying the fruits of our labours. It was my dream to build a house in Islamabad for all the family, and for Mo and I to travel together.

"It was just the two of us for four days, during which time we talked about our hopes and straightened things out. Mo was still troubled by *Africa Journal*, but I reassured him things would be OK. I told him once 'Learn to relax a little – take time to smell the roses.' He said 'I've got hundreds of roses in my garden, but my gardener looks after them.' I replied 'You're missing the point.'"

Mo took the hint and indicated he would go along with his brother's plan but, typically, told him: "You do it first." Iqbal backed his judgment and took the plunge, selling his business, but retaining a consultancy brief. He said: "In the weeks leading up to Mo's death, I stayed in constant touch with him. The idea was going ahead when he was killed. He never got to smell the roses."

There was another reason for Mo's change of tempo. Salim had met and fallen in love with a beautiful young girl. Farzana Datoo had recently returned from England, where she had been studying the airline business, to join her family at their home near Lavington. When she met Salim through mutual friends, the attraction was instant. Romance blossomed and they were married on May 13, 1994. Pictures from the wedding celebrations show two happy families and Mo, fully equipped with bionic arm, filming the occasion.

Two years, later Farzana became pregnant. Joy in the Amin household was overflowing. No one was more excited than the grandfather-to-be. On December 5, 1996, a daughter Saher (A New Dawn) was born. Mo had been killed just 10 days earlier.

CHAPTER 11

VARIATIONS ON AN ENIGMA

'He was driven by an old-fashioned sense of morality and honesty and a fundamental love of Africa'

BRIAN EASTMAN, CARNIVAL FILMS

W HAT ARE the qualities which make a man extraordinary? A singular sense of destiny? A God-given talent that separates him from his contemporaries? The determination to rise above his circumstances and prove himself in the face of adversity? Or the drive of a personal demon, some intangible quality which even the individual himself may not comprehend but by which he is swept on regardless to whatever destiny holds? Probably a combination of them all. Mo would have been hard put to explain the whys and wherefores of his mercurial life, and anyway would have considered it a waste of time.

Mike Buerk said: "I don't think anyone truly knew the real Mo. We all knew a part of him." This compartmentalising of people was a core feature of the cameraman's complex personality. He focused in on his work totally and had to be in charge. He ran his own business and he liked to run people. One way to do this was to keep them in the dark.

No one ever knew precisely what Mo was up to because he deliberately kept people apart, unless it was in his interest to bring them together. It was shrewd manipulation, jigsaw theory politics, in which only he knew where all the pieces were and how they fitted together. In this way he kept everyone guessing and waiting – sometimes for payment – while he moved off towards yet another goal. He preferred action to analysis and, like many

who have made their mark upon the world, had little time for self-examination.

Those who have tried to fathom this complicated man discovered it is no easy task. For someone who lived much of his life in a glare of publicity, he was remarkably reticent about his background.

Essential elements can be traced directly back to his immediate roots. His father Sardar was devout, austere to the point of extreme severity at times, but also deeply loving. He was proud, dignified, hated subservience and was determined to be his own man. He was not afraid to speak his own mind and he held in contempt those who pretended to be what they were not. Above all, he instilled in his children the old-fashioned credo that hard work brings its own reward.

Elder brother Iqbal said: "Mo and I were very similar. We were both unconventional, we were both single-minded and we worked long hours. Some of these traits we got from our father. He taught us the simple discipline that, to get on in life, you have to work damned hard. We both did, and we both got to the top."

Seeking no man's favour, Sardar passed another key characteristic on to his son – pride in his own race. In the days of colonialism, when Sardar was making his way in the world, he never stooped to ingratiate himself with his European 'superiors', whatever the consequences. Colonialism may be a thing of the past, but racial prejudice remains an ugly fact of life and, as Mo forged his own path, the tenets of privilege, power and preferment were seldom far from the surface.

His way of dealing with racism was to lead by example. And while he would never have said so, it gave him evident satisfaction to be an underdog and a 'brown man' succeeding in his profession against the might of the Western media moguls. Certainly, he saw ample evidence of ethnic bigotry in his 35 years as a cameraman and, while he was a consummate professional who deliberately trained himself to be dispassionate from the subject in front of his lens, the anger never left him.

One of Mo's early encounters with prejudice was during his coverage as a young man of the plight of a group of Asians who received shabby treatment at the hands of the British. In the 1970s, many Commonwealth citizens were entitled to, and held, British passports. But these documents were often conditional. So when Kenya introduced harsh laws concerning citizenship and deported 34 Asians holding UK passports, the Asians were prohibited entry into Britain.

In a classic example of shuttlecock tactics, these helpless and stateless people were bounced back to Nairobi. The moment they landed on June 6, 1970, the Kenya government promptly declared them prohibited

immigrants. Although this was the day his son Salim was born, Mo took time out to film the unfortunate victims, aware of the irony that he too was a British passport holder and could well suffer the same fate. He went on to shoot footage of the devastating effect on Asian traders of an authoritarian ruling that they sell their businesses to buyers from the indigenous population.

On that occasion, he had to bite the bullet. But two years later, he showed his contempt for racism in his own inimitable, bloody-minded fashion. Mo had flown to the Rhodesian capital of Salisbury to cover the tour of Britain's Pearce Commission, which was laying the groundwork for a proposed Anglo-Rhodesian settlement.

When he arrived at the airport with his European soundman Paul Toulmin-Rothe, the white customs officer refused to acknowledge Mo's existence and instead questioned Paul about their equipment. But Toulmin-Rothe, relatively new to the game, was very much the assistant and politely explained to the officer that Mo was in charge. The customs man would not even look at Mo so a farcical, three-way conversation ensued with Toulmin-Rothe in the middle.

Mo explained: "Paul had insisted I was the boss, but the customs man would not speak or even look at me. I was not so much angry as sad for him. It got worse when we reached our hotel where staff were horrified by the fact that I was not white. Every day, Paul got a call asking him to tell me to move to another wing. He refused, again explaining that I was in charge. It made no difference. They didn't stop asking."

There were no non-whites in the hotel's restaurant, apart from Mo. In typically stubborn style, he ate there whenever he could, enjoying the discomfort it caused other patrons. It was the only amusement he had in the three days they spent there filming the riots and brutal suppression of black citizens.

Though Mo was of Asian descent, he was proud to declare: "I'm basically an African." His instinctive empathy with black Africans was a key factor in his successful dealings with the people everywhere on that continent. He said: "In Ethiopia, if you walk into the office of the person who is going to give you permission to photograph, because of the bureaucracy he is going to give you a hard time. Not because he doesn't want to give you the permission, but because the system is the way it is. Some journalists get very upset. They say 'Look, we are here to help you, to bring in more money, to bring in more aid. What the hell is all this fuss about?'

"Well, that's exactly the wrong approach. That's deadly. You can forget about permission because, although you are helping this man, and he knows you are helping him, he doesn't want to be insulted. In an African

context, that is definitely an insult – 'even if I am begging, I don't want you to rub it in that I am a beggar.' Pride rides over these things and if you do rub it in, he's going to tell you to go to hell. And that's where a lot of my colleagues don't really understand the system. So I have an edge simply because I know the situation and, what is very important, I know the people. This is the result of years of contacts. They trust me."

Mo was always prepared to play the long game, to go the extra mile to get his own way, and the more intransigent the bureaucracy he faced, the more stubborn he became. As soon as he was confronted by obstructive red tape, unnecessary obstacles or stony-faced officials barring his path, his hackles rose and he immediately sensed a challenge from which he rarely backed down. He took petty officialdom as a personal affront, an attempt by others to stand in the way of what he considered his right – to be first at the scene, to capture the big event and to get his film to the outside world as quickly as possible. To this end he went to extraordinary lengths with his well-used ploy of dummy film, his sometimes circuitous travelling arrangements, his occasional pretences to be anything other than a news cameraman and, of course, his use of a contacts list that was the envy of his colleagues the world over.

He said: "The problems of just getting to the story are enormous in themselves, not only because of officialdom but also because of the logistics involved, particularly when travelling with a full load of television sound and camera equipment. The final obstacle and the most crucial one is getting the story back to base. Without that, the whole operation is pointless.

"It takes a great deal of sweat and resolution. But it is the bureaucracy that is the final barrier. I just work around it, and let them feel that they are doing their job. It is pointless screaming at officials, because you come to a dead end. But at the same time, you can lead them on to letting you get away with something that you shouldn't."

Sir Bob Geldof saw at first hand how Mo would 'network' for contacts. He told of an occasion when he and Mo were both at a reception attended by many international dignitaries.

He said: "I saw Mo moving among the dignitaries, chatting and laughing. Then, when he left a person or group of people, he would retire to a quiet corner and take out a little book and write down a few notes. At first, I thought it was a way of recording names to jog his memory later. But then I learned he was simply updating his contacts with the names of anyone he thought might be useful later. He was a real player."

Never one to hide his light under a bushel, Mo claimed that at any time he could pick up the phone and speak to at least 18 heads of state. One of

his more powerful friends was former Pakistani President Zia ul Haq, who personally bought hundreds of copies of the cameraman's book *Journey through Pakistan.*

During research at Mo's studios in Nairobi I discovered not just one book but entire volumes of names and addresses of people who hc had, or could, call on.

There were times, however, when even Mo's persistence failed to achieve results. It was then that he called upon his secret weapon – his irresistible charm. It flowed like a river in spate and it worked on everyone, beguiling men, women, petty bureaucrats, politicians, heads of state, gun-toting guerrillas, despots and dictators.

I have watched him in action. Resolute officials, determined to deny Mo access, a pass, a visa or permission to enter some forbidden place, were surprised to hear themselves saying "Yes" and stamping the relevant document as a smiling Mo shook their hand and was gone.

The charm offensive was the acceptable face of Mo's determination to get his own way. As John Billock, who built his bionic arm, said: "The words 'No' and 'You won't' or 'You can't' were not found in his vocabulary – especially when they related to him or something he wanted or needed. This is certainly not to portray him as being disrespectful or arrogant, but to emphasise his determined nature to prove you can do anything if you really put your mind to it." Writer Peter Moll, who worked on several books with Mo, called him: "The man who wouldn't take yes for an answer." If someone agreed to his demands too readily, Mo was instantly suspicious and many is the innocent official who found himself at the wrong end of a Mo haranguing merely for acceding to his request!

Mo's obduracy was already evident when he was a young man at the Indian Secondary School for Asian Children. It showed itself in a brash, bullying manner coupled with an ability to take command. Already he was beginning to possess that sense that he was indisputably right while others were unquestionably wrong, but as yet there was no purpose to this restless drive.

Photography changed all that. From the moment he took possession of his first camera and realised he had found more than an interest – a passion – Mo was able to harness and magnify the power of his youthful determination, and forceful personality. And as he gained experience and became aware of his talent he turned his energies to honing and improving his skills, becoming the best at what he did, no matter the cost.

It was no coincidence that he turned his abilities to frontline news work rather than to so many easier fields open to him. Here was a territory where he could allow full rein to his restless spirit, to his desire to meet a

challenge head on, to combatting the bureaucracy for which he had so much contempt and, more than anything else, to indulging his fierce competitive instincts.

Right from those early days, Mo worked like a driven man. When he was not taking pictures, he rolled up his sleeves and cleaned out the office. He once said: "I can't bear to waste time. I've never been good at just sitting around. I get irritable and start shouting at people. I am a strong believer in God and I'm sure he gave me this life to do something with. I'll have plenty of time to rest when I'm dead."

So he pursued his career like a man possessed. If he was particularly busy he would not waste time going home to rest, but would nap at his desk for a couple of hours before pushing on. He was renowned throughout his professional career for rising at 3 or 4am, driving to his office and working undisturbed in the quiet hours of the early morning. By the time his staff arrived, Mo had often completed half a day's work. By this expedient, he achieved twice as much a day as other businessmen. There was certainly no slacking when Mo was about. If his staff took time out, they would get a stream of invective in one of several languages that could be heard half way across Nairobi. If that failed, Mo would sack them.

To be employed by Mo and to have a life outside his office was almost a contradiction in terms. He preferred to hire young single cameramen for this very reason. They were less likely to balk at what was demanded of them and more likely to get the job done. Inevitably, this caused friction and the list of journalists who left his employ in frustration or anger, or both, would stretch from the Cape to Cairo.

Paradoxically, there was still a queue of people keen to work with Mo, and though he could be quick to anger and did not forgive easily, his drive, energy and sharp sense of humour endeared him to most. There was always a sense of excitement in the air at Camerapix, of something about to happen. It made employment much more than a nine-to-five experience, even if it was not always a happy one. Not everyone could live with it. If you did not hit it off with Mo fairly quickly, or did not agree with his method of operation, a parting of the ways was inevitable. Mo said: "I am single-minded when it comes to getting the best pictures, but that is how I make my living and, if it puts a few noses out of joint, then so be it. In my business there is a simple bottom line – if you don't deliver, you don't get paid." A perfect illustration of this theory was echoed in the photographic envelopes that Mo had printed up as standard for Camerapix. They all carried the same bold message on the front "URGENT – USELESS IF DELAYED!" – a message which could easily have been a metaphor for Mo's hectic lifestyle. One person whose nose was put out of joint by the

cameraman's mercurial temperament was photo-journalist Barbara Balleto who worked full-time for Mo for three years from 1986 – and quit three times. She said: "It was a love-hate relationship, but I learned more working for him than with anyone else. He was a flirt, a charmer and a bastard. Mo could put you down so badly you'd feel like giving up. He sent me so many memos rubbishing my work he undermined my confidence. Then, for the same work, I'd get herograms from UPI or some other agency. Mo liked to come across as a hard man. However, I knew that underneath it all there was a softer side. He did a lot of work for charity, but preferred to keep it quiet. When he supported Nairobi Hospital's accident and emergency department and the East African Women's League, he'd contribute beautiful photo-murals of his own work for auction then, on top of that, buy other expensive items.

"We fell out more times than I can remember. Things got so bad that I had to leave. But he was such a good operator I still worked with him on and off for 10 years. When he died, I was devastated. I miss him."

Mo wooed journalist Rita Perry from *The Traveller* (where she worked with Graham Hancock) to set up his London office. She said: "He did the charm number on me and I found myself, like so many others, unable to resist. I'd never done anything like it before, but it didn't bother Mo. He told me to get on with it – then blew a fuse when, inevitably, some things went wrong. I stayed for four years because things seemed to happen around him. Mo was like a whirlwind. He had an incredible sense of ego and no one was allowed to outshine him. The one outstanding thing I remember about him was his love for Africa. It was in his blood. It was his passion."

With such energy and determination, it was not surprising that in Mo's early days he upset established freelancers who resented the upstart in their midst. Some responded to his requests for advice by giving him false information. Such uncharitable acts cut deep with Mo, but he learned the lesson well and resolved never to do the same. With few exceptions, he gave advice freely to aspiring photographers and cameramen. When former Miss India, Pamela Bordes, turned her back on society and glamour and decided to pursue a career in photography, she approached Mo for help and advice, travelling on safari in Kenya with him to learn the craft. She is now a successful photographer working in India.

Mo's approach was straightforward: "We all have to start somewhere and if someone is enthusiastic enough to speak to me and they really want to know how it works, I never turn them down. Don't get me wrong. I'm not talking about the business side of things. If I'm on a job, my main aim is to beat the opposition and get my pictures to the right destination. But

I'm always happy to offer experience and technical help." His ruthless determination to trounce the opposition was perfectly illustrated during the civil war in Ethiopia in 1991, just 24 hours before his arm was blown off in the ammunition dump explosion. Mo had shot gripping footage of the fall of Mengistu's regime and was desperate to get his film to the outside world.

The airport, which had been captured by the rebels, was closed and the runway was blocked by a barricade of buses and trucks. Using a satellite phone, Mo chartered a plane to fly in BBC reporters from Nairobi and take out his film on the return flight. Arranging permission for the landing took him four hours of tough negotiations. Leaving nothing to chance, Mo also put into operation an alternative plan, persuading rebel leaders to take him to a satellite ground station 10 miles from Addis Ababa. Mo was aware that the soldiers holding the station had not eaten for three days. So, cunningly, he loaded his truck with food from the Addis Hilton to exchange for use of transmitting facilities.

The barter never came off, as the drive to the station became so perilous that Mo was forced to return to the relative safety of the city. There, he and his crew dashed back to the airport to meet the BBC plane. His negotiations with the rebels had worked and the runway was briefly opened. As the aircraft touched down, Mo was joined by a film crew from CNN who were confident they could use 'his' plane to fly out their own footage. No such luck!

Mo said: "They came to the airport with their bag to put on our plane and I told them 'I'm sorry, there is no way these pictures are going.' After all, they were our competitors. The US producer was really bitter and could have strangled me but I told him 'You'd do exactly the same to us. That's just the nature of the business. Your pictures are not going.' They just had to stand there with their bags seeing our plane take off." The barricades were put back in place as soon as the aircraft lifted from the runway. Twenty-four hours later, members of that same film crew were giving blood to save Mo's life.

Mo's hard-nosed professionalism might not always have been appreciated by his rivals but it won admiration from those for whom he worked. Brendon Grimshaw said: "What endeared him to me as an editor was his total reliability. He covered literally hundreds of jobs for me, illustrating all aspects of the national and social and cultural life of Tanganyika, and always delivered on time, with the pictures always usable. If Mo was flying up to Addis for an Organization of African Unity summit, I would get a call asking if I wanted the 'usual.' I always said yes. The 'usual' meant that Mo would sling an extra camera around his neck and shoot off

a roll of pictures specifically of our President Julius Nyerere and his team. The roll was handed to the pilot of the next plane bound for Dar and I had them the same night or, at the very latest, early next morning. For me, this meant a blow-up of the very best shot on the front page and a page of pictures inside. Agency prints would arrive on my desk a few days later."

It was such rigorous attention to commercial detail that saw Mo rapidly rise from obscurity to a position as one of the best and most dependable photo-journalists in Africa. Indeed, it became a matter of personal pride to be first back with the news from any assignment. By such determination he not only triumphed over his rivals but sold more pictures.

Covering frontline action was what Mo did best. There, in the heat of danger, he could think on his feet and improvise at speed to maximise a situation. Quite often, he would be shooting stills and cine for several clients at once. There was one other reason why Mo was willing to spend time in war zones; always conscious of the value of his time, he enjoyed claiming his allowances from news agencies. With characteristic prudence, he would sometimes convert his hotel toilet into a temporary darkroom and, drawing on his experience as a youngster, was able to develop his film at considerably cheaper prices than might otherwise be the case.

Such enterprise was a Mo hallmark; he always seemed to be able to make a triumph out of adversity. Faced with impossible situations, he simply made them possible. Rather in the manner of a magician performing a trick, Mo would leave onlookers – often his rivals – wondering "How did he do that?" And like a wily conjurer, the answer was usually quite simple: painstaking preparation and meticulous attention to detail, allied to unsurpassed contacts and a God-given talent often referred to as 'Mo's luck.'

But 'luck' is not an accurate assessment of what made Mo successful, though it is a theme which ran through his life. To casual observers, it often appeared just a matter of being in the right place at the right time far more often than his colleagues. Dismiss the element of coincidence and you begin to see a method at work.

Mo explained it thus: "Work has never been a chore. I get edgy and irritable when planes are delayed or cancelled – and that happens a lot in our line of work. Other journalists shrug their shoulders, curse the airlines and head for the nearest hotel pool or bar. I don't drink and I hate sitting around swimming pools or anywhere else when there's nothing to do. So I check my equipment thoroughly, double check my travel arrangements, update my contact list, call my Nairobi base and see if I can work round the problem. That's the way I've always operated and it has stood me in

good stead over the years. But because I don't follow the crowd, go with the flow, some people see me as cold and calculating, unfriendly, even ruthless. This is not true.

"In any profession there are few substitutes for hard work and dedication. I believe in both and quite a bit more. A good news cameraman needs forward planning, intuition, contacts and a lot of luck. The life is never dull. The bizarre, the fantastic, the horrific, the tragic and the comic are regular ingredients in any working day. Ask any of my colleagues and they will tell you that a sense of danger is part of the lure, the catalyst which moves the adrenaline pump up into overdrive when the heat is on."

Mo made no secret of the fact that he liked to make money. He was in business after all. He often remarked, somewhat bitterly, that cameramen took the largest share of the risks but earned the smallest share of the money. Brian Eastman, who runs the award-winning independent television company Carnival Films, had first-hand experience of the cameraman's appreciation of his own worth. Eastman was making a drama series for TV on the heroin trade, entitled *Traffik,* in which much of the action takes place in Pakistan.

It was a logistical nightmare for Brian, who was constantly at loggerheads with the impenetrable local officialdom, especially as the theme of his production did not always portray the government in a good light. With costs mounting, Eastman turned to Mo for help, mindful of his contacts within the country. Mo said he could sort out all the problems with one phone call and demanded a fee of £5,000. Eastman was outraged. "You mean you want five thousand quid to make one phone call? Get lost!" Mo said: "I told him 'Look, I could tell you it will take me weeks to get your problems sorted, but I won't. I make one call now and you can go ahead with filming. If I get permission, I get the money. If I fail, you just pay for the call.'" Eastman didn't buy it, so Mo left.

The next day, with Eastman's crews still standing idle, he phoned Mo again. "Make your phone call," Eastman told him, "and get your £5,000." Mo told him: "I charge by the day and my price has gone up. It's £10,000 now."

Eastman was incandescent, but he paid up. Mo picked up the phone and called President Zia on his private line. They greeted each other like old friends. Mo said: "I told him what the story was about and he asked me what good it was going to do for Pakistan. I told him 'Not a lot. It's about heroin, it's about drugs, it's about corruption in your government, but it's true.' So he asked again if it would do his country any good. I said 'The only good it will do you is the fact that you have allowed such a film to be made in your country and that you are committed to stopping the

trade in drugs.' He said 'What do you think?' Here's the president of Pakistan asking my advice! I said 'I think you should allow it in the interests of press freedom.' He said 'OK, if that's what you say, then fine.' I told Brian 'You have your go-ahead.' "

Mo went on to co-produce the award-winning series with Eastman, who confirmed the story, if not the details. Eastman said: "We were having trouble getting permits and permissions to work in Pakistan and someone said I should meet Mo, who was well connected with the military there. I went to see him in London, where he was in the middle of 100 different things and though we got on well he wasn't very interested in helping. But in the end he said OK.

"We were due to shoot in mid-February 1989, but letters promising permission never arrived. It was the usual pandemonium you find in Pakistan. But with Mo on board, he taught us how to talk our way around things. He could sort things out at any given level. The big Afghanistan war was going on at the time and we wanted military equipment, aircraft and helicopters. Mo fixed it, and we got some excellent footage. He always got results.

"I recall the phone call to Zia which he made for us, but I don't remember the figures. You have to take into account that prices in the news world were very different from those in the film world."

Mo and Eastman forged a lasting friendship and went on to work on other projects, including another British TV blockbuster, *The Big Battalions*, shot in Israel, Britain and Ethiopia. As a child, Eastman had suffered from polio which left him with a permanent limp. The sight of him walking alongside Mo, each with his distinctive rolling gait, drew affectionate smiles from film crews on location. Eastman added: "They used to laugh at us. We made quite an odd couple! I really enjoyed the time I spent with Mo. He was a man driven by an old fashioned sense of morality and honesty and had a fundamental love of Africa. He cared very much about his work and would show us his books in which he had great artistic pride."

Approbation from his peers meant a great deal to Mo, as did the more tangible rewards of his efforts in the shape of awards and citations. Yet there was a degree of envy in their admiration as Mo, time and again, stole a march on his competitors. Equally unsettling was his boundless confidence. To those without self-belief it was an infuriating trait but one that gained him extra psychological points whenever he went into action. He gave the impression he would win regardless, and he usually did. When Mo was on a job and began to gather his team and equipment together, other journalists would get nervous, a little edgy. Did he know something they did not? Was there a new angle? Had he found the key person in the

drama for whom they were all searching? In the highly competitive world of news gathering, where egos are eggshell thin, an advantage like that was worth its weight in gold.

But to keep that edge on the competition, Mo had to be permanently razor sharp and ready to take off at a moment's notice. He always kept an overnight bag packed, and his passport and an airline guide to hand.

One other facet which kept Mo ahead was his risk rationale. He often said he did not take unnecessary risks. But questioned further, he would admit to a more ambiguous "I only take calculated risks." In rare moments of confession, he would sometimes admit, "You just go in and hope for the best."

Mo explained: "When you are in a war zone it will be dangerous. You do what you can to minimise the risks balanced against the need to get your pictures. After that, it is in the hands of God. No story is worth getting killed for. You can never be absolutely sure about situations, but you can cut down the risk by doing the right sort of planning.

"There are times when I have not gone into a situation but waited instead for a day, two days, maybe even a week, because I knew it was too dangerous and the chances of going in and coming out with the story were zero."

Some months before Mo's death, I spoke to him about this risk philosophy, particularly in view of the punishment his body had taken over the years. We met in central London and I watched Mo walk towards me. He was unmistakable. There was the familiar limp, penetrating gaze behind thick-rimmed glasses, the goatee beard and the roguish smile. His left sleeve, tucked into his jacket pocket, was evidence of his latest and narrowest scrape with death.

"I may not be the man I used to be," he said. "One leg is shorter than the other, my right shoulder is scarred from shrapnel, and I've only got one arm. But I consider myself fortunate. Each of these 'professional souvenirs' is testimony to my good fortune in surviving incidents which would otherwise have killed me. Serious risks come with the territory. If you want the best pictures in the worst situations you have to go to the limit. That's the way I've always played the game, with total dedication. The trouble is that the dividing line between dedication and obsession is as thin as a strip of 35mm film. Some time, somewhere, over the past 35 years, I crossed that line and came to realise that pictures, cameras and news photography would always be a way of life.

"Don't ask me when it happened. But I guess when you spend 14 hours a day, seven days a week, year in, year out, doing the thing you love most in life, there is an inevitability about the outcome. There's no going back.

Even with one arm, I still couldn't do anything else and I wouldn't want to. I'm never happier than when I'm on a job with a camera in my hand. I love the adrenaline of frontline action. Confronting danger brings its own excitement and rewards."

There was an element of bravado about such an approach, almost as if Mo were trying to justify actions which appeared to others to border on the foolhardy. It was more, I suspect, to reinforce his belief in his own ability to come through.

Mo was not unaware of the irony of his chosen path – that, as is the case with all frontline journalists, his success was often founded on the misfortunes and tragedies of others. He was pragmatic about it. He said: "In a commercial world where the media have to sell themselves to survive, visual impact is everything. From a ratings point of view, war and suffering are preferable to peace and contentment. Perverse as it may sound, human tragedy now has a certain entertainment value. So if it hasn't got a body count, it's not going to rate.

"This attitude to bad news not only has the capacity to desensitise audiences to the violence and suffering of this world, it may also give them the false impression that such things are natural, inevitable, and therefore beyond anyone's ability to deal with them.

"Yet occasionally the message gets through. The horrors of the Ethiopian famine were only brought to the world's attention because of television. And for once instead of people being turned off by what they saw, perhaps for the first time in the history of the human race they acted in concert for the benefit of their fellow human beings."

For those who did not know him well Mo could appear to be indifferent to the tragedies which unfolded before his lens. But he understood only too well. He once said: "I've had a tough life which makes me try to get across the message of other people's suffering. I can do this because I've been there." Mo knew it was hard to move people with pictures of genuine human suffering when television fed them a constant diet of fictional violence. He was aware that his own footage could not always convey the real nightmare for those actually involved. He said: "Real death and real human suffering not only seem more remote, they seem less credible because they lack the dramatic impact of fiction. In other words, audiences in affluent cultures have seen better versions of war and disaster than they are ever likely to get in the news.

"The moral dilemma for the cameraman, myself at least, is not whether my presence is intrusive or that I am exploiting grief and suffering. The fact is that I am employed to cover such stories. There is no question of seeking profit and, since Ethiopia, I have been more conscious than ever

before that such coverage has to be about something more than just work."

The contradictions in Mo's character, and his own driven way of dealing with them, were mirrored in his private life. He married sweetheart Dolly Khaki on October 16, 1968. The ceremony, held in his small Nairobi apartment, was extremely quiet with just two witnesses, both photographers, being present. Mo had two reasons for keeping it low key: he had always kept his personal life apart from his work, and this was a very private matter. More importantly, he and Dolly were from opposite sides of a serious religious divide – he orthodox Muslim, she an Ismaili – and Mo was anxious to avoid the wrath of his extended family, many of whom lived in Nairobi.

In the 1960s Dolly was a stunning young model making a successful name for herself designing and modelling her own clothes. She had a large shop off Dar's Independence Avenue and seemed set for a glittering career. She was popular, enjoyed dancing and parties, came from an affluent background and mixed with the city's smart set. Mo came from a poor family, hated dancing, was something of a loner and had little time for socialising. Yet they fell in love and became inseparable.

What strange alchemy bound them together can only be surmised but the attraction of opposites may have had something to do with it, even though both had forceful personalities, which they would need to weather the family storms ahead. Mo's orthodox Punjabi background and very different social status were the main reasons for his family's concern over the affair. In turn, Dolly's family were followers of the Aga Khan and she was expected to choose her partner from the Ismaili community. That both shrugged off such opposition says much for their love at that time.

They met when Mo covered a fashion show in Dar in which Dolly was modelling her own designs. Mo knew her brother Aziz and rented half a shop from him to set up his first photographic business in 1963.

He was determined to make it a success. At that time, Mo needed financial independence to achieve his immediate ambition which was to marry Dolly. Also, he was keen to leave home which was becoming decidedly cramped. The family consisted of brothers Iqbal, Mo, Manir, Alim and Hanif, and sisters, Sugra, Sagira and Nazira. While life was certainly not unhappy, money was hard to come by. Mo's father, then 53, was thinking of retirement and wanted his family to move with him to Islamic Pakistan now that his home town of Jullundur was inside Hindu India following partition. But Mo had other ideas. He felt part African and to him the newly independent Tanganyika was home.

Eventually the family did leave, but Mo stayed behind, determined to make his way in Africa. Brother Iqbal recalls: "I was already away at college

in Nairobi and Mo had set up a steady business in Dar. There was no way he was going. I know my father was disappointed but I think they both knew it was not going to happen." When Mo was expelled from Tanzania, following his imprisonment in Zanzibar in 1966, he moved to Nairobi and took a flat near the city centre. Dolly joined him but they kept their relationship very quiet to avoid upsetting Mo's family. At that time, Mo came to look upon his uncle, Niaz Mohamed, as surrogate father and adviser. Niaz, who lived in a Nairobi suburb, was a pious man who would expect his nephew to marry within the community, and Mo knew his marriage to Dolly would not be well received. He explained: "Dolly and I had fallen in love and wanted to marry. We knew there could be a few problems but we didn't care. We didn't have time for a wedding party, so I bought a few sweetmeats for the occasion and that was it." He'd only taken half a day off for the ceremony because of an assignment in the afternoon.

If Dolly was perturbed by this somewhat peremptory approach to what should have been one of the most important days of her life, she remained stoically and tactfully silent. But she may well have had an inkling that living with a man of so singular a purpose was not going to be a bed of roses, and could have consequences for her future happiness.

In May 1970, when reigning Miss World, Eva Reuber-Staier, visited Kenya, Mo found it one assignment which did not carry a hardship tag. He covered the trip extensively, often working well into the night and not arriving home until the early hours. Given his enthusiasm for such glamorous subjects, it is not difficult to understand why Dolly was troubled.

But this was also a time of great happiness, for the following month their son Salim was born. His arrival was a dream come true for Dolly, though his birth, by Caesarean section at Nairobi Hospital, had not been easy. Soon afterwards, Mo was travelling again. His regular absences were to set the pattern for their married life. She said: "There was nothing I could do about it. You see, I loved him completely. From the moment he kissed me in his little dark room I knew he was the one for me. I gave up everything to be with him. I knew when I married him that he would often be away but it still hurt. Yet he could be caring and kind. Sometimes he would come home after weeks in the field only to leave again the following day. But I had to accept that. I adored him and he kept me in touch with everything he was doing.

"Luckily, I'm the homely kind of person so I didn't make much of a fuss about it. I am proud to have been his wife."

Dolly remained devoted and concentrated her attentions on bringing up her son. Mo was very much an absentee father, always working and more of a legend than a physical presence to his son, Salim. Inevitably,

Salim grew up to be very close to his mother and still is. He said: "I looked up to dad and respected him, but it was mum who brought me up. I know his early life had been very tough and I think he built an emotional barrier around himself for protection. He found it hard to show love."

No one knows this better than Salim, especially in a professional context. In the office, as in life, Mo imposed the most demands on himself. But family came a close second. Salim said: "At work, he went out of his way not to show me any favours, as if to prove to the staff that everybody was equal in his eyes. He was inspiring and demanding, expecting the same excellence and work ethic from me as he did from himself. But though he was very hard on me, I know that deep down he loved me very much. He was far harder on himself."

Salim also pointed to a softer side of his father's character. He said: "Dad loved children. They responded to him. I think his life would have changed considerably had he still been around. It was such a tragedy that he never saw his granddaughter. He had so much more to live for, so many plans and projects unfinished. When he died, we received hundreds of letters, a lot of them from people and organisations I knew nothing about but who dad had helped, or with whom he was actively involved.

"He was a lot of things to a lot of people. He made many friends and not a few enemies. To me he was, first and foremost, my dad. He led an inspirational life and he taught me one important lesson: anything is possible if you put your mind to it. In his case, I think that after the 1991 blast in which he lost his arm, he realised he was mortal. He seemed to have this strong urge to finish things."

This was echoed by Mo's cousin Shaffi who said: "I think all great men – and he was a great man – have to be bastards in some way. I don't believe he wanted people to know that deep down he was soft hearted, so he put over this deliberately tough exterior."

THE LEGEND LIVES ON

'Mo's story is one of courage, persistence, and humanitarian commitment'

<div align="right">

MARY ROBINSON,

UN HIGH COMMISSIONER FOR HUMAN RIGHTS

</div>

T HE LEGEND of Mohamed Amin continues through the lives of many people. In the aftermath of his death there were numerous moving tributes. The house in Lavington was inundated with cards, letters and telegrams and telephone calls of condolence were received from all over the world. One of the first to respond was President Daniel arap Moi of Kenya who knew the photographer well.

He said: "Mohamed Amin was a true son of Kenya, an ideal ambassador who always took a positive view of our country, and of Africa in general, both at home and on his many trips abroad. He was fearless in his pursuit of the truth and, through his images, made us aware of all aspects of mankind. In his profession he stood out as a beacon of excellence, never swerving from the right course, never influenced by prejudice or preferment. The nation mourned his loss, remembering his tireless efforts on behalf of those less fortunate than himself, regardless of the risk to his own life."

Affairs of state prevented President Moi attending a memorial service in Nairobi in November, 1996, but he sent the attorney general, Amos Wako and the then minister of foreign affairs, Stephen Kalonzo Musyoka.

The following month, hundreds thronged another memorial service in Addis Ababa. This was followed by a photographic exhibition on Mo's

life, hosted by the Ethiopian Journalists Association and subsequently shown around the country. On Boxing Day evening that same year, the BBC screened a documentary, titled *Mo: A Tribute to Mohamed Amin*. Mike Buerk provided the commentary.

In February, 1997, at the Royal Television Society Awards, tributes were paid to Mo by Buerk and by the editor-in-chief of Reuters, Mark Wood. At this event, Reuters announced the setting up of the Mohamed Amin Fellowship at the University of Wales, in Cardiff. The award provides for one African TV journalist to study for a year. The first winner was Solomon Omollo of Kenya Television Network in Nairobi.

In March, the CNN African Journalist Foundation paid tribute to Mo at its annual award dinner in Johannesburg. The ceremony was attended by Thabo Mbeki, vice president of South Africa. During the evening, an annual 'Mohamed Amin Photojournalist of the Year Award' was announced, to commence in 1998.

March 1997 was a busy month for Salim. He attended the One World Awards at London's Mayfair Hotel on the 18th to receive, on behalf of his father, a Lifetime Achievement Award. The next day, St Bride's Church in Fleet Street was overflowing for yet another memorial service to Mo. Twenty-four hours later, Salim and his family were in Dublin for a similar event at the Lord Mayor's residence where a tribute from Bob Geldof was read out. The following day, Ireland's President Mary Robinson was host to the Amin family at her Dublin house where she paid her respects to Mo's memory. Now the UN High Commissioner for Human Rights, she had met the cameraman on a number of occasions, and said: "He was a wonderful inspiration to all who knew him and will be especially remembered for his courageous coverage, over many years, of regions of conflict in Africa. I had the pleasure of meeting him when I opened the *Images of Conflict* exhibition in Dublin some years ago – an exhibition organised jointly by Reuters and Concern in remembrance of journalists and Irish volunteers who lost their lives in the cause of humanitarian ideals.

"That exhibition brought home starkly the dangers under which journalists operate when bringing news from war regions. It helps, even now, to put in context the courage of Mo Amin and others like him whose work challenged the international community to respond to the suffering and need which they so professionally portrayed. There is a story to be told – it is a story of courage, persistence and humanitarian commitment."

In April 1997, Harry Belafonte and other members of the USA for Africa organisation hosted a memorial tribute to Mo at Unicef House in New York. Salim then joined Bob Geldof and representatives of Unicef to celebrate the Day of the African Child in Bossaso, Somalia, where tributes

were again paid to Mo. It was at that event that Geldof took time out to remember Mo at a TV awards ceremony. He said: "I hadn't seen him for ages and when I entered the green room at the TV studios, this man put his hand over my eyes and said 'Guess who?' 'Mo', I said. He was bit annoyed that I'd got it in one and resumed his normal awkward formality by holding out his hand and asking 'How did you know?' I didn't say but of course it was that gentle, accented voice and a general Mo-ness, which is hard to specify.

"It was a rare moment of playfulness for a man who never seemed to stop thinking – checking the angle. We both got the same sort of awards and were probably both there for the same reasons – to see who we could meet to put the squeeze on for our own particular ends.

"He was of course known for his camerawork and a ridiculous disregard for danger. But Mo was, above all, in the grand African tradition, a wheeler-dealer. He knew everybody and everybody seemed to know him.

"He dealt in genteel influence and understood the exquisite patience, tact and theatrical good manners required when dealing with African authority. And yet he owed them nothing. He spared no one with his camera. When it was focused, his camera seemed to become a glaring, subjective, unblinking and shameless eye on the world's infamy.

"He was responsible for one of the most important news reports of the post-war period. There was a terrible silence about his famine pictures. A silence punctured by the whimpers of pain and despair, by the desolate moans of desert winds and hopeless humanity. It was all far, far too big and Mo reduced it to its awful, terrifying banality by focusing hard, disciplining himself with a barely suppressed anger. The camera was steady, but one felt the cameraman shaking with rage.

"Time and again, Mo moved the world from apathy to an understanding of responsibility and possibility beyond one's living room door. He was a great journalist. He made a difference.

"As a man he was flawed, at times extremely difficult and self-centred. I was always unsure whether his need to be where the action was had its motivation in good business, that dreadful drug inside him that affects the frontline crowd, who feel they're only alive when they hear a rifle crack (and swagger back home to tell the dinner party guests), or a real journalistic need to mix it up. Probably, at different times, all three.

"After the show, back at the green room, he said 'I've been holding an award for you.' I told him if it was a plastic one or something really horrible I didn't want it. He said it was nice – from the Tigreans. It was a bronze replica of Sheba's stela in Axum.

"I reminded him of the culturally significant faux pas of our receiving

our UN hunger awards, which turned out to be silver spray-painted wooden spoons. Particularly apt I thought. He pissed himself laughing as he remembered. A month later, I got a heavy packet from Nairobi. It was my bronze. There was a note from Mo inside. It said 'Another wooden spoon! Keep this one. They'll never forget you.'

"Mo, for good or ill, changed my life and hundreds of thousands of others. After all this time and all the times I've been in Africa and all the things I've seen, it's still his pictures that I remember more clearly than anything else. It is I who will never forget him."

On November 8, 1997, at the News World Conference in Berlin, the Mohamed Amin Award was launched by News World and Reuters, to honour any member of a television news team who has shown outstanding professionalism, enterprise and initiative in gathering news or a news feature item.

In April, 1998, the American Academy of Orthotists and Prosthetists launched the Mohamed 'Mo' Amin Humanitarian Award to honour those who have shown courage in the face of disability. Mo was the posthumous recipient of the first award.

Also launched in 1998 was the Mohamed Amin Foundation, a project Mo had long nurtured and one which was nearing fruition when he died. His aim was to establish a school where he could teach aspiring journalists from Africa the techniques employed in television and photojournalism and how to use the tools of his beloved trade. He had, through his company Camerapix, already commissioned the architectural plans and model for the facility. His death prevented him from overseeing the fulfilment of his dream, but it is hoped the Foundation will remain a lasting memorial to Mo and to his achievements and dedication to raising the standards of journalism in Africa. In its first year, 1998, seven Kenyan journalists were already benefiting from the Foundation. Limitation of funds, facilities and equipment have kept numbers small, but as the organisation expands it hopes to be able to offer training to between 30 and 50 African journalists a year. All donations will be invested to finance facilities and to provide professional staff.

Salim explained: "The aim of the Foundation is to do away with the need for foreign journalists and film crews, and to use local journalists who understand the problems of the continent. That is the only way forward for Africa. Personally, I want to fulfil all the projects dad was working on at the time of his death. But there is one thing I'm not going to try to do and that is to fill his shoes. That would be impossible."

Another award reflects the deeply compassionate side of Mo's complex nature. In 1986, the 73,000-strong Samburu tribe of northern Kenya, who

live around Maralal between Lake Turkana and the Ewaso Nyiro river, were faced with serious problems. This nomadic Maa-speaking people relied for their medical needs on one health dispensary in Lesirikan and this was threatened with closure.

Loss of this vital facility to the cattle-owning pastoralists was a major blow. So Gabriel Lochgan and some of his friends turned to Mo for help. There was little money available and the prospects looked bleak – just the kind of challenge which Mo relished and he plunged into the project with enthusiasm. Without fuss or publicity, Mo set about saving the situation. He enlisted the help of the ministry of health and local people, and Samburu Aid in Africa (SAIDIA) was born, and the dispensary saved.

Since it began SAIDIA has grown extensively and is now the largest provider of health care in Samburu District. The organisation currently offers services to 40,000 people in the Mathews and Ndotos areas providing community-based health care, training, water and income-generating programmes, as well as educational sponsorship. Until his death, Mo was chairman of the organisation's management committee. Since then, as a tribute to his efforts, SAIDIA has launched the Mohamed Amin Memorial Fund, creating an endowment which it is hoped will secure the care costs of development work in perpetuity.

Current projects director Eleanor Monbiot said: "Mo helped set up SAIDIA in 1985 with a group of Samburus and expatriates who saw the desperate need for health care in the drought stricken region. For 11 years right up to the time of his death, he was an excellent chairman of this small and effective charity and, under his watchful eye, SAIDIA grew to become the largest health provider in Samburu. Nothing was too small or too big for him.

"I have heard people speak of how difficult he could be to get on with, but we saw a different side. Mo was kind and caring and put all his legendary drive and energy into helping the Samburu people, never being a man to do things by halves. As such, he was an invaluable fund raiser. We were extremely privileged to see a side of Mo many others did not. His heart was deeply into what he was trying to achieve. He loved the Samburu people. It's unlikely that without him SAIDIA would be celebrating its 13th year. We miss him deeply."

One of Mo's first contacts with the organisation was Kate Macintyre, who became a lifelong friend. It was she, Gabriel Lochgan and Mary Anne Fitzgerald who developed the idea of SAIDIA and she recalled her first sighting of Mo in his office in the Press Centre in Chester House, Nairobi.

She said: "He wasn't a big man in the physical sense, but he filled a room. The first time I saw him was through two plates of glass, and across

a courtyard. I could feel his presence even at that distance. He was working on the documentary about the Ethiopian famine and, as a 22-year-old, green, aspiring journalist, just out of university, I was already impressed. As the months went by, I became more so. I came to admire and love the man for more than his impressive record as a journalist, photographer and publisher.

"I came to know him as chairman of SAIDIA. I remember vividly those first meetings as we struggled to establish the organisation. It would be 7.30am and all of us would be gathered together in his office, slightly stunned by the hour, and Mo's energy would already be apparent. You had to get up early to catch Mo and you had to talk fast. But his advice was always calm, collected and to the point. He simply didn't waste time. His generosity, tact and willingness to pay attention to detail was incredibly welcome from the beginning.

"One of the great things about Mo was his capacity to listen, not just with that casual appearance of listening, but so that you knew he had heard you. His dark-circled eyes were completely steady, his head, usually on one side, would nod occasionally and, with his fingers cirling a pen all the while, he would listen to your words and wait until you had finished. For me, this often felt close to interrogation and I would stop, breathless, wondering if I had just babbled too much and uselessly. Then, with a quizzical look and a brief smile (the bigger the crisis, the wider the smile), he'd make a few comments and suggest some simple and practical solution.

"One small example: in 1989 there had been a bad outbreak of scabies in Samburu District and nearly 80 per cent of Samburu homes were infected. Children were repeatedly returning to the clinic with what looked like third degree burns all over their small bodies. We desperately needed to get a large shipment of medicine to the north and our vehicles, as usual, were broken down. I went to Mo and asked what he could do. A quick smile and he suggested I call the Samburu Lodge near Isiolo. They flew clients in all the time – why not medicine? They did, and within a month the scabies had been brought under control.

"We never discussed philosophy and I don't know what his real feelings were about SAIDIA, though he often said he was proud to be associated with it. But Mo didn't wear his heart on his sleeve too often. Yet his dedication to the project was real enough. He loved putting fund-raising ideas on the table and would often personally follow them up. When Samburus came into town, he would put aside time to talk with them and hear their problems.

"The last time I saw Mo was in September, 1996. I'd just returned from a trip to Samburu after several years of living in the States. I walked,

unannounced, into his office. Not much had changed – the pile of drafts to be edited were probably taller, the books ready for publication more numerous, the awards on the wall were clearly breeding, the various prostheses scattered around the room were new. But the television was still on, and the faxes and telephone were still going full blast. The dynamism was the same and the welcome hug identical. He talked about new schemes and about the money he'd been raising for SAIDIA to help start a bee-keeping project.

"He was a fascinating and wonderful man. SAIDIA will miss his support and encouragement. I will miss his humour and sense of proportion. But I know that nothing he has done has been wasted. I am proud to have worked with him and seen this side of him."

Ingrid Knapp had many reasons to thank Mo, for he helped her in several projects with which she was associated. She explained: "I was working for a small non-governmental organisation which had a small budget, and we really wanted to make a video to promote its work. Mo came to help in what turned out to be a two-day shoot in Kenya. When I asked him what I owed, he smiled and said that he hoped I would find the video useful and that it would raise funds for Africa and people in need. It was through Mo that I started an African support group in Ireland.

"He came to visit us in 1992 as guest speaker at a corporate fund-raising dinner to raise money for a clinic in Ethiopia. On another visit, he appeared on television on the *Late Late Show* and there was a tremendous response. Many people said what hope he had given those with disabilities. He was a tremendous character, always so enthusiastic about what he was doing or about some new project he was planning. He really did have a terrific zest for life."

On December 8, 1996, Britain's *Independent on Sunday* newspaper ran a two- page tribute to Mo, written by Mary Anne Fitzgerald. She worked with Mo for several years and was involved in SAIDIA during much of the time he was chairman. She said: "His work for SAIDIA went way beyond his brief. He always seemed to have an answer for all the problems. Just before he died, there was a lot of trouble within the organisation. Mo became involved, fought for peace and won. But there were two sides to him. He could be a real bastard and, like a lot of strong characters, if he didn't like you he made it known, though as he got older I think he became more sensitive. Driven he certainly was, but I never really knew why. But for all his faults and virtues he was very much a part of my life."

Of all the many tributes recorded at that time, Mary Anne's encapsulated the quintessential Mohamed Amin. It ran under the headline that was the inspiration for the title of this book. In it, Mary Anne warmly recalled

Mo's comments at the time he was preparing his documentary *African Calvary* immediately following the Ethiopian famine.

She said: "He said to me 'I'm going to get Mother Teresa to do the intro. She's the right person to plug it.' And for good measure he got the Pope, Margaret Thatcher, Julius Nyerere of Tanzania and Kenneth Kaunda of Zambia on camera as well.

"I'd had my doubts about Mother Teresa, but I was wrong. They were alike in many ways. Both came of peasant stock and intuitively understood the people among whom they worked. Both were pragmatic, unsentimental and fanatically driven to achieve their objectives. Neither took kindly to people who pulled rank, but did so shamelessly themselves when it suited their purposes. Both were equally at ease with dying slum children and heads of governments.

"No one who ever worked near him doubted that Mo could network. He was on first name terms with all the ministers, press secretaries and bodyguards. Every president knew him, and he knew the value of contacts.

"He correctly pointed out that being a good journalist in Africa is 95 per cent about logistics. He was a composite of travel agent extraordinaire and maestro lobbyist. That's how he managed to persuade obdurate officials and drunken soldiers to part with information and permits, and how he sniffed out transport to get him and his film out. He bantered with everyone and then bullied them for good measure if the soft touch didn't work. In a way, he viewed Africa like a large piece of machinery of which he was the engineer. He knew every cog and lever and what to push and pull to set things in motion.

"In his office, he would shuffle through his paperwork as you talked, grunting and expelling little snorts through his nose, but he was listening. This and other eccentricities displayed his impatience with the slow pace of the rest of the world. He rose at 2 or 3am to attack a workload large enough for a team.

"When he aroused enmity, which he did, I think it was often to do with the way he delivered the message. He could be wondrously blunt. He was funny and fun to be with, but he didn't waste his charms on the opposition.

"Part of this manner was because he came from a different culture. He became a British citizen but spoke fluent Swahili, the East African lingua franca, and his allegiance, if not his passport, remained ostentatiously nailed to the African mast. It was yet another attribute which gave him the edge over visiting TV crews.

"I sometimes travelled with him to visit the Samburu and, instead of going into contortions of political correctness, as many would have done, bending over backwards not to transgress the customs of an alien culture,

Mo strode right in. Warriors were ordered to stand here with their spears held like that, their eyes on the lens.

"Once at a circumcision ceremony of 100 boys, at which ritual hysteria was well under way, Mo inadvertently blocked the path of a ceremonial cow. An enraged warrior descended on him brandishing a club topped with a lethal-looking nut filched from the wheel of a seven-ton truck. His intentions were clear. He was going to bash Mohamed's brains out. I shouted a warning. Mo turned his camera on the warrior and kept on filming. He didn't miss a beat.

"He was a man of the Third World, which was one of the reasons he was so successful within his ever-expanding ambit. He had an invaluable capacity for explaining Africa to the world. It underpinned his success as much as his inexplicable drive. He was a hero to the Samburu and other Africans, just as he was to many others.

"Mo set his own agenda and lived by it. He was too big to have been contained within the mundane world of schedules and regulations. This was why he thrived in wars. By the same token, he was a difficult employee, even though he unfailingly delivered the goods wrapped in banner headlines. His relations with his employers were often explosive. He was a man of polar extremes who made a formidable enemy, just as he was a terrific friend who inspired love and devotion. He would move heaven and earth for you if he saw fit.

"He was a legendary figure who left a legacy far greater than his pictures. His message, by example, was this: there is no obstacle insurmountable to achieve your ends. A man can change the world and make it a better place. And he did just that.

"Mohamed always went to the mountain."

MOHAMED AMIN MBE
CURRICULUM VITAE

Chief Executive, Camerapix and associate companies, Nairobi, Kenya.
1963 - 1996 Photographer, cameraman, TV producer/director, author, publisher.
1963 Founded Camerapix.
1961 - 62 TV cameraman and photographer.
1958 - 61 Photo - journalist.

ACHIEVEMENTS:
Books, documentaries and films on the Middle East, Asia and Africa. Contributor to major TV
networks and print media, including BBC, ITN, Granada, CBS, NBC, ABC, Time-Life, Newsweek,
National Geographic Magazine, Sunday Times, Sunday Express, Observer and other major
newspapers and magazines throughout the world.
Head of Africa Bureau, Reuters Television, the world's largest television news agency, since 1966.
Editor in Chief, Africa Journal, since 1994.

CREDITS:
Offices held: Chairman, Foreign Correspondents Association of East Africa (1978 - 1983).
Chairman, Africa Region, Commonwealth Photography Award (1986).
Chairman, Samburu Aid in Africa (SAIDIA) since 1987.
Chairman, Foreign Correspondents Association from April, 1991.

FILMS:
Journey through Eritrea (1996) Producer/director.
Planet Aldabra (1996) Producer.
Journey through Ethiopia (1995), Producer/director.
Journey through Seychelles (1994), Producer.
The Big Battalions (1992), six part drama, Co-producer.
Defenders of Pakistan (1991), Producer/cameraman.
Battle on the Roof of the World (1989),Producer/cameraman.
Organization of African Unity, 25th Anniversary Documentary (1988), Producer/director.
TRAFFIK (1988) six part drama, Co-producer.
Give Me Shelter (1987), Producer/cameraman.
Tomorrow's Famine (1986), Producer/director.
Uganda: Children of the Terror (1986), Co-producer/cameraman.
A Fragile Future (1985), Producer/cameraman.
African Calvary (1985), Producer/director/cameraman.
Hunters of the Jade Sea (1985), Producer/director, first of a series of
six documentaries on Vanishing Africa.
Journey of a Lifetime (1977), Co-producer and cameraman.
Search for the Nile (1971), Production manager/cameraman,
a BBC-TV/Time-Life production which won the Emmy and many other honours.
Face the Nation (1965), Consultant/cameraman, CBS-TV.

AWARDS:
Tigre Development Association Award for the development of drought-stricken
areas of northern Ethiopia, from the President of Tigre (1995).
We are the World Award presented by USA for Africa (1995).
The Television Cameramen's Award, the Guild of Television Cameramen,
for outstanding contribution to the Art of the Television Cameraman (1992).
Judges' Award, Royal Television Society, Television Journalism Awards (1991).
Giant Federation for Contribution in the field of Photography and Television (1991).
Guinness Stout Effort Award (1991).

Giant Federation In Recognition of Extraordinary Effort in the Field of Photography (1989).
Intercom '87 Film Festival Gold Plaque Award for Give Me Shelter (1987).
Intercom '86 Industrial Film Festival Gold Plaque Award for Children of the Terror (Cinema/Chicago 1986).
Valiant for Truth Media Award for "so fearlessly forcing the world to face the truth about African Famine" (Arts Club, London 1986).
Kenny Rogers World Hunger Media Awards Best Television Coverage Ethiopia (UN Headquarters, New York 1985).
University of Southern California, School of Journalism and its Alumni Association Theodore E Kruglak Special Award (1985).
National Headliner Award for Consistently Outstanding News Reporting (Atlantic City, New Jersey, US 1985).
A.H. Boerma Award by the Food and Agricultural Organization of the UN for focusing public attention to the World Food problem (1984-1985).
The Overseas Press Club of America Award for the Best TV Spot News Reporting from Abroad (1985).
Jessie Meriton White Service Award in International Journalism for Foreign Television Reporting presented by Friends World College (1985).
National Headliner Award for Ethiopian Famine Coverage (Atlantic City, New Jersey, US 1985).
The George Polk Award (US) for Foreign Television Reporting (1984).
Kenya Journalist of the Year Award for the Best News Film (1984).
The British Academy of Film and Television Arts Award for the Best Actuality Coverage (1984).
Royal Television Society Journalism Award for International News (1984).
Golden Nymph Award (Monte Carlo) for Excellence in Television Journalism (1984).
UNDA Award from International Catholic Association for Best News Programme (1984).
Cameraman of the Year, British Television Awards (1969).

DISTINCTIONS:
Order of the Grand Warrior of Kenya (O.G.W.), presented by the President of Kenya, on December 12, 1993.
Member of the Order of the British Empire (MBE) by Her Majesty the Queen on December 30, 1991, for Services to Photography and Journalism in Africa.
Relief and Rehabilitation Commission Plaque for Humanitarian Service to Ethiopia (1985).
Order of the Tamgah-i-Imtiaz (T.I.), Pakistan's second highest civil award (1983).
Fellow of the Royal Geographical Society, UK (since 1982).

EXHIBITIONS:
Kenya: The Magic Land, Commonwealth Institute, London (1988).
Defenders of Pakistan, Islamabad (1988).
Journey through Pakistan, Washington, Islamabad, Tokyo, Istanbul (1982-1983).
Cradle of Mankind, Nairobi, Commonwealth Institute, London, Royal Geographical Society, London (1981).
Pilgrimage to Mecca, Nairobi (1978).
Wildlife Safari, Nairobi (1974).

EXPEDITIONS:
Organizer and Leader of the Round Lake Turkana Expedition (1980).

PUBLICATIONS:

Spectrum Guide to Zambia (1996).
Journey Through Ethiopia (1996).
Aldabra, World Heritage Site (1995).
Spectrum Guide to South Africa (1995).
Spectrum Guide to Ethiopia (1995).
Journey through Seychelles (1995).
Spectrum Guide to Jordan (1994).
Spectrum Guide to Namibia (1994).
Journey through Namibia (1994).
Spectrum Guide to Maldives (1993).
Beauty of Ngorongoro (1993).
Beauty of Amboseli (1993).
Spectrum Guide to Tanzania (1992).
Beauty of Seychelles (1992).
Journey through Maldives (1991).
On God's Mountain, Mt Kenya (1991).
Spectrum Guide to Zimbabwe (1991).
Spectrum Guide to Seychelles (1991).
Journey through Zimbabwe (1990).
Roof of the World (1989).
Spectrum Guide to Pakistan (1989).
Spectrum Guide to Kenya (1989).
African Wildlife Safaris (1989).
MO: The Story of Mohamed Amin
by Brian Tetley (1988).
Kenya: The Magic Land (1988).
Defenders of Pakistan (1988).
Lahore (1988).
The Last of the Maasai (1987).
Journey through Nepal (1987).
Railway Across the Equator (1986).
The Beauty of the Kenya Coast (1986).
Karachi (1986).
Insight Guide, Kenya (1985).
Journey through Tanzania (1984).
The Beauty of Kenya (1984).
We Live in Pakistan (1984).

Portraits of Africa (1983).
The Beauty of Pakistan (1983).
Ivory Crisis (1983).
We Live in Kenya (1983).
Journey through Kenya (1983).
Run, Rhino, Run (1982).
Journey through Pakistan (1982).
Cradle of Mankind (1981).
Mecca (1980).
Lust to Kill (1979).
Pilgrimage to Mecca (1978).
Nimeiri's Sudan (1978).
Legendary Africa (1977).
The Flying Sikh (1975).
One Man, One Vote (1975).
Mzee Jomo Kenyatta (1973).
East African Safari Rally Comes
of Age (1973).
Kenya's World Beating Athletes (1972).
Tom Mboya: A Photo Tribute (1969).

INDEX

A

Abate, Leul 20, 21
Acholi 154,158
Addis Ababa 18, 19, 60, 98, 108, 122, 123, 237, 275
Addis Hilton 19, 215, 237, 247, 275
Aden 64, 65, 95, 147
Afghanistan 114, 137, 278
Africa Journal **137,** 260, 263-267
African Calvary 195, 222-224, 291
Aga Khan, The **82,** 190, 281
Ahmed (elephant) 104, **129**
Aideed, General 263
Alamata 216, 218
Algeria 57
Alim, Mohamed 281
American Academy of Orthotists and Prosthetists 253, 287
Amiani, Richard 97
Amin, Dolly (Khaki) 6, **24, 25, 27, 29, 34, 37, 38,** 53, **76,** 93, 101-102, **201,** 262, 281-283
Amin, Farzana (Datoo) **34,** 267
Amin, Idi 67, 96, 106, 107, 111, 124, 125, **130-133,** 146, 148, 152-158, 161, 163-169
Amin, Saher **38,** 267
Amin, Salim 6, 19, 30, **31, 32, 34, 38, 76,** 102, **201,** 211, 253, 261, 263, 266, 267, 270, 282, 283, 285, 287
AMREF 246, 249
Angola 55
Arafat, Yasser **132,** 157
Archbishop Janani Luwum 158
Archbishop Paul Marcinkus 107
Asmara 122
Astles, Bob 67

B

BAFTA 224
Bagamoyo 52, 57
Baghdad 115
Balletto, Barbara 6, 274
Baluchistan Times 188
Band Aid 219-221, 227, 258
Bangladesh 118
Bangui 159
Barratt, Michael **195**
Barre, Mohamed Siad 260
Barron, Brian 6, 161-167
BBC 22, 49, 65, 66, 102, 113, 114, 117, 119, 121-124, 151, 161, 165, 167, 212 213, 218, 221, 224, 239, 242, 244, 249, 251, 257, 262, 275
Belafonte, Harry 6, **201,** 220, 225, 226, 285
Bengalis 118-119
Berlin 287
Biafra 67
Biafran War 155
Billock, John 6, **236,** 251, 272
Binaisa, President Godfrey 168
Birmingham Gazette 225
Blane, Colin 6, **233,** 240-242, 244, 249
Bloch, Dora 157, 158
Bogdan, Stephanie **1,** 5, 251
Bokassa, Jean-Bedel 106, **140,** 150, 158, 160
Bordes, Pamela 274
Britain 39-40, 45, 47, 52, 63, 65, 67, 97, 111, 269, 270, 278
Brokaw, Tom 218
Buckingham Palace 57, 257
Buerk, Michael 3, 6, 11-13, **14,** 15, 22, **83,** 115, 213, 214, 217-218, 221-222, 224, **231,** 233, 239-242, 244, 248-249, 257-258, 268, 285
Burrows, General Eva 228
Bush, George **76,** 224
Bhutto, Zulfiqar Ali 120, **137**

C

Calcutta 118, 119, 222
Cambridge 267
Camerapix 44, 48, 70, 101, 104, 115, 126, 161, 187, 190, 193, 273
Carnival Films 273, 277
Carter, Jimmy **76**
CBS 53, 55, 59, 60-61, 94, 98
Central African Republic 106, 150, 158-159
Chaudhri, Rafique 6, 98, 99, **142, 143**
China 55, 57
Chou-En-Lai 49
CNN 259, 275, 285
Colito Barracks 54
Commonwealth Conference 141, 152, 253
Comoros 20-22, 263
Congo 55
Cradle of Mankind 108, 110
Cuba 55, 57-58

D

Daily Express 45
Daily Mail 45, 97
Daily Mirror 45, 97
Danakil Depression 122
Dar es Salaam 7, 23, 41, 42, 46, 47, 48, 49, 51, 55, 59, 63, 64, 152
Davis, Ivor 224, 225
de Gaulle, President Charles 59
Delhi 255
Dergue 122, 123
Desert Island Discs 117, 257
Dhillon, Mohinder 6, 68, **81,** 105, **145,** 213, 223, 225
Diverse Productions 223
Djibouti 59, 60, 64, 65, 68, 211, 213
Do They Know It's Christmas 220, 258
Donovan, Tony 6, 114, 115
Douala 159
Drum 45, 47
Dublin 285

E

East African Community 67
East African Safari Rally 30,
 31, 44, 104, 117, **145**, 211,
 261
East African Women's
 League 274
East Germany 55
East Pakistan 117-119, 121
Eastman, Brian 6, **72**, 268,
 277, 278
Egypt 57, 60
el-Molo 90, 157, 172
Eldon, Amy **197**
Eldon, Dan 197, 263
Entebbe 111, 124, 125, 153,
 157, 158, 161, 170
Eritrea 212, 216
Ethiopia 14, 15, 18, 19, 56,
 59, 62, 64, 94, 97, 108-110,
 113, 121, 122, 151, 168,
 197, 211-214, 217, 218,
 220-223, 226, 228, 237,
 239, 247, 248, 250, 253,
 255, 259, 270, 275, 278,
 280, 289-291
Ethiopian famine 64, 195,
 211, 222
Eurovision 169, 218

F

Financial Times 111
Fitzgerald, Mary Anne 6,
 288, 290
Fleet Street 22, 45, 188, 193,
 263
Flight ET 961 9, **16**, **17**, 19,
 21
Frankfurt Book Fair **70**,
 107, 213
Frelimo 50, 57
French Foreign Legion 60

G

Gaddafi, Muammar 164
Gaiger, Debbie 6, 237, 247
Gamal, Nasser 60
Geldof, Bob 6, **202**, 219,
 220, 271, 285, 286
General Gowon 155, 156
Gill, Steve 6, 265, 266
Goodwin, Paul 250

Greenberg, Paul 219
Grimshaw, Brendon 6, 43,
 44, 275
Gulf war 114

H

Haile Selassie 122, 123,
 140, 257
Hancock, Graham 6, 187,
 190-193, 274
Hanif, Mohamed 281
Haq, Rukhsana 6, 18, 256
Haq, Zia ul **83**, 190, 191,
 272, 277, 278
Hart, Alan 117-121
Hawke, Bob 221
Heath, Ted **81**
Hopkinson, Sir Tom 45
Horn of Africa 19, 59, 65,
 94
Hughes, Nick 240, 242, 244
Hulse, Keith 6, 122, 123
Hussein, President Saddam
 114

I

Independent on Sunday 6,
 290
India 39, 42, 43, 56, 113,
 118, 119, 194, 213, 274
Indian Secondary School for
 Asian Children 272
Iqbal, Mohamed 6, **23**, 39-
 41, **82**, 267, 269, 281, 282
Ireland 285, 290
Islamabad 191, 267
Israel 102, 111, 124, 125,
 157, 158, 191, 278
Italy 94
ITN 49, 54, 55, 66
Ivory 127

J

Jackson, Marlon **201**
Jackson, Michael 203, 220,
 227
Jade Sea 108, 109
Japan 105, 118
Jeddah 165-167
Jessore 119
Jinja 40, 163, 164
Johannesburg 285
Jones, Quincy **83**, 227

Jordan 102
Juba 189
Jullundur 39, 40

K

Kabaka 151, 152
Kabul 114
Kampala 153, 155, 156,
 161-163, 169, 258
Karachi 118-120
Karume, Sheikh Abeid 58, 62
Katanga 160
Kaunda, Kenneth 291
Kenya 18, 39-41, 52, 66-68,
 77, 93-107, 110, 111, 113,
 115, 116, 121, 151, 152,
 155-157, 161, 163, 164,
 168, 169, 188, 189, 212,
 242, 247, 249, 262, 266,
 269, 274, 282, 284, 285,
 287, 290
Kenya People's Union
 (KPU) 100
Kenyatta, Jomo 41, 52, **78**,
 100, 101, 106, 107, **146**,
 148, 152
Khaki, Aziz 48, 281
Khaki, Bahadur 93
Khartoum 57
Kigali 67
Kikuyu 97, 99, 100
Kiley, Sam 6, 238
Kilimamigu 61
Kilimanjaro **87-89**, 97, 105,
 106, 177
Kisumu 100
Knapp, Ingrid 6, 290
Knight, Nick 161
Kogan, David 6, 114, 248,
 255, 264
Koobi Fora 108, 110
Korem 15, 208-209, 212-
 216, 218
Kotch, Nick 263
Kragan, Ken 6, **83**, 220, 225,
 227
Krauss, Hansi 263

L

Lagos 259
Lahore 190
Lake Turkana 49, 90, 92,

103, 108, 110
Lake Victoria 100
Lalibela 215
Langara College 261
Langi 154, 158
Lavington 107, 264, 267
Lawley, Sue **72**, 117, 257, 258
Leakey, Richard 110
Libya 161, 164, 165
Live Aid 220, 227
Lochgan, Gabriel 288
London 12, 22, 49, 53-55, 59, 61, 63, 68, 99, 111, 112, 114, 119, 121, 152, 160, 166-168, 193, 213, 218, 221, 223, 227, 255, 256, 259, 262-264, 266, 274, 278, 279
Longonot, Mount **86**
Los Angeles 220, 259
Lule, Yusuf 162, 168
Luo 90, 98-100

M
Macharia, Anthony **136**, 263
Macintyre, Kate 6, 288
Mad Mitch 65
Madagascar 20
Magny, Jean 255
Maina, Hos 263
Major, John 6, **141**, 253
Makele 13, 199, 212, 214-216, 218, 226, 258
Maldives 87
Malindi 95
Mancham, Sir James **77**
Mandela, Nelson **77**
Manir, Mohamed 281
Mathai, John **231**, 240, 243, 244
Mau Mau 41, 52
Mauritius 67, 124
MBE 57, **69**, 257
Mbeki, Thabo 285
Mboya, Tom 98, 99, 100, 103, **142**, **143**
McHaffie, John 6, 105
Mecca 106, 165, 190
Medina 190
Merkuria, Yonas 20
Menelik Palace 238, 239

Mengistu Haile Mariam 212, 237-239
Middle East 102
Mitchel 66
Mkapa, President Benjamin **80**
Mo Productions 223, 224
Mogadishu 13, 258, 261, 263
Mohamed Amin Foundation 287
Moi, President Daniel arap 6, **79**, 107, 128, 152, 284
Moll, Peter 104, 272
Mombasa 39, 40, 106, 107, . 111, 112
Monbiot, Eleanor 6, 288
Mondlane, Eduardo Chivambo 50, 57
Moscow 59
Mossad 20
Mother Teresa 222, 291
Moyale 97
Moyenne 44
Mozambique 20, 50, 55, 61, 125
Mrembo 96
Murchison Falls 154
Museveni, President Yoweri **80**, 169, 170
Musyoka, Stephen Kalonzo 284

N
Nairobi 9, 18, 19, 39-41, 46, 51, 64, 66-68, 93, 95-100, 102, 105-107, 109-112, 115, 116, 119, 121, 152, 159, 161, 164, 165, 167, 168, 170, 187, 189, 190, 192, 193, 214, 218, 223-225, 237, 241, 242, 244, 246-249, 255-257, 261-264, 266, 269, 272-276, 281, 282, 284, 285, 287, 288
Naivasha 96
Nakuru 40, 164
Nasser, President Gamal 60
Nazira 281
NBC 218, 219
Nepal 91, 113

New York 61, 63, 157, 218, 224-226, 259, 285
Niaz, Mohamed **23**, 282
Nicholson, David 122
Nigeria 67, 113, 155, 156, 259, 260
Nile 151, 154
Njuguna, Zack 214
Norfolk Hotel 110, 192, 193
Nujoma, Sam **81**
Nyerere, Julius 47, 48, 51, 63, 64, **79**, 161, 169, 276, 291

O
Obote, Milton 103, 151-154, 168, 169
Odenyo, Michael 21, 22
Odinga, Oginga 100, 101
Ogaden 123
Okello, John 52
Okello, Tito 169
Omo River 108, 110
Optex 251
Organization of African Unity 66, 124, 140, 155, 156, 157, 275
Osman, John **137**
Ougadougou 258

P
Pakistan 40, 56, 85, 104, 106, 114, 117-121, 272, 277, 278
Panorama 117, 119, 121
Paris 157, 160, 255, 256
Payne, Mike 6, 255, 264, 265
Pearce Commission 270
Pele **145**
Pemba 51
Perry, Rita 6, 274
Phonogram 220
Platter, John 100, 101
Pope John Paul II **81**, 107, 113, 222, 291
Powers, Stephanie **73**
Port Louis 67
Portugal 67
Prakash, Prem 255, 256
Prince Charles 97, 102
Prince Philip 47, 51, 52, 56

Princess Alexandra **82**
Princess Anne **83**, 102
Punjab 39, 118, 119
Pyser-SGI 250

Q
Queen Elizabeth II 56, 57, **82**, 253, 257
Quraishy, Masud 106

R
Ramgoolam, Sir Seewoosagur 124, 151
Ramrakha, Priya 67
Reagan, Ronald 221
Reuber-Staier, Eva 282
Reuter, Henry 102
Reuters 13, 98, 114, 169, 256, 260, 263-266
Rhodesia 61, 106, 125, 126, 270
Ritchie, Lionel 6, **204**, 220, 227
Rift Valley 40, 96
Riyadh 165
Robinson, Mary 6, **197**, 285
Robson, Ronnie 65, 120, 121
Rogers, Kenny 6, **80**, 225, 227
Rome 225
Royal Television Society 224, 285
Royal, Dennis 65
Russia 55, 58, 59, 114
Rwanda 66, 67, 261

S
Sagira 41, 281
SAIDIA 288-290
Salisbury 125, 270
Salvation Army 228
Samburu 91, 288-292
Sandys, Duncan 55
Sao Tome 67
Sardar Mohamed **23**, 39, 40, 269
Saudi Arabia 164-167
Save The Children Fund 221
Search For The Nile 151, 154
Searle, Peter 223, 224

Seeds of Despair 213
Segal, J 55
Sese Seko, Mobutu 66, 130
Seychelles 9, 44, 77
Shaba Province 160
Shaffi, Mohamed 6, 46, 169, 261-263, 283
Shields, Brooke 113, **144**, 213
Somalia 59, 64, 94, 136, 211, 213, 257, 259-261, 263, 285
South Africa 21, 48, 125, 126, 157, 213, 265, 285
Sposito, Mike 114
St Bride's Church 22, 263, 285
Stewart, Peter 102
Sudan 46, 57, 102, 106, 189, 213, 261
Sugra 281
Suguta Valley 108, 109
Sunday Express 111, 168
Sunday Nation 261
Sunday Times 257

T
Tanganyika 24, 27, 40, 41, 43, 45, 47, 54, 56, 101, 275
Tanzania 18, 49, 56, 58, 61, 63, 64, 67, 68, 86, 93, 94, 96, 152, 153, 156, 161-164, 168, 169, 261, 266, 282, 291
Telli, General Diallo 66
Tetley, Brian 9, 17-20, 22, 44, 54, 65, **71**, **82**, 109, 114, 119, 126, **139**, 154, 155, 187-190, 192-194, 211, 219, 223, 225
Thatcher, Margaret **195**, 222, 291
The Big Battalions 278
The Nation 47, 97, 105, 121, 212
The Observer 155
The Times 45, 94, 227, 238
The Traveller 190, 274
Thirer, Eric 6, 161, 162, 165-167
Thompson, Graeme 250
Tigre 212, 286

Time-Life 60
Tokyo 105
Tororo Barracks 155
Toulmin-Rothe, Paul 270
Traffik 72, 277
Twala, Abdul Aziz 62

U
Uganda 13, 39, 40, 46, 67, 68, 96, 102, 106, 111, 113, 124, 151-158, 161-164, 166-170
Unicef 285
United Nations (UN) 6, 20 170, 211, 259, 260, 285
UPI 100, 274
UPIN 53, 68
UPITN 227

V
Visnews 53, 59, 61, 65, 67, 68, 99, 105, 113, 114, 122, 126, 159, 165-167, 191, 192, 213, 214, 221, 224, 239, 240, 248, 250, 253, 255, 256, 258, 263, 264

W
Wako, Amos 284
Washington 224, 259
We Are The World 201, 204-205, 207, 220, 227
West Pakistan 118-120
Willetts, Duncan 6, 22, **71**, **82**, 105, 107, 112, 126, 169, 187-190, 192, 194
Wilson Airport 96, 111, 112, 161
Wonder, Stevie 227
Wood, Mark 6, 265, 285
Wooldridge, Mike 6, 123, 169, **206**, 212-214, 216, 218, 262
World Vision 215, 218, 223
Wossen, Tafari 214, 215, 249

Z
Zaire 66, 102, 160
Zambia 156, 291
Zanzibar 24, 51-56, 58-63, 68, 101, 151, 262, 282
Zimbabwe 225, 253